Collins

# Collins
# Digital SLR
# Handbook

John Freeman

Collins

*To Chris Pailthorpe, who never lived to see this book.*

## The Author

John Freeman is a highly experienced professional photographer and author of several books on photography, including *Practical Photography, Lighting for Interiors* and *Photography: The Complete Guide to Taking Photographs*. He has a regular column in *What Digital Camera?* and *Digital Camera* magazines. For further information and a gallery of his photographs, visit www.johnfreeman-photographer.com

First published in 2007 by Collins
an imprint of
HarperCollins*Publishers*
77–85 Fulham Palace Road
Hammersmith, London W6 8JB

www.collins.co.uk

Collins is a registered trademark of HarperCollins Publishers Limited.

11 10 09 08
6 5 4 3

A catalogue record for this book is available from the British Library

*Technical Contributor* Doug Harman
*Editor* Helen Ridge
*Designer* Alison Fenton

ISBN 978 0 00 724210 8

Colour reproduction by Dot Gradation, UK
Printed and bound by Printing Express, Hong Kong

# Contents

# Introduction

For many years, the 35mm SLR film camera has been the cornerstone of the serious photographer's kit but, with a speed that few could have imagined, the digital single lens reflex (DSLR) camera has now taken over its role.

## The rise of the DSLR

There are those people who still maintain that the age of digital photography is all about 'manipulation' and that photographs produced digitally cannot come close to those printed on bromide in a wet darkroom. While no one would deny that shooting on film, developing it and then making a print is a craft that one spends a lifetime learning, equally no one should underestimate the different skills required to get the best from a digital camera, especially a sophisticated DSLR model.

## Digital developments

Since the mid-1970s, when Kodak developed the first solid-state image sensor, the developments in digital photography have been as varied as they have been rapid. Only a few years ago, a compact camera boasting a 2mp (megapixel) image sensor was thought of as state of the art. Comparing that to my Canon EOS 1DS MK2 DSLR, which has a 17mp image sensor, it would be foolish to think that the technology will do anything but improve. This camera has now become the centre of my kit, and there are few applications that it can't cope with just as well as, if not better than, my old film cameras once did.

The DSLR camera body is at the centre of a vast and continually growing system that is perfect for the professional photographer and enthusiastic amateur. Apart from being able to record high-definition images that can be enlarged to billboard-size proportions, the lenses available can be applied to virtually any shooting situation. These range from ultra wide-angle, such as the 180° fisheye lens, through to ultra telephoto lenses of 1000mm or more. In between there is a plethora of other lenses, such as macro, shift and tilt, image stabilizing lenses and more. Then there are the accessories, such as interchangeable focusing screens, macro ring flash, angle finders, underwater housings and so on.

However, just as it was with the old film SLRs or, indeed, with any equipment, it is you, the photographer, that makes the difference. After all, it is your 'eye' that sees the picture – the camera can only record it in the way you tell it to. With the help of this book you can learn how to see in a way that will enable you to get the most from your DSLR system.

Light is the lifeblood of photography, and the DSLR system enables you to capture the light at the end of the tunnel probably better than any other camera. Even in difficult situations, such as shooting in this canyon, the DSLR's ability to record an image in low light is second to none.
> Canon EOS 1DS, 24mm lens, 2 secs, f/11.

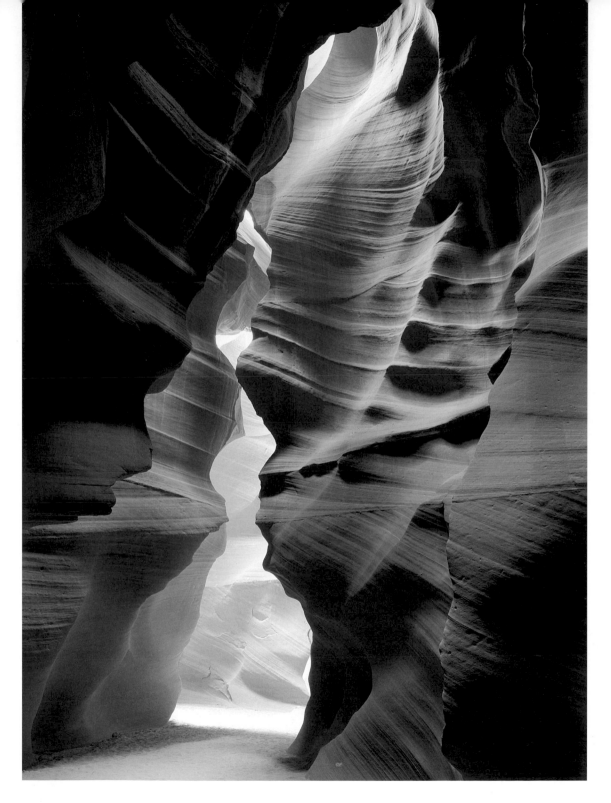

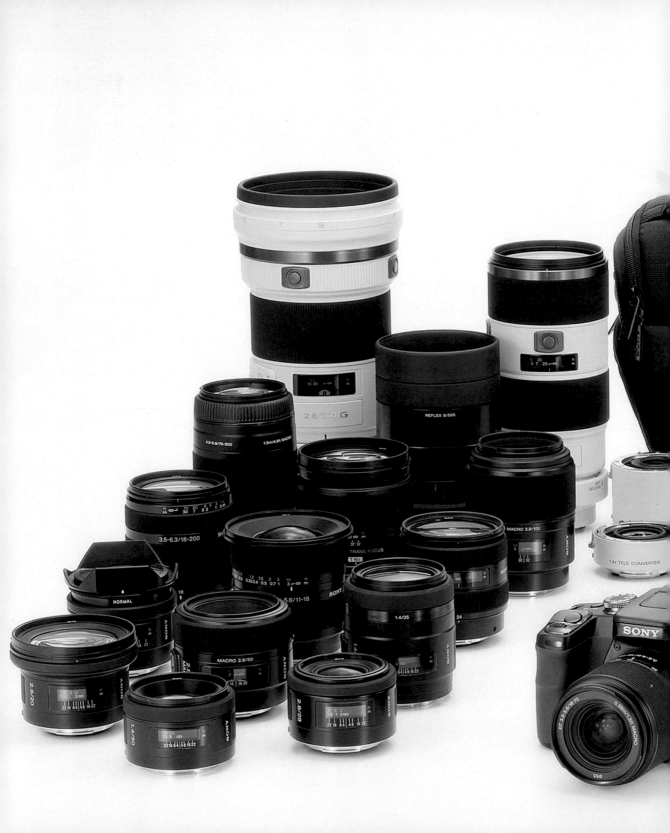

# The DSLR system

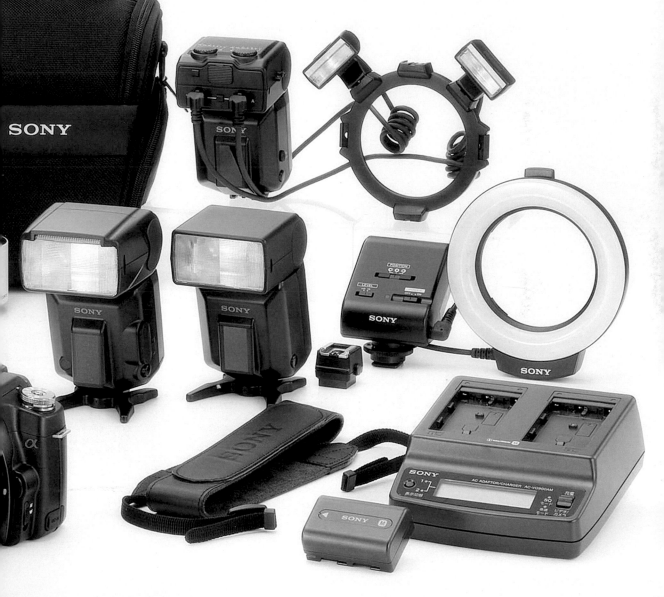

# The DSLR explained

Digital SLR cameras developed out of film SLRs. The earliest models were hybrids of film and digital technology but, as digital technology has advanced, DSLRs have become the camera of choice for many professional and amateur photographers.

## How it all started

The main difference between a DSLR and an SLR camera is that in a DSLR, film is replaced by a solid-state image sensor. The images are created digitally within the camera, without the need to develop an image on film using chemicals.

In the mid-1970s, Kodak developed the first solid-state image sensor, known today as a CCD (charge coupled device), and by 1986, it had unveiled to the world the first megapixel sensor. With 1.4mp (megapixels), it was able to produce a photograph measuring around 130 × 170mm (5 × 7in). The company then pushed on to develop the Photo CD system for digitizing and storing photographs on a CD.

It was fitting that, in 1991, Kodak revealed the first commercially available DCS (digital camera system). Aimed at professionals, its DCS 100 was made up of a Nikon F3 camera body and a Kodak digital camera back with a 1.3 megapixel sensor on board.

## Advances in technology

The benefits afforded to digital photographers quickly became apparent as the technology proved itself. Admittedly, the cameras available were chunky and needed a bus for carting the batteries around on, and they were also expensive: some of the first DSLRs cost over £20,000, making them a serious investment for any professional snapper and out of the reach of most enthusiast photographers.

However, the fact that you had a fast turnaround of images, could check your shot on the back of the camera as you went and had no film and development costs became key factors in the growing popularity of DSLRs. You could also use the same lenses on your digital SLR as you could on a film SLR, so owners of Canon and Nikon digital SLRs (the first two main manufacturers working with Kodak to make the digital aspects of the machines) did not need to buy loads of other camera kit.

Slowly, the move – for professionals at first, then for amateurs – from film to digital grew apace. The technology became (and continues to become) better and cheaper. And the key benefits of speed and control, plus the removal of worries over film and film processing, meant that any

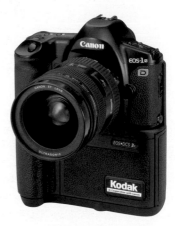

**One of the first cameras produced by Kodak and Canon was the EOS DCS 3, comprising a Canon EOS 1N film body adapted to take a Kodak digital 'back'. The camera shows how the early digital SLRs were a hybrid of film and digital technology.**

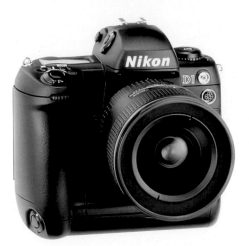

Nikon's ground-breaking DSLR, the simply named D1, revolutionized not only the DSLR camera market, but also what photographers came to expect from their cameras.

photojournalist who didn't swap over to digital would be left behind in the rush to get their images on the picture editor's desk.

The introduction of Nikon's D1, fully integrated and, for the first time, complete DSLR (not needing the addition of a digital 'back') in 1999 transformed the marketplace. At last, there was a complete, user-friendly, reasonably sized and, importantly, reasonably priced DSLR, and it took the market by storm. Well made and featuring all the photography tools you'd expect from a top-end model but in a svelte package, the D1 left almost everyone wanting to own one. It also meant that there was no turning back for the marketplace.

## The range of DSLRs

Today's DSLRs cover a broad spectrum of the marketplace: there are cameras to suit everyone, from novice users, those swapping from film to digital, as well as high-end professionals. Those cameras aimed at the novice, such as Canon's EOS 400D and Nikon's D50, are still extremely sophisticated pieces of kit but they are both built to a price.

Even though the Canon EOS 400D marks the latest in the company's line of DSLRs aimed at the beginner end of the market, it still boasts a 10.1 megapixel sensor and a host of advanced features only dreamt of when the first DSLRs arrived. It also costs a fraction of those early professional cameras.

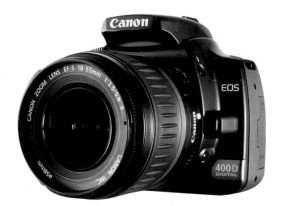

Consequently, they lack the professional level of build quality, some of the finer control available on higher-end models and also some of the faster internal processors that make them tick.

Sony has entered the fray with its first DSLR, the Sony Alpha 100, based on Konica Minolta technology. Olympus has taken a different route, with Kodak (again), and developed a new range of DSLRs for the professional and enthusiast featuring the specially developed FourThirds system. This incorporates a range of new lenses and a new 4:3 aspect ratio Kodak sensor (hence the name of the system). Nikon, meanwhile, has introduced another enthusiast level DSLR in the shape of the D80.

At the top end of the scale, there are the professional-level DSLRs, typically built to withstand the knocks meted out on, say, match day at a football ground in the pouring rain, and the dust and dirt of harsh environments, such as war zones. The camera bodies and the internal electronics are tough, all of them offer high-resolution sensors capable of the highest image quality, and they come at a premium in price as well.

Canon's EOS 1D MK2 represents one of the high-end DSLRs designed for professional use. Even though the body is tougher and the internals more complex than those of less expensive EOS DSLRs, this camera can still use the same range of lenses and accessories.

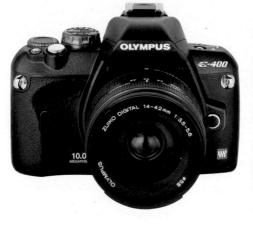

Olympus's E400 FourThirds system DSLR camera features a small, easy-to-use body and a Kodak-developed 4:3 aspect ratio sensor requiring a new lens mount and lenses. Its compact size is an advantage for those not wanting the heft of 'normal' DSLRs.

## Advantages of DSLRs

DSLRs are extremely versatile, offering key advantages over compact digital cameras and many SLRs. The fact that they can use a range of varying focal length lenses or lenses designed for specific tasks is, of course, key to their success.

Since DSLRs come with larger lenses and brighter glass elements than those available to digital compacts, it means that they offer higher-resolution optics. The amount of detail that can be captured is increased and the wide range of optics available for a variety of jobs helps, too. With a DSLR, you can cater to all tasks, including specialist jobs, such as macro photography, where the lens must be able to focus very close to the subject, and architectural work, where a shift or tilt lens can correct converging verticals.

Accessories, such as flashguns that mount on a hotshoe on top of the camera allowing for more control of lighting, provide even more versatility, as does the ability to use studio flash systems for professional portrait shoots, for example.

**A DSLR is part of a system of lenses and accessories that enables the photographer to shoot a huge variety of subjects while retaining complete control of the shoot, making this type of camera truly versatile.**

See also:
**Accessories** pp. 26–31
**Studio flash** pp. 118–19
**Shift and tilt lenses** pp. 176–9
**Macro lenses** p. 198

# The equipment

A DSLR camera is a complex piece of machinery with advanced technology to help it do its job. There are many pieces of additional equipment, from lenses to accessories, that all go to make up the camera and the system to which it belongs.

## Camera body

Foremost in any camera system is the camera body, followed by its lenses and then the accessories that help to expand the capabilities of both; these include flashguns, lens filters, hoods and so on. In this chapter, the key elements of all the equipment you're likely either to own or encounter as you use your DSLR are discussed but, first, let's look at the DSLR camera and its technology.

lens     lens barrel     camera body   viewfinder

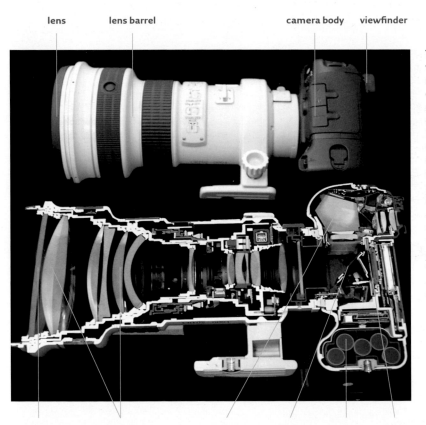

front lens    internal lens    pentaprism   45-degree   batteries   sensor
elements              angled mirror

This cutaway of a Canon EOS 1DS with a large telephoto lens reveals the inner workings and complexity of a DSLR. The largest element is the lens on the front of the body. The various internal lenses and their respective curvatures show how light is captured and channelled down the lens barrel, focused and passed on, into the camera body. Here, the light encounters a 45-degree angled mirror that directs light upwards and through a pentaprism to the photographer's eye placed at the viewfinder. When you take a shot, the mirror flips up and out of the way, the shutter behind it fires, the sensor sitting behind the shutter is exposed to light and a photograph is made.

# Sensor

Today's DSLRs use special, light-sensitive sensors to capture light and record images, thereby starting the process of turning light into a digital image. There are three types of sensor: the CCD (charge coupled device), the CMOS chip (complementary metal oxide sensor) and the more recently introduced Foveon X3 sensor. The CCD and CMOS are, in essence, the same but they use different technologies to do the same job. The Foveon sensor is quite different.

All three types of sensor use millions of tiny, discrete picture elements, known as pixels. The more pixels there are, the higher the sensor's resolution. The CCD and CMOS chips have their pixels laid out on a flat plane, and each pixel can be thought of as a small light well.

Every pixel has a tiny micro lens on top of it (special Fuji sensors use two pixels and micro lenses at each pixel location) that helps to focus the light properly within each pixel. Any light entering a pixel is converted to a digital signal and sent to the camera's on-board computer. The captured light is given a value corresponding to its brightness and colour, and all these values added together form the final digital image we see.

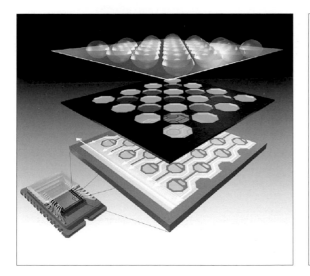

**This sensor diagram of a Fuji 4th Generation SuperCCD reveals the CCD's micro lens layer (top), the RGB mosaic filter (middle) and the dual pixels (bottom) used by this type of sensor technology to help capture even finer gradations of highlight in an image.**

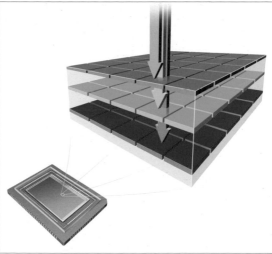

**This diagram of a Foveon X3 sensor shows how the varying colours of light are collected from different depths within the sensor's silicon.**

However, CCDs and CMOS chips are actually colour-blind so to create the colours we see in an image, a filter grid of red, green and blue squares (RGB for short) overlays the pixels and under the micro lens layer. It is this RGB filter mosaic that creates colour in the images and is analogous to the colours created on a TV screen, which use the juxtaposition of red, green and blue pixels to create colour.

In a Foveon sensor, the pixels are embedded within layers of a silicon wafer at varying depths. Foveon sensors take advantage of the fact that the components of white light (red, green and blue light) can only penetrate the silicon to different and specific depths, so each pixel can record each colour at each pixel location depending on its depth, meaning that no extra colour processing is required.

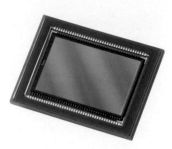

**A CMOS sensor in all its glory, as used in a Canon EOS 1DS MK2.**

The advantages of one type of sensor over another are debated long and hard, particularly by the manufacturers, but, in truth, the actual quality of an image is dependent on not just the sensor but on the entire DSLR system, such as the metering, white balance control, image processing and, most importantly, the lens. Poor-quality lenses deliver poor-quality light to the sensor, so the better the optics within a camera system, the better the images. No matter how many pixels a sensor houses and no matter how good the processor (see below), if the light is blurred as it hits the CCD, your pictures are compromised.

## Processor

Once the light information has been captured by the sensor, it is passed to the camera's 'brain' – its internal computer, or processor. The processor must chew on the data to get the most from the image, dealing with colour and signal processing, as well as image compression, and controlling the colour display and white balance. Processors are often given names or brands: Canon's processor, for example, is called a DIGIC processor and is now in its third iteration: DIGIC III. Whatever the camera and processor's name, they all do the same jobs, helping to make the most of your images.

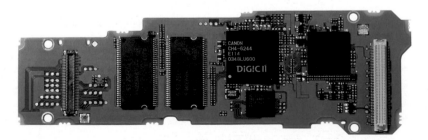

**DSLR image processors are the digital workhorses in any digital camera and come in various guises. This is Canon's DIGIC II processor, the 'brains' behind the image processing performance, helping to get the best from both the camera and the image.**

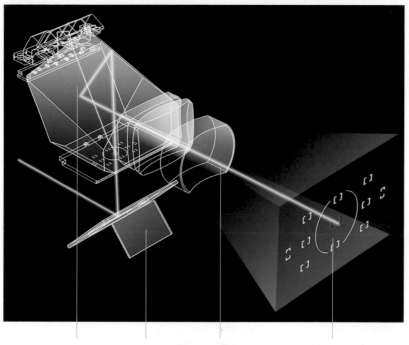

This cutaway diagram shows how the pentaprism in a DSLR works. At the bottom is the angled mirror that reflects light coming in from the lens (at left and indicated by the white line) up into the pentaprism itself. Here, the light is flipped up, round and back out towards the eye (the yellow line), through the viewfinder optics. The 11 focus zones are shown as a 'head up' display in the viewfinder – the central (red) AF (automatic focus) point is active in this diagram. The red line shows the focusing information used by the camera to determine the AF point to use and indicate within the head up display.

pentaprism   angled mirror   light      viewfinder optics

## Viewfinder and pentaprism

The viewfinder allows you to see what you're about to shoot directly through the lens you have mounted on the camera. Top-end DSLRs have a field of view (the amount of the subject the lens will capture) that represents 100 per cent of the scene before you; less expensive models have, typically, around a 95 per cent field of view.

Shooting information, such as shutter speeds, indication of under- or overexposure, focus area information and confirmation, is usually on show through the viewfinder as well, along with the number of exposures left on a memory card, the shutter speed and aperture in use and if flash is activated or needed. In other words, a DSLR viewfinder can keep you abreast of the camera's settings without you moving your eye away from it.

The key to all this utility is the pentaprism – a five-sided reflecting prism that catches the light entering the lens, turns it over, then flips it back into the viewfinder for you to see, without inverting the image. Some lower-end DSLRs use a pentamirror set-up instead of a pentaprism. However, they are not so bright as pentaprism viewfinders, which makes viewing more difficult in low light.

The diagram above shows how light travels through the lens to the viewfinder via the pentaprism.

See also:
**Accessories** pp. 26–31
**White balance** pp. 38–9
**File formats** p. 40

# Equipment care

A DSLR system represents a significant investment, so it pays to look after it, especially as repairing a piece of equipment after the warranty has expired could be extremely costly, sometimes amounting to even more than the purchase price.

## Care and common sense

Caring for a DSLR camera and lenses is a combination of care and common sense. Be careful not to drop them, and keep them free from dirt, dust, sand and water, even if you have a high-end DSLR that's proofed against water and dirt ingress. Sand is particularly destructive, especially if it gets on the front element of a lens. Common sense dictates that you keep your camera in a strong, well-padded camera bag when you're not actually using it (see page 31); the same goes for any other paraphernalia, such as lenses. A camera isn't difficult to clean externally: wipe it down with a lint-free cloth – a microfibre lens cloth is ideal, as the tiny microfibres absorb dirt and finger grease.

When inserting memory cards or electrical leads, such as a USB cable, never use force, and ensure that you put them in the right way round – they will only connect one way. Make sure that rubber caps over external sockets are tightly shut, too. If you store your DSLR for any length of time, place it in a camera bag with a pack of silica gel to keep moisture levels down. Also, remember to remove the batteries, which could leak and cause corrosion.

## Protecting the sensor

Many DSLRs have sensors that are not shielded from dust, so each time you swap a lens, dust can fly in and perch on the sensor. There are special cleaning kits for DSLR sensors available but most manufacturers don't recommend them. Cleaning a sensor is best left to the professionals, although, admittedly, this can be expensive.

It's important to prevent dust getting on the sensor in the first place. Try changing your lenses in a clean plastic bag, for example, and keep the camera shielded from draughts or wind when switching optics.

If dust does manage to get into the camera, a small lens blower-bulb and a gentle puff of air on the sensor might help. Try this with the camera facing down, and all but the most stubborn dirt should drop out. Make sure that you don't use pressurized (canned) air for this, as it can damage the sensor *and* leave moisture marks that will require professional cleaning to remove.

---

**Professional tips**

- Taking good care of your camera and lenses will help ensure that they perform as they should at all times.

- Shield your camera and lens from draughts or wind when changing optics.

- Never use pressurized (canned) air to remove dust from inside the camera.

---

See also:
**Sensor** pp. 15–16
**Camera bag** p. 31
**Safety first** p. 86

# Lenses

The DSLR system comes with the widest range of different lenses available to cameras. Even medium-format cameras, such as Hasselblads, and large-format models and rangefinder types, such as Leicas, have far fewer compatible lenses.

## Range of lenses

Not only are DSLR lenses available in different focal lengths, from fisheye to ultra telephoto, but there are also many specialist lenses, such as shift and tilt lenses and macro lenses. (See pages 19–25 for pictures of the most usual lenses and the types of image that they produce.) In addition to the lenses made by the camera manufacturers, there are many independent lens producers who supply competitively priced alternatives.

With such an array, you might feel daunted trying to select suitable lenses. What's important is that you buy the best in their field – there is no substitute for high-precision optics. If that seems extravagant, remember that your lenses will outlast your camera by years, provided they are treated with care.

## Buying lenses

When I buy a lens, it is because I need it for a specific purpose and because I know I will get the maximum use out of it. Although it might

**50mm focal length lenses, when used with the 35mm format, have roughly the same field of view as the human eye, which makes them perfect for recording images in much the same way as when we first see them, with little distortion or compression.**
> Canon EOS 1DS, 50mm lens, 1/125 sec, f/8.

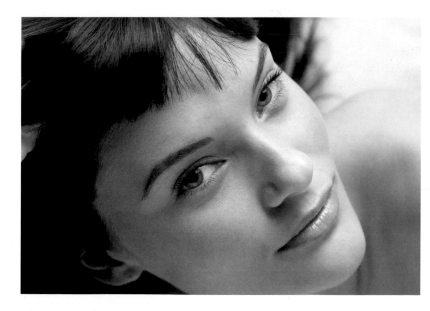

See also:
**Shift and tilt lenses** pp. 176–9
**Macro lenses** p. 198

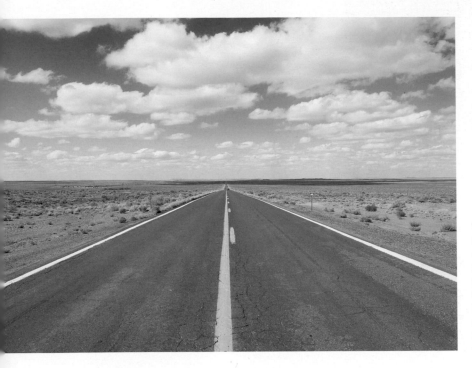

Wide-angle lenses, such as 24mm, are perfect for shooting expansive landscapes. However, it is all too easy to include great swathes of uninteresting foreground detail and bland skies. In this shot, the road and cloud detail add to the composition.
> Canon EOS 1DS, 24mm lens, 1/400 sec, f/11.

be desirable to have a 600mm telephoto lens in my kit, the financial outlay can't be justified – lenses such as this cost thousands – unless I am going to do a lot of wildlife or sports photography, for example. If I intended to use it only occasionally, I would consider hiring one from a professional photographic dealer instead.

Three lenses form the cornerstone of my kit: 16–35mm, 24–70mm and 70–200mm. With these I have wide-angle, normal and telephoto capabilities that cover most shooting situations. They all have a maximum wide aperture of f/2.8 throughout their range (see below), and their quality is superb. As I shoot a lot of architecture, I have a range of shift and tilt lenses, which are invaluable for correcting converging verticals. I also have a fisheye, which is particularly useful when shooting interiors of large buildings, such as churches. A macro lens completes the kit. I use this for close-up work, chiefly nature subjects.

## Apertures

All lenses have a maximum aperture, such as f/1.4, f/2.8 or f/5.6. Lenses with a maximum wide aperture of f/1.4 are sometimes referred to as 'faster' than a lens of the same focal length whose maximum aperture is f/5.6. The quality of a fast lens is far superior to that of a slower one.

The maximum aperture on a zoom lens can vary. For instance, a 70–200mm lens might have a maximum aperture of f/3.5 when it's set

Telephoto lenses are great for bringing distant subjects closer. This is essential in wildlife photography, where being near to the subject would probably scare it away.
> Canon EOS 1DS MK2, 200mm lens, 1/500 sec, f/2.8.

Zoom lenses are a great way of reducing the amount of kit that you need to carry. Three zoom lenses, such as a 16–35mm, 24–70mm and 70–200mm, should cover virtually all normal situations. They are also excellent for creating in-camera effects, such as in the shot on the right.
> Canon EOS 1DS MK2, 28–200mm f/3.5–5.6 zoom lens, 1/15 sec, f/16.

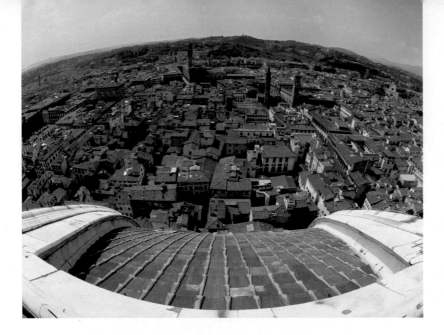

Although fisheye lenses have limited uses, they can create unusual, eye-catching shots, often giving a different outlook on familiar views, such as this cityscape of Florence. The 180° view of a fisheye means that you need to be extra careful about what you include in the frame.
> Canon EOS 1DS, 15mm f/2.8 fisheye lens, 1/250 sec, f/8.

at 70mm but the maximum aperture might be only f/5.6 when set at 200mm. This loss of speed might create problems if you're shooting in low light. In my experience, a zoom lens with a variable aperture will not have the resolving power and sharpness of a lens with a constant aperture throughout its focal length range, such as f/2.8. However, you might end up paying up to four times more for this superiority in a lens. Wider-angle lenses, due to their inherent characteristics, have greater maximum apertures than telephotos, such as f/2.8, while a superior 600mm telephoto might have a maximum aperture of only f/4. However, for a 600mm lens this is extremely fast.

## Sensor size

At the top end of the DSLR range, most lenses have sensors equivalent in size to the old 35mm film format (i.e. 24 × 36mm), which means that they are compatible to the focal lengths attributed to them. However, many DSLRs come with a sensor that is too small to capture the same image possible with a film camera. This is not so much of a problem when taking portraits or if you require maximum telephoto capabilities, but it can be a problem with wide-angle lenses. A 28mm lens on a DSLR with a sensor of only 23 × 15mm, for example, will result in the lens having an equivalent focal length of only 44mm. This is hardly wide angle and makes the lens not worth buying.

Manufacturers are now addressing this problem by producing ever wider lenses – whereas 17mm would have been thought of as extreme only a few years ago, it is now possible to buy a wide-angle lens with a focal length of only 10mm for a DSLR camera.

Macro lenses enable you to get close to nature – magnification up to life size (1:1) is possible – and are excellent for photographing plants and flowers. Working distances can be problematic in certain situations due to the proximity of the lens to the subject.
> Canon EOS 1DS, 100mm f/2.8 macro lens, 1/85 sec, f/5.6.

## Ghosting and flare

Another problem with DSLR camera lenses, particularly long lenses, is 'mirror' reflection. The sensors in digital cameras are different from their film equivalents and have a reflectivity that creates flare and ghosting inside the lens. For example, if you were to use a 300mm telephoto lens with a protective glass flat in front of the first lens element, any light entering the lens from a bright light source would be reflected off the sensor and back onto the protective glass, causing ghosting.

To eliminate 'mirror' reflection, some DSLR manufacturers now make their lenses with a meniscus lens (one convex and one concave side with equal curvatures) used in place of the flat protective glass. The meniscus lens means that light reflected from the sensor forms an image in front of it and then disperses. As most light that's dispersed does not hit the reflective elements, ghosting and flare are prevented.

## Fringing

What we perceive as white light is, in fact, a combination of different colours uniformly mixed so that we don't see any one colour in particular. If we shine this light through a prism, it will disperse, creating a rainbow-type spectrum caused by refraction because the individual colour wavelengths are focused at different points. To some extent, the same thing happens with photographic lenses. Called 'chromatic aberration', it appears as 'fringing' along the edges of the subject matter in photographs. In good-quality lenses, this is corrected by a combination of different types of optical glass with different dispersal and refraction qualities. In lens construction, these are known as 'elements' and are placed in the lens barrel in a series of 'groups'. It is this combination, together with the quality of the glass, its shape and coating, that makes one lens superior to another, even if it's the same focal length. This also explains why some lenses cost considerably more than others.

**Shift and tilt lenses are one of the many specialist lenses available to the DSLR camera user. They are especially suited to architectural photography, as they eliminate the problem known as converging verticals, where buildings appear to taper towards the top.**
> Canon EOS 1DS, 24mm f/3.5 TS-E lens, 1/400 sec, f/11.

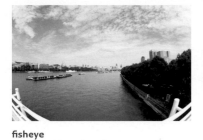

fisheye

50mm

300mm

16mm

70mm

400mm

24mm

100mm

600mm

35mm

200mm

800mm

Viewed from top to bottom and left to right, this sequence of views over the River Thames shows how different lenses capture the same scene from the same viewpoint.

# Accessories

Having selected your lenses, there are several accessories you should consider buying, not only to help you make the most of your camera and lenses but also to protect them.

### UV and skylight filters

The first is a UV or skylight filter. Both make virtually no difference to colour temperature and exposure, although the UV filter does absorb UV light without cutting visible light, reducing haze on sunny days, while a skylight filter reduces the blue cast caused by sky and water reflections. Despite such minimal effects, I have one of these filters permanently attached to my lenses to protect them from dust and scratches – after all, a filter costs only a few pounds, whereas a lens might cost thousands.

### Lens hoods and shields

I always fit a lens hood whenever I am shooting, not only to cut out flare and prevent stray light from entering the lens, but also to protect it from knocks, which could damage the front element. Although most lenses come with a lens hood, they are not always adequate in certain lighting conditions. For this reason I would recommend a separate lens shield that is attached to the lens with a flexible arm. This can be varied to cope with extremely bright conditions and is more effective than a hood. Consider your own eyes when the sun is bright: it is a normal reaction to raise your hand to protect them or to wear a cap that has a large peak.

**Without a lens hood, flare can enter the lens, as it has in this shot, ruining the photograph.**

### Lens extenders

A lens extender fits between the camera body and the lens. Depending on its strength, it increases the focal range of the lens. For example, if you're using a 200mm lens with a 2× extender, the effective focal length goes up

**UV filter**

**Lens hood**

to 400mm. Although this entails a loss of speed, giving an f/2.8 lens, say, a maximum aperture of only f/5.6, the portability of the extender and its low cost compared to that of a 400mm lens far outweigh this reduction.

## Extension tubes and bellows

As well as an extender, I always carry a set of extension tubes. Again, these fit between the camera body and the lens, and enable you to get extremely close to your subject. They normally come in sets of two and can be used individually or doubled up for greater magnification. However, once fitted, your lens will not be able to focus on infinity. Extension bellows perform a similar function but are bulkier and, therefore, more suited to indoor work.

## Focusing screens

As you would expect from the vast DSLR camera system, there are more than just lens accessories to enhance your shooting capabilities. One such accessory is the focusing screen that is visible when you look through the eyepiece of the viewfinder. The benefits of interchangeable focusing screens are not just to aid focusing but also to help with composition. The grid screen does this particularly well, which is the reason why it is my favourite out of all the different screens. It has horizontal and vertical lines etched on to its surface and is invaluable for shooting architecture or where careful positioning of your subject in a particular area in the frame is essential.

With the cross-split image screen, the subject you are focusing on appears divided into two. As you focus the lens, the subject begins to merge and once it becomes pin sharp, only one image is visible. For precision focusing this screen is unbeatable, and it is the kind of system that made the world-renowned Leica rangefinder camera so popular with professional photographers.

Whatever screens you favour, you can easily interchange them yourself or ask a professional photographic dealer to do it for you.

**2x extender**

**Extension tubes**

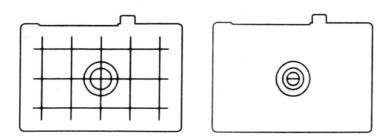

**Grid screen**        **Cross-split image screen**

## Angle finders

DSLR cameras also have interchangeable viewfinders. These are essential in certain situations when it's impossible to look through the camera using its standard viewfinder. For example, if your chosen viewpoint is at ground level or you are shooting in a confined space and the camera is back against a wall, you will not physically be able to look through the viewfinder. In such situations, an angle finder, fitted over the camera's viewfinder, lets you look down and view at right-angles to the camera eyepiece. These viewfinders are also very useful if your camera is mounted onto a copy stand for photographing images and/or flat artwork.

The digital angle finder attaches to the eyepiece in a similar way but, instead of having to look through an eyepiece, the image is displayed on an LCD, which is at right angles to the eyepiece. As well as being useful for shooting at ground level or in a confined space, this type of finder is invaluable when shooting in a crowd, where you might have to hold the camera at arm's length above your head. You can see what the lens is focusing on with the LCD display.

An angle finder fitted over the camera's viewfinder is useful when the angle of a shot is such that you can't look through the standard viewfinder.

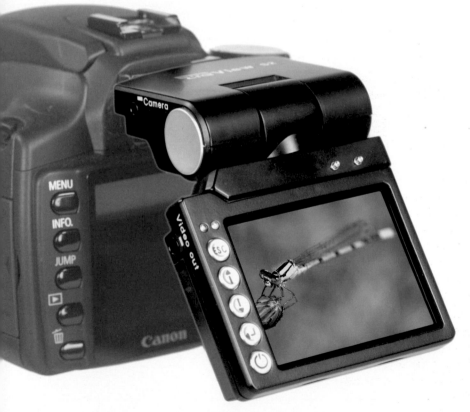

An alternative to the angle finder is the digital angle finder, which displays the image on an LCD. It is particularly useful for shooting in a confined space or at ground level.

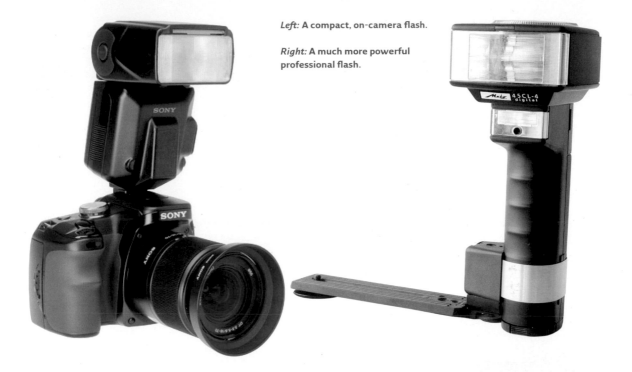

*Left:* A compact, on-camera flash.

*Right:* A much more powerful professional flash.

## Flash

When most people think of camera accessories, flash is normally at the top of their list. While it is definitely a useful addition, flash needs to be used extensively and in many different situations before you can say that you have mastered it.

Many DSLR cameras have built-in flash, located at the top of the pentaprism and which pops up when required. The benefits of such a unit are illustrated by its absence in top-of-the-range cameras. Next time you see a group of photographers on the television news, observe how many use this type of flash. I guarantee there won't be any because, quite frankly, the versatility and power of a built-in flash are completely inadequate. It would be far better to spend your money on a higher-spec camera and buy a separate flash-gun.

There are two main types of external flash. One fits on the top of the camera and is attached to the hotshoe. This requires no additional leads, unless you are using it off-camera, in which case a dedicated lead is slotted into the hotshoe at one end and the flash-gun at the other. The other type is usually mounted on a bracket and attached to the side of the camera. It is synchronized via a lead to a socket on the camera. This type of flash is usually much more powerful and, in some cases, several guns can be fired together.

Detail of an on-camera flash in action, showing how the flash head swivels. Professional flash guns also have this facility.

Both these units can be used fully automatically when the camera is set to auto mode. This means that the camera will read the flash output through the lens (TTL) and adjust it or the aperture accordingly. You can also angle the head of the flash in a variety of different directions so that you can 'bounce' the flash. Both units also have full manual override. DSLR cameras can synchronize flash only at shutter speeds of around 1/125 second – any faster than this will mean that some of the frame is unexposed.

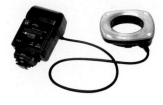

**Ring flash**

The ring flash is another useful type of external flash. As the name suggests, it is made up of a circular flash tube that fits around the lens. Originally developed for medical and scientific photography, the ring flash gives a completely even light and creates a thin, faint shadow all around the subject. It is particularly useful for close-ups and, as with all equipment, it needs a certain amount of experimentation in order to achieve the best results.

## Tripod

Although many people see tripods as burdensome, they are useful for more reasons than just keeping the camera steady.

The first thing I look for in a tripod is rigidity. This might seem like stating the obvious but there are so many flimsy models available that would blow over in a gust of wind that they really aren't worth bothering with. A good tripod should extend to a reasonable height and remain stable. Quick-release legs are preferable to screw versions, which can become cross-threaded and irreparable. Make sure that the legs can be splayed at right angles to the head, which will enable you to shoot from low angles while keeping the camera steady.

Another useful addition is a central column. As well as giving additional height, this column can be inverted, which is an alternative method of getting a low-angle shot. On some models, this column can be attached at right angles to the tripod, which is a useful feature for close-up overhead photography. To top it off, purchase a good pan-tilt head so that the camera is free to move in a variety of directions.

**Tripod**

## Cable release

As you will normally be shooting at a slow shutter speed when using a tripod, it's a good idea to have a cable release to help you fire the shutter release more smoothly. If you fire it in the normal way with your finger, the camera can move, even if it's on a tripod.

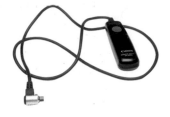

**Cable release**

## Monopod

At an athletics meeting or a motor race, for example, where you are using an ultra-telephoto lens, such as a 400 or 600mm, a tripod might be inappropriate but you still need some means of supporting the camera. These long lenses are almost impossible to hold steady, and their weight means that you need the arms of a bodybuilder. This is when I use a monopod. As its name suggests, the monopod has only one leg, and while it will not support the camera by itself, it will help to keep it steady.

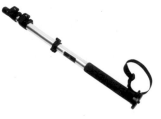

**Monopod**

## Camera bag

Finally, you will need a good case to keep the kit in. If I am travelling, I have all my equipment stored in a rigid flight case, which is foam-filled with cut-out compartments so that each piece is held firm and instantly visible. This is important because I can see immediately if anything is missing. When shooting outdoors, I transfer the appropriate equipment into a backpack. This leaves my hands free to hold the camera and take shots without having to put down and pick up the case repeatedly.

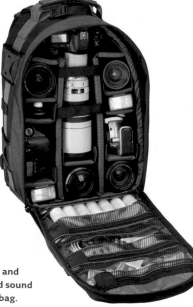

**Keep your camera, lenses and small accessories safe and sound in a well-padded camera bag.**

See also:
**Equipment care** p. 18
**Ghosting and flare** p. 24
**Studio flash** pp. 118–19
**Action** pp. 162–9
**Filters** pp. 172–5
**Close-ups** pp. 198–201

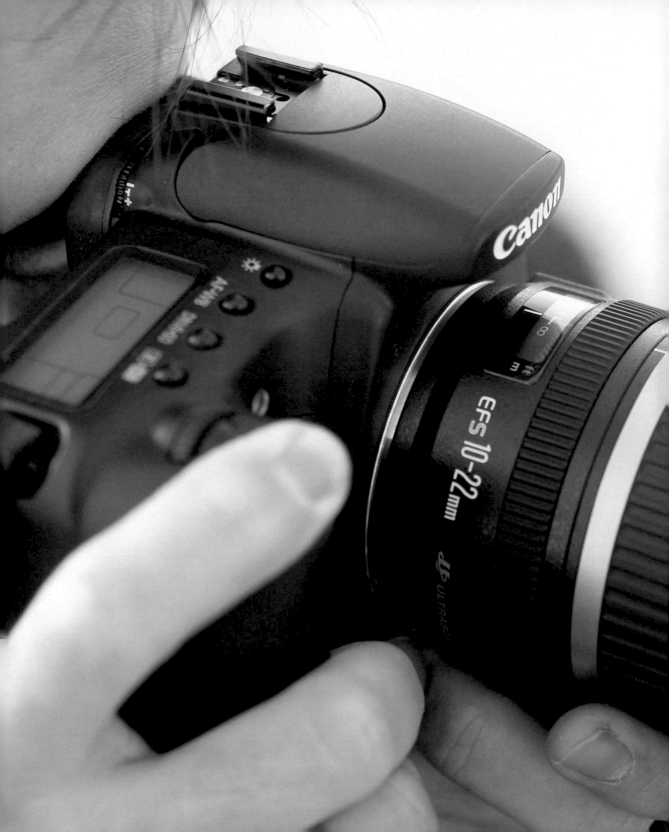

# Getting to grips with your DSLR

# DSLR basics

You're the proud owner of a new DSLR and, naturally, you can't wait to get out there and start snapping. Here are some simple tips and tricks to help you get the most from your new camera.

## How to hold the camera

Holding the camera correctly so that you can use it freely at the same time as keeping it secure is most important. Hold the camera in your right hand, then allow the index finger of that hand to fall naturally over the shutter release. The control dial on the back should then line up easily with your thumb. Meanwhile, cradle the camera and lens barrel in the left hand with the palm uppermost, and wrap your fingers lightly around the zoom or focus ring of the lens. Now you're in complete control of your camera.

**Holding a DSLR correctly makes it easier to use and helps keep it steady for each shot you take.**

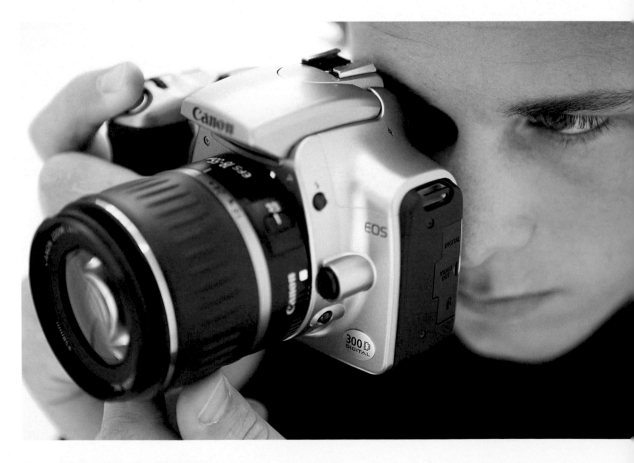

## Fitting and charging batteries

It should come as no surprise to learn that a DSLR uses batteries to power its systems and allow you to take pictures. Most DSLRs use a single, rechargeable lithium-ion battery pack that is supplied with the camera, together with a charger.

It's important to give a new battery a full charge before you use it in the camera. The amount of time a full charge needs varies depending on the make and model of the camera/battery combination but, typically, expect at least a wait of a couple of hours. Check the camera's manual for specifics to be safe. To charge the battery, slot it into the charger – it will only go in one way – and plug the charger into a mains socket. A small LED will flash or glow, depending on the make of your camera/ charger, indicating the charge is progressing.

Once charged, insert the battery into the camera. This may seem fiddly but is really quite simple because, just as with the charger, the battery will go in only one way. A flap, which is usually on the camera's base, must be opened to reveal a cavity for the battery. Slot the battery home, close the lid and now you're ready to insert a memory card.

## Inserting a memory card

No matter what type of storage your camera uses, it will be housed within the camera in a slot under a flap either on the base or the side of the camera body. The memory card-housing lid must be opened to reveal the slot into which the card slips home.

The card fits in only one way, so don't force it. There is usually a small diagram alongside the card slot, indicating which way round the card will go (check the manual if you're at all unsure). Once the card is slotted safely in place, close the hatch and you're ready to get snapping.

*Above:* DSLR batteries come in different shapes. Whichever one fits your camera, it can only slot home one way round – its shape means that you can't get it wrong.

*Above:* Many DSLRs are supplied with a special battery pack and charger, similar to the kit shown here. Always give a new battery a full charge before use.

A DSLR memory card slots in only one way. Once ensconced in its special port, all your shots will be stored on this removable memory.

# Menus

DSLR menus might seem daunting at first but they're actually quite logical and, once you're familiar with them, you'll be able to navigate to various settings quickly and easily.

## Navigating the menus

DSLRs use a system of menus displayed on their large screen to help you get at and set up many settings within the camera. Menus allow the external complexity of the camera to be simplified – there are fewer buttons – and allow specific items to be changed, such as setting the time and date or altering the compression used when an image is saved to the memory card. More powerful options include changing how the focus system behaves in a given situation or selecting a specific image optimization setting, such as making colours in an image more vivid.

Most menus are set out in batches, just like a filing system, so all the shooting settings will be in one menu, while menus for playback preferences or general set-up settings, such as the date and time, will be in another menu 'file'. It pays to explore the menus on your camera with the manual to hand. That way, you'll quickly familiarize yourself with the many options presented, what they do and when they might be needed. Most new DSLRs have a built-in help system that can be invoked to explain a particular menu or setting should you forget, which is particularly useful.

The importance of becoming familiar with these menus cannot be overstated since many of the more powerful tools in the camera's armoury are held within them. However, using the camera and not being afraid to experiment is the key to understanding what they do.

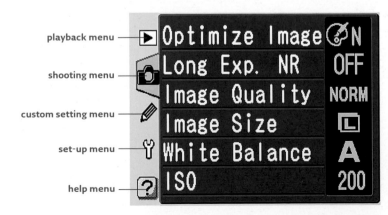

playback menu

shooting menu

custom setting menu

set-up menu

help menu

This menu from a Nikon D50 is typical of a menu display on a DSLR screen. The camera icon, which represents the shooting menu, is coloured yellow to indicate it is the active menu, and its various settings are on display. In the custom setting menu, you can tailor specific elements of the camera controls to behave how you want. The set-up, or settings, menu allows you to, among other things, change the date, format a memory and change the video output.

# Camera settings

All DSLRs have the equivalent of a point-and-shoot mode, where you turn on the camera, switch to auto-everything mode and away you go. But, eventually, you'll want to wrest control away from the camera and be more creative with it, or there may be a situation the auto-setting cannot cope with and you will need to take charge.

## ISO (sensitivity)

The term ISO (International Standards Organization) was originally used as a rating to denote the sensitivity of camera film to light. For example, film with an ISO of 100 is less sensitive to light than that with an ISO of

*Left:* Getting a sharp shot of these flamenco dancers in low light required a sensitivity of ISO 1250 to ensure a fast-enough shutter speed. Such a high ISO has resulted in a picture replete with noise, visible as monochromatic dots and small red and blue speckles.

*Above:* The noise is especially noticeable in this close-up. Extra processing on a computer would be needed to clean the image.

400, and so on. Therefore, the higher the number, the gloomier the conditions you can shoot in without resorting to flash.

Although there is no film in a DSLR, the term ISO is still used in digital photography to denote the sensitivity of the sensor. It's the same principle as with a film camera, except increasing the ISO of a DSLR increases the gain (think of it as the volume) of the sensor. Just as in film, the higher the ISO, the more sensitive the sensor becomes to light, but a downside (as with film) is that increasing the sensitivity can make images look 'grainier'. 'Grain' in digital terms is known as 'noise' since raising the ISO increases the chance of picking up 'noise' from non-image forming elements within the camera's system. Analogous to the static 'snow' on a TV that's not properly tuned, image noise typically makes its presence felt in areas of shots that are dark (the shadows), lighter areas (plain, grey skies) or in uniform areas of colour or areas that lack detail.

## Establishing the ISO

The following ready reckoner shows when to use a particular ISO (sensitivity) setting and why, based upon typical DSLR sensitivity settings. Your camera may have more or fewer options available, but this guide works well as a rule of thumb:

- **ISO 100** Bright daylight, sunny conditions, hand-held shooting, where clean images (no noise) are a priority.
- **ISO 200** As for ISO 100, but where a faster shutter speed or a slightly longer focal length is required and where you need extra flexibility with apertures and shutter speeds.
- **ISO 400** Indoor or slightly overcast conditions, where you want to avoid using flash or you need fast shutter speeds and full aperture control to shoot hand-held.
- **ISO 800** Overcast or dark indoor shooting, or sports or action photography, where you need to freeze the motion, and noise issues are not paramount.
- **ISO 1250** Low light or indoors, long lens shooting (hand-held), but noise may become an issue.
- **ISO 1600** Night-time, low light, very long lens shooting; noise will almost certainly be evident in shots.
- **ISO 3200** As for ISO 1600, but where high shutter speeds are required; noise will be evident in shots.

## White balance

The human eye and brain automatically compensate for the different colour temperatures of various light sources, so that white always appears white to us. As DSLRs can't do this, they have special settings to ensure that white is white, no matter what the lighting conditions. If the

**Professional tips**

- The higher the ISO, the greater the risk of 'noise'.
- If your camera has one, use the noise reduction setting from the menu.
- Remember that light is 'warmer' at the beginning and end of the day.
- In indoor light, your shots will come out with an unwanted colour cast if you do not adjust your camera's WB from the daylight setting.

WB (white balance) is not set correctly, it can make a huge difference to your shots and the off-colour casts created can ruin a photograph.

With a DSLR, you can quickly set the camera to, say, sunlight, cloudy conditions, tungsten lighting or fluorescent light, but there is also a separate easy-to-use manual setting, which you can save in the camera's memory to use again, allowing you to tailor the WB even more closely to the lighting conditions. Typically, you'll need a piece of white paper illuminated by the lighting you want the camera to be set for. Filling the frame with a sheet of white paper and setting the WB to it (the exact process is usually straightforward but varies from camera to camera, so check your camera's manual) will mean the camera can shoot ensuring the whites are balanced and without any odd colour casts.

Although the human eye perceives daylight as 'white light', it is actually made up of lots of colours of light mixed together – all the colours of a rainbow, in fact. During the course of a day, the quality of light changes. At sunrise and sunset, for example, when the sun is visible, the light is said to be 'warm', or red, in colour. At noon, when the sun is at its highest, the light appears 'cool', or blue.

## Kelvin scale

Without being bogged down by science, this variation in the colour of light is measured in Kelvins (so named after Lord William Kelvin who invented the scale in the mid-1800s by heating a block of carbon until it glowed, producing a range of colours as the temperature increased). Broadly, the lower the Kelvin figure, the warmer, or redder, the colour; the higher the figure, the cooler, or bluer, the colour. DSLRs that allow you to adjust the WB take account of this colour shift and correct for it; some even have a Kelvin scale adjustment for fine-tuning your settings.

The guide overleaf to colour temperature and the corresponding light source shows how adjusting the WB setting, or the Kelvin scale if your DSLR has it, can radically affect how colours appear in your shots.

*Above left:* The fluorescent lighting has created an unnatural green colour cast across the entire image because an incorrect WB setting was used.

*Above right:* In this shot, taken at the same location and seconds after the first image, the WB was set correctly and there is no colour cast.

Light is measured in Kelvins, and the temperature of light can affect your images. The atmosphere in this shot is helped greatly by the warm glow of the setting sun, which has a relatively low Kelvin temperature of around 2000K to 3000K. The same shot taken at noon in direct daylight, which has a Kelvin temperature of around 5500K, would have a blue cast if the WB were not adjusted accordingly.

- **1700–1800K**   Match flame
- **2000–3000K**   Sun: sunrise and sunset
- **2500–2900K**   Household tungsten bulbs
- **3200–7500K**   Fluorescent lights
- **5000–5400K**   Sun: direct sun at noon
- **5500–6500K**   Daylight (bright sun in clear sky)
- **6000–7500K**   Overcast (cloudy) sky
- **7000–8000K**   Outdoor shade

## File formats

DSLRs shoot images and save them on removable storage or memory cards. But the way the images are saved – the file format – has a significant bearing on image quality. DSLRs can typically shoot and save using the JPEG or TIFF compression file formats, although the latter is less popular, or the image data is left unprocessed as RAW files.

JPEGs are processed inside the camera and then squashed down into a (much) smaller file size, thereby saving space on the memory card. The downside is JPEG compression loses detail; for that reason, it's known as a 'lossy' format. As the file is compressed, the camera's computer removes self-similar pixels, such as large areas of blue in a landscape's sky, thereby reducing the size of the final, saved file. When the image is then opened up on a computer, for example, it 'guesses' which pixels to replace, reducing image detail. JPEG files can be heavily compressed.

TIFF files are also compressed files, but they use a different compression method, allowing files to be reduced by up to around 50 per cent, but no more. This is a 'lossless' format, as no detail is lost.

RAW is not a format as such but the raw, unprocessed image data from the camera. Advantages include no compression and complete control of how the image looks – after the fact. With RAW files, the photographer carries out the processing – exposure, noise, white balance, even control of detail – later on a computer. Put simply, a RAW file is a digital negative and one of the photographer's most powerful tools.

See also:
**Sensor** pp. 15–16
**ISO (sensitivity)** pp. 37–8
**Processing RAW files** pp. 213–15

# Interchangeable lenses

One of the key benefits of a DSLR is the versatility offered by interchangeable lenses, and no matter what make of DSLR you own, there is a set way to remove and replace your lenses.

## Removing a lens

Typically, there is a button or lug alongside the lens that must be pressed to release the lens locking mechanism. Then you need to rotate the lens, either to the left or right (this depends on the make of camera) to release it from the lens mount and body.

Always make sure that you replace the lens cap (and the body cap if you're not going to replace the lens with another lens) to protect the delicate electrodes and mechanics of the lens's mounting system, prevent damage to the mount itself and stop dirt and dust reaching the sensor.

## Attaching a lens

To attach a lens to the body, you must align indexes on the camera body and lens, bring the lens into contact with the mount and then rotate the lens (again, clockwise or anticlockwise, depending on your camera) to lock it home. It will click into place and won't budge once it's there. If it doesn't click or moves, it's not locked home.

Don't force the lens onto the mount in the wrong position – you could damage the mount or lens – and don't touch any gold-coloured electrical contacts. Finger grease and sweat are slightly acidic and, as these contacts are the means of communication between the lens and camera, you really don't want them to corrode and stop working.

**On this model of camera, the large lock/unlock lug, which must be pressed to release a mounted lens, is positioned to the right of the silver lens mount ring.**

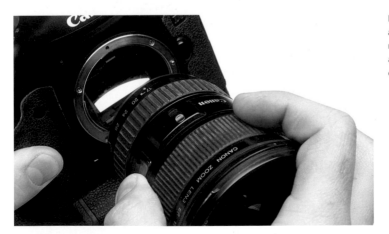

**Indexes on the camera body and lens must be aligned when removing/attaching a lens from a DSLR. On this camera, the red dots need to be aligned.**

# The viewfinder

Your view of the world through a DSLR is dominated by the viewfinder. Although what appears on the screen does vary a little from camera to camera, the image below shows the comprehensive information you can expect to see.

## Viewfinder display

In the main viewing area of the diagram below, you can see the five AF (auto-focus) zones, shown as square brackets spread across the central portion of the screen. The memory card warning symbol illuminates if there is no card in the camera. The information in the black area covers a wide range of information, from aperture and shutter speed in use to the number of images remaining on the memory card. The viewfinder display varies slightly from camera to camera.

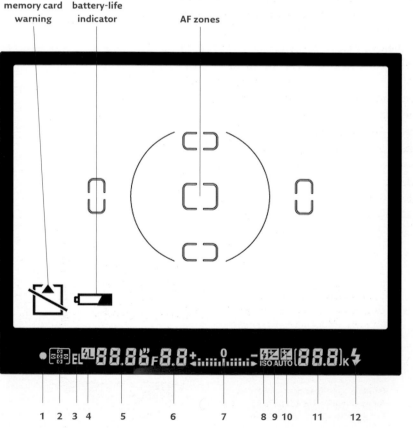

memory card warning    battery-life indicator    AF zones

Across the bottom of the viewfinder in the black zone, from left to right, the following information is displayed:

1   Focus confirmation LED
2   AF area in use
3   Exposure lock
4   Flash needed warning/Flash status lock
5   Shutter speed
6   Aperture
7   Under-/overexposure and bracketing
8   Flash compensation
9   Auto-sensitivity indicator
10  Exposure compensation
11  Number of images/space (in kilobytes) left on memory card
12  Flash ready

1  2  3  4      5        6        7        8 9 10    11       12

# Image and colour performance

Another key benefit of a DSLR – indeed, of almost all digital cameras, bar the most basic – is the control that you have over the way an image is treated by the camera's computer.

## Enhancing the image

All DSLRs allow you to alter and enhance the camera's image processing of a specific scene or colour set-up. For example, Canon's high-end professional DSLRs use a Colour Matrix set-up to help enhance colour by increasing or decreasing the saturation, and preset the colour performance for a type of subject, typically portraits, or for a specific colour space.

## Preset modes

DSLRs aimed more at the consumer than the professional, such as the Sony Alpha 100, have other presets for both colour performance, such as Standard, Vivid, Sunset and Portrait, and for specific scenes. These Subject Program, or Scene, modes can set the camera for specific subjects as opposed to simply a type of colour performance.

Scene modes, such as Portrait, Landscape, Macro and Sports, allow you to set the camera quickly to get the most from the subject at hand, automatically setting the camera to its optimal settings (including shutter, aperture and metering) for the selected scene. These can be used in conjunction with the colour settings as well, if required.

In each case, the camera applies special processes to captured images and optimizes those attributes you've selected to enhance the image in the way that you'd like. In practice, unless you know from experience what these settings offer, you will need to do some experimenting since, for example, a vivid setting on one shot of flowers may look oddly artificial on a portrait picture.

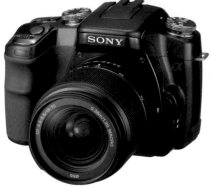

**DSLRs, such as this Sony Alpha 100, have powerful image performance enhancing settings built into them. These allow you to predefine the colour parameters and image processing attributes, as well as the camera's physical settings (shutter speeds and/or apertures, for example), all in advance of taking a shot.**

# Exposure

The metering modes, exposure compensation and bracketing are some of the more powerful controls at your fingertips on a DSLR. Using them to fine-tune your images helps you to create shots that look exactly as you want them.

## Metering modes

A DSLR can measure the light for a given scene in a variety of ways. It has a matrix of light sensors, or meters, that covers the area you see through the viewfinder to give a general light reading. Even though it has a large number of zones to measure light from, it can also do it using smaller, specific areas of the frame.

There are three main modes of metering: matrix (multi-zone or honeycomb), centre-weighted and spot metering. The first uses all the metering zones the camera has at its disposal (the number varies from model to model, and manufacturer to manufacturer) and measures an average of all the zones to give the 'as metered' exposure value.

The second, centre-weighted metering is, as the name suggests, where the light in only the central portion of the frame is measured. The third mode, spot metering, is where a small, central spot of the subject or scene is metered; in some cameras, you can adjust the size of the 'spot' yourself from, say, a 4 per cent (in area) 'spot' to an 8 per cent 'spot' in the centre of the frame.

The advantages of one method of metering over another depend on the subject being photographed but, broadly speaking, matrix metering works perfectly well for most shooting situations. Centre-weighted metering is ideal for complex lighting, or where there are areas of deep shade or light and you want to bias exposure to one or the other. Spot metering allows you to meter precisely from a small area, which makes it ideal for portraits or macro work, where it's important to get the metering spot on, so to speak.

## Exposure compensation

Exposure compensation is a method of fine-tuning the exposure of a scene by compensating for overly bright or dark areas. This is done by, typically, up to three stops of exposure, depending on the type of DSLR you have. Set using a specific control on the camera, exposure compensation can be applied to one image at a time, or until you reset the compensation feature back to its 'as-metered' exposure level, where there is no compensation.

**Professional tips**

- Use the centre-weighted, or spot, mode when shooting portraits with strong backlighting.

- Auto bracketing is useful when you are having to work under pressure.

- With spot metering you can check the light in specific areas of your shot to ascertain the best exposure.

- Although digital cameras have a wide exposure latitude, there is nothing like getting the right exposure to begin with.

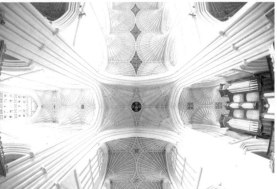

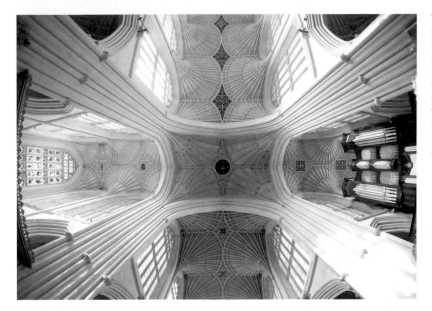

This sequence of photographs shows how you can automatically bracket around the metered exposure for a shot to provide more choice later on, allowing you to see what has actually worked best for the image. The exposures shown (clockwise from above left) are: one stop underexposure, one stop overexposure and as metered.

## Auto-bracketing

Automatic exposure bracketing can be thought of as an insurance policy for your snaps. It is similar to exposure compensation in that it changes the exposure to a predefined level and for the same reasons, but when an image is shot, the camera will automatically shoot one image (or more, depending on the camera) at the set amount of overexposure and one at the same set amount of underexposure. You'll get three (or more depending on the camera) images, one of the correct 'as-metered' exposure, then one underexposed by, say, half a stop and one overexposed by the same amount, depending on what you've set the camera to do. Then you can decide later (on the camera screen or on the computer, for example) which is the best for the subject.

# Using auto-focus (AF)

One of the key factors affecting the success of any shot is how sharply focused it is, even though you may sometimes want creative blur or an unfocused look. Whatever the shot, DSLRs have special focusing modes to help produce the desired effect.

## Single and continuous modes

In essence, the Single AF mode sets the AF system to find the main subject in a scene, focus upon it and then lock. It's ideal for static subjects. Continuous AF, on the other hand, finds the subject and (depending on your camera) tracks its movement. A special predictive AF set-up ensures that when the shutter eventually fires, the subject is sharp.

Both these focus modes can work in conjunction with another powerful AF tool found on DSLRs, the AF Area Mode. Here, the type, number and shape of the AF zones that will be active are controlled. Typically, there is a Single Area AF, where just one AF zone works at a time, and a Dynamic AF (sometimes referred to as Servo AF), which allows just one, a whole group or all the AF zones to work together simultaneously – this helps when shooting complex or moving subjects and adds to focus accuracy.

Some DSLRs have a Closest Subject Priority AF, which will always try to focus on the main part of the scene closest to the camera. This is useful when there is a cluttered or possibly distracting background.

## Switching off the AF

If you want to take complete control of the focusing chores on a DSLR, you can. Most AF lenses allow you to override the AF manually at any time, or you can turn off the AF, if required. To do this, there will be an on/off switch on your camera body and/or on the lens.

On this Canon DSLR, you can see the AF controls on the top plate (to the left) that control the focus modes and a switch on the lens barrel marked AF/MF to turn the AF on and off (manual focus).

# Shutter or aperture priority

With a DSLR you can choose to have either aperture priority or shutter priority. Which you choose depends on the type of shot you are going to take and the effect you wish to create.

## How and when to use

The mode dial of a DSLR has a range of automatic settings and a manual setting ('M'). There are two other controls: aperture priority ('A', or 'Av') and shutter priority ('S', or 'Tv', which denotes time value). When one of these is selected, the camera automatically adjusts the other to keep a properly metered exposure.

Simply, if you need to control the depth of field but shutter speeds are less of an issue – for example, when the camera is tripod-mounted for a macro shot – use aperture priority. You then select the best aperture for the required depth of field while the camera takes care of the shutter speed. If shutter speed control is paramount – for example, if you need to ensure a fast shutter speed to freeze an action shot – then select shutter priority. While you ensure the shutter speed is fast enough, the camera sets an aperture to keep the shot correctly metered for the scene.

This image shows the mode dial on a DSLR with the various automatic settings on view, plus the all-important 'Av' and 'Tv' (aperture and shutter priority) settings. The 'M' setting is the manual control where the user controls both the apertures and shutters, as required.

## Depth of field preview

DSLRs have a small button on the camera body, usually adjacent to the lens, that, when pressed, shuts the aperture to the current setting – this is the depth of field (DOF) preview control. With the DOF preview button depressed, the aperture of the lens closes to its current setting (if it's smaller than the maximum aperture), allowing you to look through the viewfinder and assess how much of the scene will be sharp from in front of the lens to the distance.

A large aperture, that is a low f/number, such as f/2.8, gives a very narrow DOF, which means that the subject will be sharp, but everything behind and in front of it will be blurred. A higher f/number, say, f/22, will give a deep DOF, resulting in a sharp foreground and background.

The button at the bottom left corner of this DSLR is the DOF preview button. Pressing it will stop the lens to the metered or selected aperture, enabling accurate assessment of the DOF.

# Seeing the picture

# What the eye and camera see

Many people find they're disappointed with their photographs because they never seem to come out in the way the shot is remembered. The reason for this is that the camera doesn't see things in the same way as the eye.

## Interpreting information

When you notice a subject, the eyes send a signal to the brain, which, in turn, interprets the visual information. The brain is very good at editing scenes and pushes some of the angle of view into the background,

Cameras have an advantage over what the eye can see because you can either zoom in or out, or change lens. This shot was taken with a 50mm lens and gives an angle of view roughly the same as the eye.

*Right:* By changing the lens to 24mm, you have a much wider angle of view from the same viewpoint without having to scan the scene, which would be the case with your eyes.

removing any distractions. It does this by keeping the part of the scene you are focusing on sharp, while letting the other parts go out of focus. This is a great asset, as it means you can concentrate on the important information and discard the rest. Of course, you are still aware of these indistinct parts but they do not impinge on your main focus. Perhaps the easiest way to understand this is to draw your attention to what you are doing right now: reading this book. You can see the typeface easily but if you think of the surrounding area, you realize that you are only aware of it and can't see it properly.

Now when you look through the camera lens and take a shot, the camera interprets the scene differently. The chances are that not only will the book be in focus but the rest of the room will be sharp as well. This makes it difficult when you look at the finished photograph to concentrate on anything in particular because the scene is a jumble.

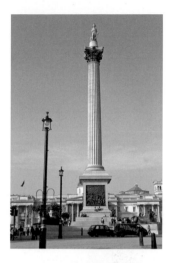

## Getting the desired shot

With a DSLR camera there is a plethora of lenses and accessories, together with a range of different features built into the camera, that will help you capture exactly what first caught your attention. Knowing what all these features are capable of is essential if you are to make full use of the DSLR system. You can then start editing in-camera in the same way as your brain edits what your eyes see: you can keep all the scene sharp or just a part of it; you can include a wide-angle or zoom in; you can use the shutter creatively and learn to be selective with your viewpoint.

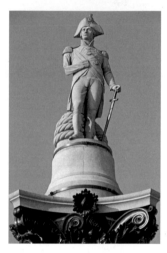

*Left:* When you watch television or read a book, your eye automatically concentrates on what is important to you. Although you might be aware of other detail in your peripheral vision, it is, in effect, put out of focus by your brain.

*Top:* This shot of Nelson's Column in London was taken with a 50mm lens. No matter how hard you try, it's impossible to make out all the detail at the top of the column.

*Right:* When you look at a similar scene through the camera lens, especially a wide-angle one, nearly everything is in focus. This can make it quite difficult to concentrate on the important details of the scene.

*Above:* With a 400mm lens, all the detail of the statue has become clear.

# The golden section

If you want your pictures to stand out, there are a few simple rules that will give you the basis for perfectly composed pictures every time you shoot. These rules, which have been followed by artists down the generations, are all based on the principle usually known as the golden section, or the rule of thirds.

## What is the golden section?

It was the Ancient Greek mathematician Euclid who first espoused the principle of the golden section. The theory of this visually satisfying ratio dictates that the subject of a picture or photograph be placed at the intersection of imaginary lines drawn vertically and horizontally

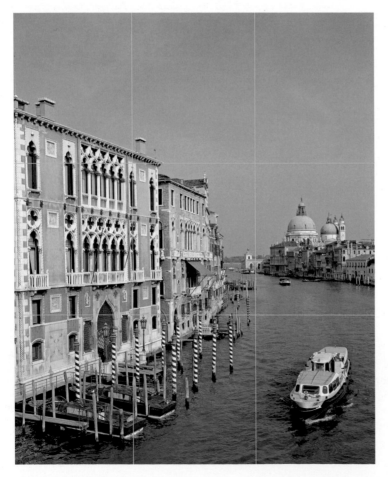

When composing your shots, try to imagine a grid like the one illustrated here. If you place your subject at the intersection of imaginary lines drawn vertically and horizontally one-third of the way in from the sides of the picture, your composition will be well balanced.
> Canon EOS 1DS, 50mm lens, 1/125 sec, f/8.

In this shot, I have used the tree to frame the picture – it occupies the left-hand and top-third of the shot. This gives a strong balance and leads the eye into the centre of the shot.
> Canon EOS 1DS, 28mm lens, 1/125 sec, f/16.

one-third of the way along the sides of a picture. Sculptors and architects have also followed the principle to produce classically proportioned statues and buildings. The Ancient Greek mathematician Pythagoras later proved that the golden section was the basis for the proportions of the human figure, and showed that the body is built with each part in a golden proportion to all other parts. Later, during the Italian Renaissance, Leonardo da Vinci adopted and perfected Pythagoras's theory.

## Following the principle

There are important elements to consider every time you compose your pictures, and all of them relate to the principle of the golden section. The first of these is framing the picture. You should ask yourself whether the shot would look better taken with the camera held in landscape mode or turned vertically in its portrait mode. The second is viewpoint, and you should explore whether you should change it from a high viewpoint to a low one or vice versa. At the same time, you need to pay attention to the foreground and background and how you can make them work within the overall composition. Since a DSLR camera with its lenses can zoom in and out, crop and include, blur and keep sharp, you can use it to control and enhance all the elements that go into making up the overall composition.

See also:
**Framing the picture** pp. 54–5
**Viewpoint** pp. 56–7
**Foregrounds** pp. 58–9
**Backgrounds** pp. 60–1
**Wide-angle lens composition** pp. 62–3
**Telephoto lens composition** pp. 64–5

# Framing the picture

Probably the greatest advantage of a DSLR camera is that when you look through the viewfinder, what you see is exactly what the lens sees. This is the most accurate way of viewing your subject, which should make it easy to frame your shot perfectly.

## Taking your time

Even with this advantage, many photographers develop the unfortunate habit of always having their subject in the middle of the frame and always shooting with the camera in its landscape (horizontal) mode. Usually this is the result of trying to work too quickly and not giving enough time and thought to placing the subject in its optimum position.

Placing your subject slap in the middle of the frame often fails to produce the best picture because there can be too much distracting detail surrounding the subject. Using the landscape mode to shoot a portrait also results in unwanted peripheral detail. The human face fits far more comfortably in portrait mode, and you can zoom in and literally fill the frame – all you need do is turn the camera 90°. Many DSLR cameras have duplicated controls, so that the shutter release button is as easy to reach in landscape or portrait mode.

**Professional tips**

- Don't be afraid to go in close to your subject and fill the frame.

- Change lens if you can't get in close enough to your subject. Cropping the picture on the computer at a later date will result in a loss of quality.

- Look at your subject with the camera in both portrait and landscape modes.

- Try a few shots where your subject is to one side of the frame and not in the middle.

- If you are hoping to have your pictures published, consider where the gutter or type might be positioned.

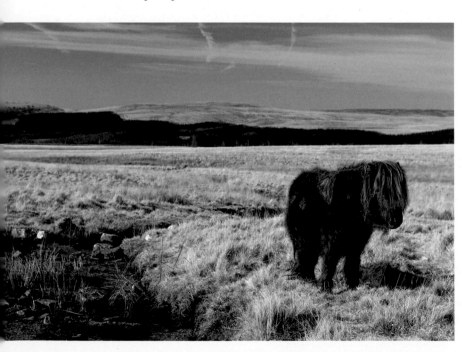

I deliberately placed this Welsh mountain pony to one side of the frame, as I thought it might make a double page spread picture in a magazine. The gutter would fall in a neutral area of the shot and there is enough blue sky for some type to be dropped in. Even so, the picture works well and looks much better than if I had centred the pony.
> Canon EOS 1DS, 28mm lens, 1/60 sec, f/11.

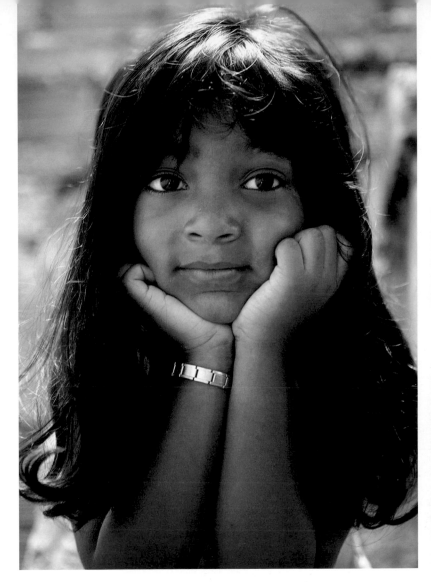

*Left:* **This portrait fills the frame perfectly. Imagine how much background would have been included had I shot it with the camera in landscape mode.**
> Canon EOS 1DS MK2, 70mm lens, 1/15 sec, f/2.8.

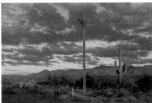

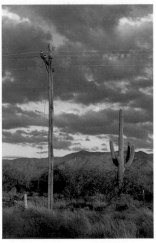

## Photographs for publication

Many professional photographers compose their pictures with an idea already in mind of how they might be published. For example, they may compose their shots so that they will fit over two pages in a magazine or book. When doing this, it is important that the gutter (where two facing pages join in the middle), which may have to slice through the shot, is in a position that is not going to affect the main subject.

Another consideration is where the type might go. Throughout this book there are double-page pictures that have some text over them. If the shots had been taken without enough of a neutral area, then the type would be illegible.

*Top:* **The telegraph pole and cactus look lost in landscape mode.**

*Above:* **A tighter composition has been achieved in portrait mode.**
> Canon EOS 1DS, 70mm lens, 1/50 sec, f/11.

See also:
**Viewpoint** pp. 56–7
**Portraits** pp. 110–21

# Viewpoint

Selecting the best viewpoint for a shot is often low down in the list of priorities because, having seen a view of a subject that we find attractive, many of us shoot from that very spot. In some cases this might work, but if we had given ourselves just a little more time, the shot might have been so much better.

## Important questions

Having chosen what you are going to shoot, take time to look carefully at the subject and ask yourself the following questions:

- From where I'm standing, is the sun in the best possible position?
- Are there any unattractive shadows dominating the picture?
- Is there any foreground interest?
- Are there any features in the foreground that can be used to enhance the overall composition?
- Is the background interesting? Does it overpower the main subject?
- Am I seeing the most attractive features of the subject?
- Have I chosen the right focal length of lens or adjusted my zoom?
- Would the shot look better if I took it from a lower or higher viewpoint?
- Can I be bothered to walk around the subject to see if there is a better angle from which to take the shot?

I was attracted to this terrace of houses, particularly the one with wisteria growing over its walls. I took my shot but realized that I'd done so from the worst possible viewpoint: there is too much uninteresting foreground, half of which is in deep shadow, the wisteria is hardly visible and the 24mm lens has made the shot too wide-angled.

I then moved around the building and chose another viewpoint. Although this focused more on the house with the wisteria, the background was still in deep shadow, as were the steps. In addition, the wall on the left was uninteresting and, even though I had reduced the focal length to 35mm, there was still too much unwanted material in the shot.

For many people this would seem an intimidating list of questions and one not really worth bothering with. However, the fact that you have chosen to use a DSLR camera indicates that you are a cut above the average photographer and that you want your shots to look special. After all, if you bought a Ferrari, would you use it only for the weekly shop? No, you would want to explore its full potential.

Once you get into the habit of asking yourself these questions, you will be amazed at how differently you view your subjects – this is possibly the most important part of developing a 'photographic eye'.

*Above:* **For this shot, I moved round to the right so that I was facing the house more 'full on'. This cropped the oppressive background out of the frame, as well as the uninteresting wall on the left. However, the small wall in the foreground didn't add anything to the composition and the power lines in the sky irritated me.**

**For the final shot, I moved a little more to the right. The house was now at the correct angle and the wisteria shown to best effect and in a good light. A higher viewpoint meant that I could disguise the power lines with the branches of the trees, and by stepping back slightly, I could include the bluebells in the foreground.**
**> Canon EOS 1DS, 24mm lens, 1/100 sec, f/11.**

# Foregrounds

Invariably, it is the foreground of a shot that first attracts attention. It's therefore important that you give whatever occupies this part of the frame due consideration.

## Creating interest

Placing an item of interest in the foreground of your overall composition will help to give it balance, as well as being a tool to lead the eye into the picture. However, it's important not to place an item in the same part of

**Professional tips**

- Wide-angle lenses give more depth of field, so you can keep both the foreground and background sharp.

- Telephoto lenses appear to alter the perspective between foreground and background.

- If it's difficult matching the exposure of the foreground with the background, ask yourself if it would be better to take the shot at a different time of day.

- Look at your subject from high and low viewpoints.

Not all shots need to be taken with a wide-angle lens to emphasize foreground interest. I used a telephoto lens and a small aperture to get maximum depth of field for this picture. The monk in the foreground is the focus of interest, while the one in the middle distance helps lead the eye into the rest of the shot.
> Canon EOS 1DS, 100mm lens, 1/15 sec, f/22.

the frame, such as the bottom right-hand corner, in all your shots, otherwise they will take on a familiarity that will become monotonous to the viewer, especially if your shots are presented in a folio or album.

Although tradition would have us placing foreground interest to one side of the frame, there is no reason why a shot shouldn't work with the point of interest placed centrally. This is true when an element of symmetry is required or when the foreground is to occupy at least half of the entire frame. Choosing a dominant foreground can help to reduce clutter in the composition because all its detail will be clear, while the background will just be hinted at, even though it might be quite sharp.

## Wide-angle v. telephoto

Depth of field is greater with a wide-angle lens, so you will be able to keep items that are quite close to the lens as sharp as those placed further away. This will give them greater prominence in the foreground. Be careful that working at such close proximity does not create distortion. Wide-angle lenses can create the illusion of greater space between the foreground and the background, so make sure that distant objects don't become so small that they are difficult for the eye to read. For this reason it might be preferable to use a telephoto lens. You will then be able to keep the foreground interest prominent, while appearing to reduce the distance of the background. As with any combination of lens and foreground, viewpoint will be of paramount importance.

I had to work quickly when photographing this corporate function, as there were only a few minutes between the caterers finishing their work and the guests arriving. I took several shots but decided that this higher viewpoint enhanced the foreground the most and emphasized the styling of the table settings.
> Canon EOS 1DS, 28mm lens, 1/15 sec, f/8.

I chose a low viewpoint for this shot, so that the emphasis would be on the ropes and jetty in the foreground. The texture of the rope adds interest to the foreground, while the boards of the jetty give a strong sense of perspective.
> Canon EOS 1DS MK2, 24mm lens, 1/125 sec, f/8.

See also:
**Lenses** pp. 19–25
**Viewpoint** pp. 56–7
**Wide-angle lens composition**
    pp. 62–3
**Telephoto lens composition**
    pp. 64–5
**Depth of field** pp. 66–7

# Backgrounds

If foregrounds can help to lead the eye into a shot, then backgrounds can create the backdrop to set off the subject. Whatever you are shooting, it is always possible to alter how the background will appear, whether you are taking portraits or other scenes, such as landscapes.

## Altering the background

The background of a shot can often appear so far away in the distance that it would seem impossible to alter its presence. However, by choosing the correct viewpoint and the appropriate focal length lens and aperture, it can be enhanced in many different ways.

## Softening and sharpening

When photographing outdoors, whether a portrait, wild animals, flowers or a still life, it's likely that you will want to soften the background, so that the emphasis is placed firmly on your subject and that they are isolated against an unobtrusive background. A medium telephoto lens in the region of 100 to 200mm, set to its widest possible aperture to reduce the depth of field, is ideal for this. If, on the other hand, you are working with a wide-angle lens, you will have much less control over the background. This is because a wide-angle lens keeps more of the picture in focus, even at wide apertures.

There are situations where keeping the background as sharp as possible is desirable, either because it is telling you something about the subject or it is making a point about the environment. A wide-angle lens would probably be the best choice for this because it will keep more of the shot in focus. However, if you are using a telephoto lens, you may need to stop the aperture right down to give as much depth of field as possible. Remember, a telephoto lens foreshortens the picture and makes the distances between near and far objects appear less than they are.

This butterfly shows up vividly against a blurred background. To achieve this, I used a 200mm telephoto and a 2x extender to give an effective focal length of 400mm. The purple flower and green stem provide an interesting splash of colour.
> Canon EOS 1DS MK2, 200mm lens, 2x extender, 1/30 sec, f/5.6.

## Previewing the shot

Shooting with a DSLR means that you have the advantage of using the depth of field preview, which allows you to see what a shot will look like after stopping down the lens. This is important, as something in the background that might not be apparent at full aperture – how we see through the viewfinder – could appear to be growing out of your subject's head when the lens is stopped down.

*Above:* I waited quite some time for this gasometer to fill so that it would take up the entire background of the shot. I liked the way it towered over the houses in the foreground, creating an oppressive and claustrophobic feel.
> Canon EOS 1DS MK2, 200mm lens, 1/100 sec, f/8.

Softening the background for an outdoor portrait, so that it doesn't detract from the subject, is often desirable. Here, the background is a mottled blend of greens that contrasts perfectly with the pink dress. If you are using auto-focus for a similar shot, make sure the sensor is on the eyes.
> Canon EOS 1DS MK2, 70–200mm zoom lens, 1/125 sec, f/8.

# Wide-angle lens composition

As their name suggests, wide-angle lenses have a far greater field of view than normal or telephoto lenses. This means that you need to take care when composing your pictures to prevent them looking cluttered with unnecessary detail.

## Points to consider

Since what you see through a DSLR viewfinder is what you get in your shot, it should be relatively easy to crop out anything unwanted. However, it is surprising how often non-essential elements creep in.

The first thing to consider when using a wide-angle lens is that it will exaggerate the distance between the front and back elements of your shot. While this can be used to your advantage in a creative way, it can also produce unflattering portraits: eyes can appear bulbous or noses distinctly larger than they really are. If you point a wide-angle lens upwards when photographing a tall building, it will taper sharply towards the top and look far taller than it is.

A poor-quality lens could also suffer from barrel distortion, which makes the edges of the picture appear to curve. This is unavoidable with a fisheye lens, which has an angle of view of 180°, but, again, this can be used to your advantage. For example, I find that a fisheye lens can lend a new perspective to how the intricate plasterwork of many churches and cathedrals is viewed. It is best to use a tripod with a fisheye lens, especially when looking upwards. If the camera and lens aren't completely level, the balance of the shot might be affected. I normally mount my camera on a tripod and then use a small spirit level to square it up.

### Professional tips

- Keep distortion to a minimum unless you can use it to enhance the composition of your picture.

- Depth of field is far greater with wide-angle lenses, even with a wide aperture.

- Featureless skies and wide-angle lenses are a poor combination. If this is the case, look for strong foreground detail and get in close.

- Polarizing filters have an uneven effect used with lenses that have a shorter focal length than 28mm.

*Far left:* **This has all the ingredients of the quickly taken photograph, composed with little forethought to the final outcome.**

*Left:* **Using the same wide-angle lens but from a different viewpoint has resulted in a far more interesting portrait.**
> Canon EOS 1DS, 24mm lens, 1/125 sec, f/8.

Taking a low viewpoint for this shot of Antony Gormley's *Angel of the North* meant that there was always the danger of including too much sky. However, by carefully composing the picture so that the right-hand side of the sculpture filled the frame, the dominance of the sky has been reduced and the sheer size of the figure emphasized.
> Canon EOS 1DS MK2, 21mm lens, 1/200 sec, f/5.6.

## Landscape photography

If you use an extreme wide-angle lens, such as 21mm, for landscape photography, you will need to pay attention to the sky part of the composition. On a cloudless or overcast day, the sky will look bland and dominate the picture. Using a polarizing filter on a lens wider than 28mm will produce an uneven effect, with the blue sky darker at one side of the frame and lighter on the other. The horizon line will also seem to be further away than it really is. For this reason, foregrounds with interesting detail will make more successful pictures than those where vast swathes of grass or scrubland fill the bottom portion of the composition.

For creative effect, I chose a low viewpoint and a 24mm lens for this shot of two street entertainers. I positioned their hands so that they were only a short distance from the lens but didn't obscure their faces. The building behind them adds interest to a cloudless sky without overpowering the main subject. Even though the aperture was f/5.6, the depth of field is enormous.
> Canon EOS 1DS MK2, 24mm lens, 1/250 sec, f/5.6.

See also:
**Lenses** pp. 19–25
**Framing the picture** pp. 54–5
**Viewpoint** pp. 56–7
**Landscapes** pp. 74–97

# Telephoto lens composition

As well as bringing distant objects closer, telephoto lenses are useful in a wide range of applications, from sports to portrait photography. For full-frame DSLR cameras, these lenses range in focal length from 70mm to 1000mm.

## Points to consider

A telephoto lens allows you to fill the frame and crop out unwanted details when composing your pictures. These lenses also give far less depth of field than standard or wide-angle lenses, which means that if you choose a wide aperture, f/2.8 for example, the background will be quite blurred – a particularly effective technique for portraits that makes your subject stand out with greater clarity, while the background becomes an attractive mottled range of hues. To increase the depth of field on a telephoto lens, you might have to stop the lens down to f/16 or f/22, which, in turn, means that you will have to increase the shutter speed or ISO.

As well as softening backgrounds, telephoto lenses appear to compress distances between various elements in a composition, making them appear closer to each other than they really are. Although only an illusion, you can put this effect to good creative use.

### Professional tips

- To avoid camera shake, use a tripod or monopod.

- Depth of field is far less with these lenses, so use it to your advantage by blurring the background.

- A 100mm telephoto lens is ideal for portraits, but not essential.

- Make the most of the 'compressing' effect of a long telephoto lens to create interesting effects in your compositions.

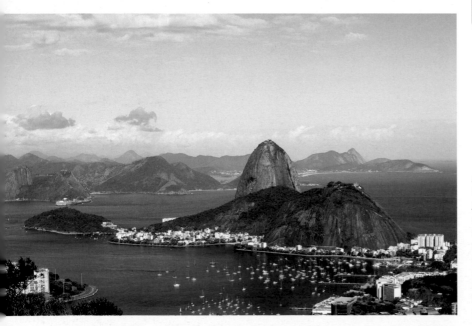

A small telephoto lens was ideal for this shot of Rio de Janeiro's Sugarloaf mountain. It allowed me to crop out unwanted detail from the sides of the frame while retaining the background detail. At the same time, the mountain remains at the heart of the composition.
> Canon EOS 1DS MK2, 70mm lens, 1/640 sec, f/11.

*Above:* **A wide aperture means that very little of the background in this picture is sharp. The emphasis is therefore firmly on the child, even though the colour of her hair is not dissimilar to that of the background.**
> Canon EOS 1DS MK2, 200mm lens, 1/160 sec, f/2.8.

## Shutter speeds

Depending on the focal length of the telephoto, the shutter speed required might be too slow to prevent camera shake. One way of solving this problem is with a tripod or monopod, or by supporting the lens in some other way. Alternatively, you can invest in an image stabilizing lens; I have a Canon 70-200mm f/2.8L IS, which is superb. A good rule of thumb is that for a lens with a focal length of 100mm, you should use a shutter speed of at least 1/125 sec. On the other hand, a lens with a focal length of 200mm will require a shutter speed of 1/250 sec, and so on.

## Filters

Very long lenses usually need larger filters because the front lens element is much larger than normal. For this reason, some ultra telephoto lenses have a system for slip-in filters nearer to the camera body.

**Telephoto lenses are excellent for isolating detail, such as this lone tree, which I managed to bring to the foreground of the shot. The distant wall of the Grand Canyon completely fills the frame and acts as an interesting but neutral backdrop.**
> Canon EOS 1DS, 200mm lens, 1/320 sec, f/11.

**See also:**
**ISO (sensitivity)** pp. 37–8
**Depth of field** pp. 66–7
**Filters** pp. 172–5

# Depth of field

DSLR cameras give you far greater control over depth of field than compact cameras, which means that you can be much more creative with your compositions.

## What is depth of field?

Depth of field (DOF) relates to the overall sharpness of your picture. Whatever the aperture, there is an area immediately in front of and behind the point that you have focused on that is sharp. It is this area that we refer to as the depth of field.

    With a wide aperture, such as f/2.8, very little behind the point of focus, and even less in front of that point, is sharp. While this shallow area of sharp focus can be put to good effect for certain shooting situations, in others it can be a disadvantage. If you stop the lens down, for example to an aperture of f/8, more of the area in front of the point of focus, and even more behind it, will be sharp. If you stop down even further, for example to an aperture of f/22, then an even greater area of the shot will be sharp. Of course, stopping the lens down necessitates a slower shutter speed, but this might mean that if you have an aperture of f/22, the shutter speed required will be too slow for you to hold the camera steady, even if you are using a lens with IS (image stabilizing).

**Professional tips**

- Use the DOF preview to ascertain the area in sharp focus before you shoot.

- Ask yourself whether the shot would look better with more in focus or less.

- Telephoto lenses have less DOF than wide-angle lenses, even at small apertures.

- The closer you are to your subject, the smaller the DOF, even at small apertures.

*Far left:* I wanted to show as many dishes as possible in this still life and for them to be sharp, so I stopped the lens down to f/22. As I was quite close to the subject, the depth of field wasn't as great as it might have been. Even so, all the dishes are distinguishable.
> Canon EOS 1DS MK2, 150mm lens, 1/60 sec, f/22.

*Left:* When I opened up the lens to f/2.8, the emphasis shifted to the dish in the foreground, leaving the others blurred. While both shots are valid, this one definitely focuses the eye on the food.
> Canon EOS 1DS MK2, 150mm lens, 1/60 sec, f/2.8.

I took this sequence of shots from the same viewpoint with the same camera and lens but varied the aperture to show how it affects the depth of field, which, in turn, changes the look and impact of the composition. At f/2.8, the rails in the foreground are out of focus, as are the rails and trees in the background, so the eye focuses on the model.
> Canon EOS 1DS MK2, 70mm lens, 1/400 sec, f/2.8.

## Focal lengths

Bear in mind that depth of field varies with lenses of different focal lengths. For example, if you are using a 24mm wide-angle lens, the area of sharp focus will be quite large, even without stopping the lens right down. On the other hand, with a 50mm lens, this area of sharp focus will decrease, even at the same aperture. With a telephoto lens, the area of sharp focus is even more reduced. Remember that if you are using the camera's 'aperture priority' setting, you will be able to select the aperture manually while the camera automatically selects the shutter speed.

Far from being a drawback, these variations in depth of field can be put to good effect because they allow you to isolate your subject and make it stand out from the background. This is particularly true when taking portraits, where a sharp background can be a distraction.

DSLR cameras always show the image in the viewfinder at wide open, so you need to use the depth of field preview to determine what area in your shot will be in sharp focus and what its effect will be on the overall composition.

*Above left:* **By stopping the lens down to f/8, both the foreground and background are sharper.**
> Canon EOS 1DS MK2, 70mm lens, 1/50 sec, f/8.

*Above right:* **At f/22, virtually the entire picture is sharp, making it more difficult to focus attention on the model.**
> Canon EOS 1DS MK2, 70mm lens, 1/6 sec, f/22.

### See also:
**Lenses** pp. 19–25
**Viewpoint** pp. 56–7
**Portraits: outdoors** pp. 110–13

# The shutter

While the aperture determines how much light passes through the lens and onto the sensor, the shutter governs the amount of time that the light is allowed to do so. Having two different methods of controlling the light exists for specific reasons and not just for exposure control, although there is a correlation between the speed of the shutter and the size of the aperture.

## Blurring and freezing movement

On pages 66-7, I explain how the aperture can control the depth of field and therefore the overall sharpness of the picture. Here, you will see how the shutter can control the degree of sharpness by either blurring or freezing the movement in your pictures.

The shutter range on most DSLR cameras is quite extensive, with 30 seconds to 1/8000 of a second not uncommon. In addition, there are usually one-third increments in between the main shutter speeds: for instance, there are two other available speed settings between 1/30 and 1/60. With such a huge choice, you should be able to cope with any shooting situation.

In addition, there is a setting 'B', or 'bulb'. With this in use, the shutter remains open for as long as the shutter release is held down. The setting is most commonly used for night shots and situations where the light levels are extremely low and a long exposure is required.

### Professional tips

- Try using different shutter speeds to vary the outcome of your shot. A slow speed may seem inappropriate but it may result in the most evocative image.

- Long exposures may increase the level of noise, so make sure you select the noise reduction function before you shoot.

- Camera batteries drain rapidly at the 'B' setting, so have plenty of spare batteries to hand.

- To avoid camera shake at slow shutter speeds – even when the camera is on a tripod – use the mirror up facility and a cable release to reduce the risk.

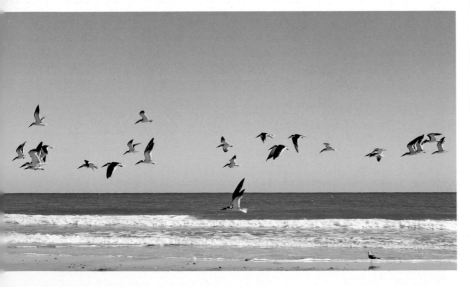

**To keep the movement of the birds and water perfectly sharp, I chose a shutter speed of 1/1000 sec. A slow shutter speed would have blurred any movement and made the birds unrecognizable.**
> Canon EOS 1DS, 70mm lens, 1/1000 sec, f/11.

As I took this shot in available light, I needed to set the ISO to 800 so that the shutter speed would be fast enough to keep the barman and the drinks sharp. This has increased the level of camera noise, but it is still within the bounds of acceptability.
> Canon EOS 1DS, 100mm lens, 1/125 sec, f/2.8.

However, such exposures may result in an unacceptably high degree of noise, so if your camera is fitted with a noise reduction function, make sure that you set it.

If you are shooting a moving object, such as a bird in flight, you will need to set the camera to a fast shutter speed to 'freeze' the movement. This would be at least 1/250 sec, although 1/500 or 1/1000 wouldn't be unusual. Anything slower than this will result in the bird becoming blurred. While this might be used to advantage in certain situations, in others it could mean that the subject is unrecognizable. Another reason for using a fast shutter speed is to eliminate camera shake. This can happen even when your subject is static because it is you that is moving. Even if your camera is on a tripod when you are working with a slow shutter speed, camera shake can still occur as the mirror flips upwards after the shutter release is pressed. By using the 'mirror up' function, this problem can be reduced.

*Top:* **Photographed with a shutter speed of 1/60 sec, this Bangkok tuk-tuk appears motionless.**

*Above:* **Changing the shutter speed to 1/8 sec conveys the speed and bumpiness of the ride.**
> Canon EOS 1DS, 24mm lens, 1/8 sec, f/22.

See also:
**ISO (sensitivity)** pp. 37–8
**Action** pp. 162–9

# Perspective

One of the essential elements of a good photograph is a sense of perspective. Since photographs are two-dimensional, it is down to you to create a feeling of space and depth between the various objects that make up your shot.

## Lenses and perspective

The lens you choose can help create this sense of perspective: wide-angle lenses create an appearance of greater space between near and far objects, whereas telephoto lenses seem to reduce the distance. Of course, this is an illusion: if you took a shot of the same subject with two lenses of different focal lengths and enlarged the wide-angle one so that it was cropped the same as the telephoto version, the compression would appear the same. Obviously, the quality of the wide-angle shot would suffer because the degree of enlargement required would increase the noise and reduce the sharpness of the image.

## Changing viewpoint

It's also possible to create a sense of depth by choosing a viewpoint that increases the distance from the foreground of your shot to the background. You can use something in the foreground to lead the eye

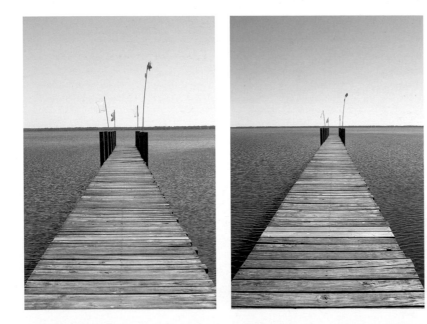

### Professional tips

- Take more time to look at the various possibilities when choosing your viewpoint – the right one will definitely enhance the feeling of perspective.

- When pointing the camera upwards your subject will appear taller than it really is. This is true of full-length portraits of people as well as of buildings.

- Wide-angle lenses give the illusion of greater perspective.

- Check whether you can use a framing device, such as an arch, wall or tree, in the foreground to increase the sense of depth in your shot.

*Far left:* **A 70mm lens gives the appearance of perspective as the jetty tapers away.**
> Canon EOS 1DS, 70mm lens, 1/250 sec, f/11.

*Left:* **Taking the shot from the same viewpoint with a 28mm lens makes the jetty appear a lot longer than it really is, which, it could be argued, gives the picture a greater sense of perspective.**
> Canon EOS 1DS, 28mm lens, 1/250 sec, f/11.

*Left:* I chose this viewpoint so that the wall of the modern building in Barbican, London, would act as the tool to lead the eye into the shot. As the wall tapers towards the centre of the shot, the feeling of depth increases, and the spatial effect between the various elements is emphasized. The ancient wall in the foreground is another important element of the composition as your eyes shift their focus from it to the more modern architecture in the rest of the picture.
> Canon EOS 1DS, 28mm lens, 1/125 sec, f/11.

into the picture, as demonstrated in the shot above. Using foregrounds in this way greatly increases the feeling of depth, or perspective.

The angle at which you hold the camera is another way to enhance the sense of perspective. If you look at a building from a distance so that the viewpoint is straight on, it could be argued that it looks its 'normal' height. However, if you move in closer and change your viewpoint so that you look upwards, the building will appear to taper towards the top. This is known as converging verticals and will make the building look taller than it actually is. A wide-angle lens will increase this effect even more.

The high viewpoint that was used for this shot of a multi-DVD recording tower makes the tower taper away from the viewpoint, so that it appears to leap out from the picture.
> Canon EOS 1DS, 17mm lens, 2 secs, f/22.

Photographed from a close viewpoint with the camera pointed up, this building appears a lot taller than it really is. This is because it tapers towards the top, increasing the illusion of perspective. Shots taken in this way can can look more dynamic than those where all the verticals appear strictly vertical.
> Canon EOS 1DS, 17mm lens, 1/85 sec, f/5.

## See also:

**Lenses** pp. 19–25
**Viewpoint** pp. 56–7
**Depth of field** pp. 66–7
**Shift and tilt lenses** pp. 176–9

# Black-and-white or colour?

One of the great benefits of a DSLR is that you can take all your pictures in colour and then convert them to black-and-white in Photoshop at a later date. Nevertheless, there are several DSLR models that allow you to shoot in black-and-white.

## Seeing in black-and-white

Shooting in black-and-white requires you to be much more observant than when shooting in colour. Learning to see in black-and-white is essential for a monochrome picture to work well - you have to look at

These multicoloured umbrellas are easy to tell apart because their colours are so contrasting. Even the three pastel shades in the foreground are noticeably different from each other.
> Canon EOS 1DS MK2, 50mm lens, 1/85 sec, f/2.8.

Shot in black-and-white, the pastel-coloured umbrellas all look the same shade, making it impossible to tell them apart. The same is true of the umbrella on the right in the row behind: the green and red panels have come out an identical shade of grey.

*Below:* I took the shot of this man in colour but always envisaged printing it in black-and-white.

*Right:* The black-and-white print is grittier and more engaging than the colour one. The man's pores are more noticeable, and his left eye becomes the focus, resulting in a portrait with increased depth of expression.
> Canon EOS 1DS MK2, 50mm lens, 1/85 sec, f/2.8.

the world in a different way, and be much more aware of contrast and shadow. Colour photography can cover a multitude of sins, but black and white will expose them ruthlessly.

In colour photography, different colours can stand out vividly from each other, while in black-and-white photography two different colours can end up looking the same shade of grey. Consider green and red. In colour photography, they contrast well with one another and are easy to tell apart. In fact, it is a combination you might actually look for when taking a shot. However, if the same image is shot in black-and-white, it will be virtually impossible to tell the colours apart. For example, if you were to photograph someone wearing a green top and placed them against a red background, the contrast would be completely lost. In black-and-white photography, it can also be difficult to distinguish one object from another if the lighting is subdued and there is very little shadow detail. Shots with strong texture and a certain degree of side lighting work well in black-and-white. An overcast sky, though, will create a diffused flat light that won't highlight even strongly textured surfaces.

Black-and-white photography is particularly suited to portraits, as the eye isn't distracted by strong colours and, instead, concentrates on the subject, skin tones, composition and lighting.

See also:
**Black-and-white landscapes**
pp. 90–3
**Filters** pp. 172–5
**Black-and-white from colour**
pp. 232–5

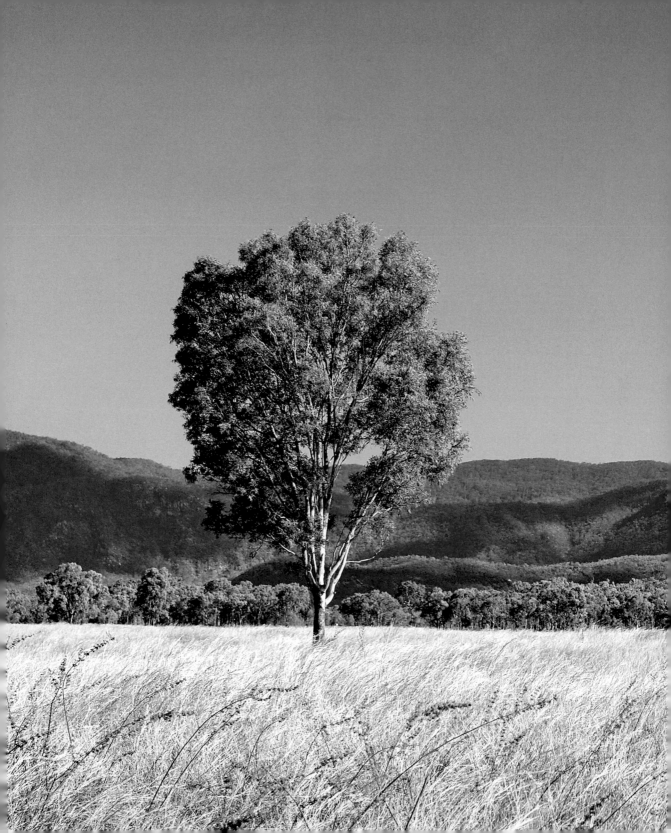

# Landscapes

# Shooting landscapes

The variety of photographic challenges posed by shooting landscapes, especially changing light and unpredictable weather, means it's important that you are as well equipped as possible. But since you might have to carry your kit for long distances, try to keep the weight to a minimum.

## Basic kit

I usually carry three key zoom lenses with me for photographing landscapes: 16-35mm, 24-70mm and 70-200mm. These are all 'fast' lenses with maximum wide apertures of f/2.8. Each one has a hood, not only to eliminate flare but also to provide a certain degree of protection from rain and knocks. I also carry a 2× extender, which gives me a maximum telephoto focal length of 400mm. The extender does mean that I lose some speed, though, and the maximum wide aperture drops from f/2.8 to f/5.6. However, this has never caused me any problems and is infinitely preferable to carrying a prime 400mm lens.

Another item I always pack is a set of extension tubes. These are useful for shooting close-up detail of flowers or texture, and take up very little room. I always carry a tripod with me, despite the fact that it's slightly bulky. A tripod is essential when a long exposure is unavoidable but it's impossible to hold the camera steady. A cable release helps to fire the shutter release more smoothly (if you fire it in the normal way using your finger, the camera can still move, even if it's on a tripod).

**Professional tips**

- A backpack-style camera bag is more versatile than a shoulder bag or case, leaving your hands free for scrambling over rocks or climbing up and down steep inclines.

- A zoom lens has the advantage of reducing the number of fixed focal length lenses you need to carry around with you.

- Always take a tripod – you never know when you might need one.

- Plastic carrier bags provide cheap, lightweight protection for your camera and lenses.

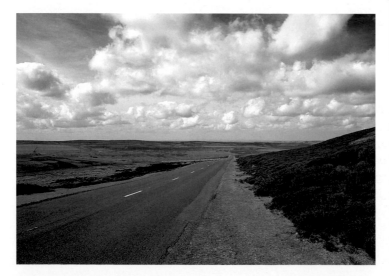

When exposing for the sky, the foreground often ends up underexposed, while if you expose for the foreground, the sky will be burnt out. To balance the exposure between sky and foreground for this Cumbrian landscape, I fitted a graduated ND filter.
> Canon EOS 1DS MK2, 24mm lens, 1/60 sec, f/8.

Obviously the time of year that you photograph landscapes has an important effect on the final result, so it's always advisable to take your shot as and when you see it, and never kid yourself that you will do it at a later date. I shot this scene in Provence in late spring, when everything was vibrant and fresh, and the blue flowers made a beautiful swathe of colour in the foreground.
> Canon EOS 1DS, 105mm lens, 1/400 sec, f/11.

I revisited the scene in autumn and, although the warm light and golden browns aren't unattractive, the shot is definitely not so striking as the spring picture. What's more, when I returned a year later, the tree had still not grown back to its former glory. I was so pleased that I hadn't put off taking the shot in spring.
> Canon EOS 1DS, 105mm lens, 1/250 sec, f/11.

## The extras

In addition to my basic kit, I pack a polarizing filter (all my lenses have the same size filter thread) and two graduated ND (neutral density) filters of different strengths, together with a filter holder. The filters are great for balancing the discrepancy in exposure that can occur between the sky and elements in the foreground. For a really dramatic effect, I use both filters at the same time. If you're shooting reflections, you may need to remove the polarizing filter because it's likely to reduce their intensity. A hand-held meter for accurate incident light readings is useful for close-ups. Finally, I pack a couple of plastic carrier bags to help protect the equipment if it's raining, wet or there is a lot of dust around.

See also:
**Lenses** pp. 19–25
**Accessories** pp. 26–31
**Exposure** pp. 76–7
**Filters** pp. 172–5
**Close-ups** pp. 198–201

# Summer

Most of us look forward to summer with the longer hours of daylight, sunshine and warmer, drier weather. However, hazy skies and glaring light mean that conditions are not always ideal for photographing landscapes.

## Light and shadows

My preferred time of day for shooting in bright summer light is first thing in the morning and late afternoon or early evening, when the sun creates extremely long shadows that add interest and texture to landscapes. To capture such scenes in the morning often entails getting up extremely

**Strong shadows last for only a short time first thing in the morning, so for this shot I made sure that I was up early to take advantage of them. As well as casting noticeable shadows on the roof, the sun has clearly defined the rows of lavender.**
> Canon EOS 1DS MK2, 400mm lens, 1/6 sec, f/22.

early, perhaps before the sun has even risen and the sky is still dark. Once the sun comes over the horizon, it then rises extremely rapidly, and while it might seem that you have all the time in the world to take your photographs, you don't, and if you're not careful, you will miss out on the best light and so lose the optimum shot. Towards the end of the day, you are fighting against fading light, so being in position beforehand is just as vital as it is early in the morning. It's also advisable to take your shots early on in the season – you never know when a field of golden wheat will be harvested and reduced to stubble!

As the sun climbs in the sky, shadows becomes shorter, resulting in less contrast to a scene. In my experience, there are few situations where this high, bright light suits landscape photography. This is especially true in expansive landscapes, such as farmland fields, deserts or seascapes, where foreground interest is in short supply.

The light first thing in the morning as well as towards the end of the day tends to be warm, which creates tremendous atmosphere in your shots. It is, therefore, essential that you set the camera's WB (white balance) manually; automatic white balance (AWB) may neutralize the scene and the warm atmosphere will be lost.

**Meadow flowers, such as these poppies, can have quite a long season of interest but are vulnerable to farm machinery. For this shot I made sure that the flowers in the foreground took prominence by using a wide aperture, which reduced the area of sharp focus.**
> Canon EOS 1DS, 200mm lens, 1/500 sec, f/2.8.

---

See also:
**White balance** pp. 38–9
**Telephoto lens composition**
  pp. 64–5
**Depth of field** pp. 66–7
**Filters** pp. 172–5

---

# Autumn

This season, so rich in colour, is probably the shortest for photographers, so planning ahead is essential. Autumn is also unpredictable, its beauty dependent on the summer just past, when a lack of rain can cause leaves to brown early without ever turning a golden hue. They can also fall from the trees before the season has really started.

## Changing colours

The colour of trees in autumn can be breathtaking, with strong sunlight making all the difference to the impact of your shots. A deep blue sky acting as a backdrop to a tree covered in rich golden-red leaves, for example, is particularly striking. A polarizing filter will help to deepen the blue of the sky, and the earlier in the morning you can take your pictures, the better – the shadows are deep and long, adding drama to your compositions. Later in the day, when the sun is higher, this effect will be lost because the shadows are much shorter.

A telephoto lens is good for isolating detail, and either a macro lens or an extension tube will help you get in close for fine features, such as the veins of a leaf. In this case, you might want to try a shot from a low angle with the sun backlighting the leaf.

**The strength of this simple composition lies in the contrast between the rich colours of the foliage and the deep blue sky. I took the shot early in the morning and used a polarizing filter to deepen the colour of sky.**
> Canon EOS 1DS, 17mm lens, 1/100 sec, f/11.

Without the early-morning sun, the furrows in this out-of-season lavender field in Provence would look flat and uninteresting. The strong lines created by the furrows combined with the overall golden hue of the landscape make this an attractive composition.
> Canon EOS 1DS, 28mm lens, 1/6 sec, f/11.

## Other autumnal themes

There are other features associated with autumn besides the changing foliage of trees. Pumpkins, for instance, are increasingly popular at this time of year, primarily because of their connection with Halloween. They present the photographer with a variety of shooting possibilities: their colour, size and texture can all be utilized to great effect. To accentuate the texture, it's a good idea to use strong side lighting to form deep shadows in the ridges of the pumpkin's skin.

Early-morning light has created strong shadow detail in the ridges of this pumpkin. To make it more prominent, I used a telephoto lens, while an aperture of f/16 ensured that the other pumpkins were still visible.
> Canon EOS 1DS, 200mm lens, 1/60 sec, f/16.

See also:
**Lenses** pp. 19–25
**Accessories** pp. 26–31
**Filters** pp. 172–5
**Close-ups** pp. 198–201

# Winter

Winter is a great opportunity for shooting snow pictures, and a DSLR also gives you the scope to photograph distant wildlife with a telephoto lens or details with a macro. Although a compact digital camera might also offer these options, it will never provide the range of lens alternatives of a DSLR system.

## Snow readings

Where there is a lot of snow, it can be difficult to determine exposures accurately, especially with the camera's built-in exposure meter. This is because with so many bright and reflective surfaces, the meter may think that there is more light than there actually is, which could result in your shots coming out underexposed. When you start shooting, keep an eye on the camera's LCD screen for the first few shots and pay particular attention to the histogram. This will give you an accurate indication as to whether the meter is performing correctly.

## Timing

The best pictures are usually taken immediately after it has finished snowing, when the trees are weighed down with snow and the sun is out (but see the daffodil picture, opposite). If there is no shadow detail and the skies are leaden, snow scenes can easily look uninteresting. A strong blue sky, on the other hand, provides colour, as do wild flowers and berries or a brightly coloured sign, and relieves the monotony of endless stretches of virgin snow with little or no shadow detail.

**The only way to get close to a bird in a situation like this is to shoot with a telephoto – here, a 300m lens. With a lens this length or longer, it is essential that you use a tripod or at least a monopod.**
> Canon EOS 1DS MK2, 300mm lens, 1/50 sec, f/5.6.

**Professional tips**

- Have camera care at the forefront of your planning when taking shots in freezing and icy conditions.

- Keep the camera well protected when not in use; I tend to put mine under my jacket for protection but also to keep it warm.

- Although it is unlikely, camera batteries may seize up if they get too cold. Always carry a couple of spares with you and store them next to your body to keep them warm.

- If you slip over in ice and snow, chances are your camera will get covered in snow. If it's allowed to melt, water will then seep into your camera and lens, causing irreparable damage. Avoid this by blowing the snow off immediately, rather than wiping it away.

**Above:** Snow details can often look better than an expansive view. I had seen this 'tongue' of snow in Champery, Switzerland, from a cable car and needed to walk only a little way down from the stop to get the shot. The snow is in striking contrast to the deep blue sky, while the dark rock and the strong sun define its texture well.

> Canon EOS 1DS MK2, 150mm lens, 1/1000 sec, f/8, 100 ISO.

**Left:** Great pictures may be taken while it is still snowing. The layer of snow on this daffodil provides strong colour contrast to the grey background, while the streaks of falling snow, captured with a relatively slow shutter speed, add to the composition by breaking up the grey.

> Canon EOS 1DS MK2, 200mm lens, 1/30 sec, f/5.6.

See also:

**Equipment care** p. 18
**ISO (sensitivity)** pp. 37–8
**Exposure** pp. 44–5
**Nature** pp. 98–107

# Spring

Unlike winter, which can sometimes feel endless, spring can, if you're not careful, be over before you realize it. One minute, the trees are bare and flowers a rarity; the next, the trees are covered in leaves and flowers are everywhere.

## Planning ahead

Spring flowers, unfortunately, won't last for ever, so all the more reason to make sure that you know where and when they will be in bloom: daffodils, for example, are at their peak for only a few days. Plan ahead if you need to shoot in an unfamiliar area, and when you arrive, try to enlist the help of local knowledge to prevent wasting time and getting lost.

## Close-ups

When taking close-ups of flowers, use a telephoto and perhaps an extension tube to allow you to get in really close to your subject, while keeping a physical distance. This is important because if you are too close to your subject, you or your camera might cast a shadow over it. Alternatively, use a macro lens: a 100mm macro lens, for example, allows you to magnify your subject without getting physically close to it, which would be impossible with a 50mm lens.

**Professional tips**

- Although it's possible to shoot in overcast conditions, sometimes even when the light is quite dull, the sun makes all the difference to the outcome.

- Early-morning light is infinitely better than midday sun. There is always good shadow detail to be found, and the intensity of the light is much more vibrant.

- Even if you live in a city, where the signs of spring are not so obvious, there will always be a viewpoint that will crop out the detritus of urban living.

*Above:* **Although clouds had obscured the sun, conditions were still bright enough to shoot this garden. However, it has resulted in a picture that looks flat and rather uninteresting.**

**Look at the difference the sun has made in the same shot. Everything looks brighter, while the shadow detail on the path adds depth to the picture and gives the background more interest.**
> Canon EOS 1DS, 70mm lens, 1/30 sec, f/16.

*Above:* A field of oil seed rape makes a striking contrast to the new leaves on the trees and blue sky. A graduated ND (neutral density) filter has balanced the exposure required for the sky with the foreground, retaining the detail in the clouds that otherwise would have been lost.
> Canon EOS 1DS MK2, 40mm lens, 1/100 sec, f/8.

*Left:* I took this shot with a 200mm telephoto and a No.1 extension tube, which enabled me to get in close and focus on the head of the flower. I chose a low viewpoint and positioned myself so that I could take full advantage of the sun that was backlighting the outer petals.
> Canon EOS 1DS MK2, 200mm lens, 1/400 sec, f/5.6.

See also:
**Lenses** pp. 19–25
**Extension tubes** p. 27
**Viewpoint** pp. 56–7
**Filters** pp. 172–5
**Close-ups** pp. 198–201

# Water

Shooting water in all its various forms – rivers, waterfalls, lakes, oceans – provides endless opportunities for great imagery, but being well prepared in terms of equipment and its protection goes a long way in ensuring the success of your photographs.

## Safety first

DSLR cameras and water don't mix, so it's a good idea to take a few initial precautions before setting off on a shoot, especially if you are going to be by the sea. I always keep each lens and also the camera body in individual plastic bags to shield them from the wet, even if I'm carrying them in a backpack or camera case as well. The bags also protect them from sand, which gets everywhere and is particularly destructive: sand on a lens can ruin the front element within seconds. Another way to protect your lenses is to fit each one with a UV, or skylight, filter. These cost only a few pounds to replace, unlike a lens, which can cost thousands of pounds. If a lens does get wet, wipe it immediately with a soft, dry cloth to remove all visible signs of moisture.

Dropping the lens and/or camera body into water will probably be the end of them. Even if they could be repaired, the cost of doing so is likely to be prohibitive.

**Although brightly lit, this scene in Cairns, Australia, still needed a tripod. The shutter speed was only 1/20 sec because I wanted to use a polarizing filter, which requires up to two stops more exposure than normal. A small aperture allowed me to create the greatest depth of field and maintain sharpness from foreground to horizon.**
> Canon EOS 1DS MK2, 17mm lens, 1/20 sec, f/22.

*Left:* To give the impression of fast-flowing water in this shot of Terrace Falls in the Blue Mountains, Australia, I chose a shutter speed of 8 seconds. As well as being essential for such a slow speed, using a tripod meant that I could take the shot from the middle of the river without worrying about getting the camera wet.
> Canon EOS 1DS, 55mm lens, 8 secs, f/22.

For this version of the same scene, I used a shutter speed of 1/250 sec to virtually 'freeze' the flow of the water. It has resulted in a perfectly acceptable shot, although not as dynamic, which could have been taken without a tripod.
> Canon EOS 1DS, 70mm lens, 1/250 sec, f/2.8.

## Using a tripod

When shooting fast-flowing water, you might want to use a slow shutter speed to 'blur' the water. To do so, you will need to keep the camera completely still. Even though you might be able to brace yourself against a tree or rest the camera on a rock, for example, the support might not be in the best position for your shot. This is when you need a tripod.

## Filters and reflections

A polarizing filter is a particularly useful accessory when photographing water. Apart from darkening a blue sky and highlighting clouds, it will also change the appearance of the water. However, you need to use it with care if the reflections in the water, such as clouds, overhanging branches or mountains, are an important part of your picture because one of the other functions of the polarizing filter is to eliminate reflections. In this case, you might be better off using a graduated ND (neutral density) filter, which will balance the exposure required for the sky with that of the foreground without affecting the quality of the water.

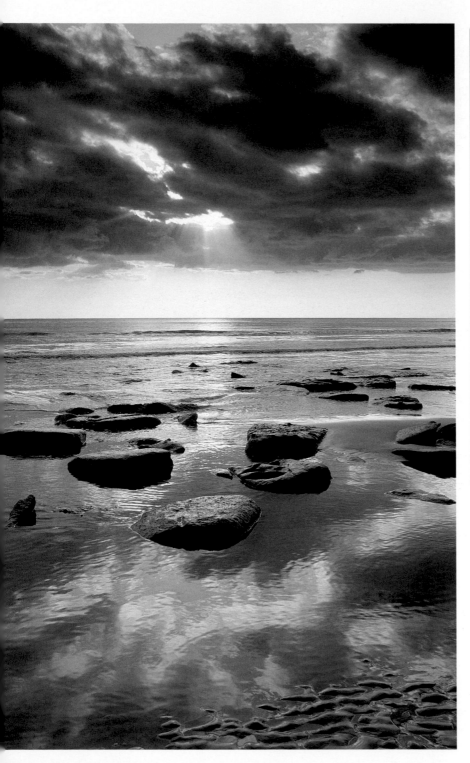

## Professional tips

- Although you might find a tripod cumbersome to carry, remember that the world's top landscape photographers use one for almost all their shots.

- At sunrise, water is generally at its calmest and mirror-like reflections are possible. Later in the day, and often quite rapidly, the water will start to ripple, making any reflections disappear.

- A polarizing filter intensifies the blue of the sky and gives greater clarity to clouds.

- When using a wide-angle lens for a landscape shot, avoid including vast amounts of uninteresting detail in the foreground and 'pushing' the background so far away that it is difficult to read any detail.

- Set the camera's white balance to K for shooting late in the day or at sunset.

For this sunset over a rocky South Wales shore, I set the camera's white balance at K to retain the warmth and detail of the sky. A graduated ND (neutral density) filter also helped to accentuate the cloud details.
> Canon EOS 1DS, 24mm lens, 1/4 sec, f/11.

## Foreground interest

When composing pictures of large areas of water, think carefully about the foreground – nothing is worse than a vast area of water, sand or grass in the foreground of the picture with no interesting features to break it up. Always be on the lookout for a point of interest, which could be anything from a boat or unusual foliage to a piece of driftwood. If such a feature is at hand, think about where you are going to place it in the frame and vary the composition from shot to shot. You don't want to end up with a series of pictures that always feature the foreground interest in the bottom right-hand corner, for example.

## Sunrise and sunset

If you are shooting a sunrise or sunset over water, it will be best to use the K setting of your camera's white balance. Having the camera set to AWB (auto white balance) could neutralize the warmth in the sky, which is probably the reason why you are taking the picture in the first place. As with so many controls on DSLR cameras, there is a time and place to use them in their auto mode, but getting to grips with the manual settings will give you far more creative control over your shots. The great advantage of digital over film, after all, is that you can review the results instantly on the camera's LCD, so try to make full use of it.

Using an ultra wide-angle lens, taking a low viewpoint and pointing the camera downwards to emphasize the foreground have worked well for this shot taken in the Everglades, Florida. The wind has created an intriguing ripple effect in the water, which could have looked quite 'dead' without any movement.
> Canon EOS 1DS, 17mm lens, 1/320 sec, f/5.6.

See also:
**Equipment care** p. 18
**Accessories** pp. 26–31
**White balance** pp. 38–9
**Depth of field** pp. 66–7
**Filters** pp. 172–5

# Black-and-white landscapes

Black-and-white photography has always been popular for shooting landscapes. Today, many examples of the work of great landscape photographers of the past, such as Ansel Adams, Edward Weston and Edwin Smith, are available as greetings cards and posters the world over.

## Shooting in black-and-white

Many DSLR cameras have a black-and-white mode so you can shoot and review specifically in monochrome. Taking photographs in this way also gives you the advantage of being able to print directly, either through the camera or from the memory card. If your camera doesn't have this facility, you can convert your colour images to black-and-white at a later stage, once they have been downloaded onto the computer. Bear in mind that when you shoot in black-and-white, you cannot later convert your shots to colour. Of course, you can always shoot in both modes, which gives you the best of both worlds.

## Coloured filters

Although coloured filters for black-and-white film photography can still be used with DSLR cameras, the results are not so pronounced as they are with non-digital cameras. A more effective way to enhance DSLR black-and-white images is with a computer program, such as Photoshop.

### Professional tips

- Include filters, such as yellow, red and green, in your kit.

- Pack spare batteries and plenty of memory cards before going on a trek.

- Take a tripod – essential for long exposures.

- To reduce the risk of camera shake, even when the camera is on a tripod, use the mirror up facility and a cable release.

- Protect your camera from the elements, such as wind and rain – something as simple as a plastic bag will do the job.

**There is nothing to beat the light of the early morning sun, and this shot taken in Death Valley is no exception. I was in position before the sun had even risen to be sure that I could capture the extreme shadow detail that would be formed when it did rise.**
> Canon EOS 1DS, 200mm lens, 1/60 sec, f/11.

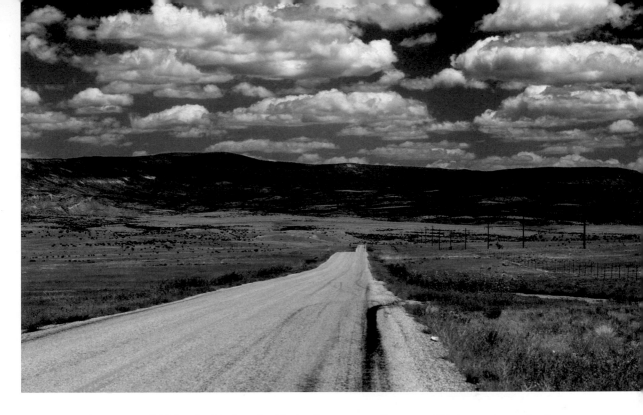

The most useful filters for black-and-white landscapes are yellow, orange, red, green and one or two graduated ND (neutral density) ones of different strengths. A No. 12 yellow filter is essential for enhancing the sky, making a blue sky slightly darker and adding definition to clouds. Most filters, except UV and skylight, require an increase in exposure. As the camera's TTL (through the lens) metering should adjust for this, there is no need to override the exposure, but it is worth checking the histogram to make sure the levels are evenly spread across the graph.

An orange filter produces the same effect but more so, darkening the sky even further, while a No. 25 red filter can make a blue sky so dark that it looks as though it were photographed at night. A No. 25 requires an increase in exposure of about 1 stop but, again, the TTL metering should adjust for this. Although this filter can add a sense of surrealism to your shots, it can also make them look unevenly balanced and tacky.

Filters the same colour as your subject will lighten it. For example, a green filter will turn a mass of green foliage lighter, whereas an orange filter will darken it. Lightening foliage in black-and-white photography can be beneficial because it often appears quite dense and heavy when reproduced at printing stage.

If you use a coloured filter and are shooting colour as well as black-and-white, remember to remove the filter each time you switch mode, otherwise you will have a colour cast on all your colour shots.

**This is a good example of how a No. 12 yellow filter can accentuate a sky and bring out cloud detail. Using this highway in New Mexico as a tool to enhance perspective leads the eye into the picture and gives a great feeling of space.**
> Canon EOS 1DS, 28mm lens, 1/125 sec, f/11.

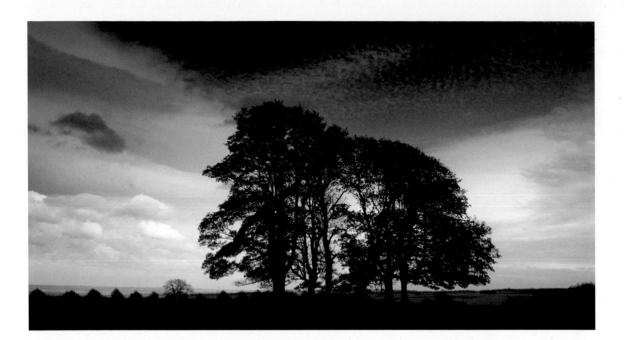

## Graduated neutral density filters

The other type of filter essential for landscape photography – for shooting in black-and-white or colour – is the graduated neutral density (ND) filter. It balances the exposure required for the sky with that needed for the foreground. Depending on how bright the day is, the discrepancy in exposure can be considerable and, without balancing the two areas, the sky will either get burnt out and there will be no cloud detail, or the foreground will be underexposed with very little shadow detail.

## Tripods

Although it might seem burdensome to carry a tripod when trekking through countryside or over mountains, believe me, it is well worth the effort. There might be situations when you need a long exposure but it's not possible to hold the camera steady, and even if you can find a suitable surface on which to steady the camera, it might not be in the right position for your chosen viewpoint. Some tripods come with a ball-and-socket head, which means that the camera can be angled, and even if you are placing it on a surface such as a rock, the tripod will give you more stability than if you were to try to keep the camera steady by hand-holding it. Regardless of the size of the tripod, I would still recommend using a cable release. Bear in mind that a small tripod can be better than none at all, and there are many available that are no more than 250mm (10in) in length.

**Taking the exposure from the sky has underexposed the foreground and the trees but has resulted in a moody atmosphere, with the trees silhouetted against the clouds. High contrast shots like this can also be created later on the computer.**
> Canon EOS 1DS, 28mm lens, 1/60 sec, f/8.

I used a wide-angle lens to emphasize the natural perspective created by these rocks as they stretch from the foreground into the sea. A graduated ND filter has made the sky dark and moody.
> Canon EOS 1DS, 28mm lens, 1/60 sec, f/8.

See also:
**Equipment care** p. 18
**Accessories** pp. 26–31
**Black-and-white or colour?**
pp. 72–3
**Filters** pp. 172–5
**Black-and-white from colour**
pp. 232–5

# Urban landscapes

While most people associate landscape photography with the countryside, there is another way landscape can be interpreted and that is through the built environment. As the majority of the world's population now live in cities, these tend to be a rich source of photographic opportunities.

## Precautions

Towns and cities can be challenging to photograph, but a DSLR system is so flexible with the range of lenses and accessories available that you'll be able to shoot in almost any situation. The system is also quite light and not particularly bulky, so that you can carry a reasonable amount of kit comfortably without getting in people's way. However, shooting with a lot of expensive kit on show could make you a target for robbery. I've found, though, that having my camera on a tripod and appearing familiar with my surroundings can work to my advantage. People assume that I'm a professional and probably not working alone. In addition, there is a limited market for selling stolen professional kit, whereas a more modest camera is easier to dispose of.

This version of urban clutter is at Rio de Janeiro's famous Copacabana beach. From this high viewpoint, the beach umbrellas look as though they have taken up every square centimetre of space.
> Canon EOS 1DS, 80mm lens, 1/250 sec, f/11.

*Above:* This jumbled environment of telegraph and electricity poles, parked cars and background buildings in San Francisco appears even more compressed through a telephoto lens.
> Canon EOS 1DS, 200mm lens, 1/400 sec, f/8.

It was almost a cliché to find this young boy asleep in front of a Bangkok cash machine, and I couldn't resist the shot. In similar situations, I would usually discuss taking the photograph with the subject, rather than do it secretly.
> Canon EOS 1DS, 50mm lens, 1/125 sec, f/2.8.

## Choosing the ISO

One of the great advantages of a DSLR is that you don't need different speeds of film in order to change the ISO. I find that either 100 or 200 ISO is suitable for most situations. However, if the light is low, I can increase the ISO to suit. Even at 800 ISO, the results are amazingly good and the level of noise is negligible. In any case, I would rather cope with noise than use flash, which could easily ruin the atmosphere of a shot.

## Subject matter

When shooting urban landscapes I tend to focus on the detritus created by people living in close proximity to one another. This doesn't have to mean the obvious – piles of rubbish on street corners, although this can be interesting – but rather the way we clutter the environment with electricity cables, street signs, billboards, graffiti and so on. I never set out to portray the built environment as one of chaos and decay. After all, my home is in London, which I find a fascinating and vibrant place, as well as a source of beautiful architecture, both old and new.

## Using colour

Colour plays a big part in the built environment, so I am always on the lookout for ways I can use it in my shots, unlike many photographers who tend to shoot in black-and-white as a way of portraying the negative aspects of city life. Remember that if you shoot in colour, you can always convert your images to black-and-white at a later stage on the computer, thereby giving you the best of both worlds. If you shoot in black-and-white, though, you won't be able to convert it to colour.

I like the man-made 'canyons' that modern cities create. Clusters of tall buildings shot from a distance and with them towering over you look the most dramatic. I chose a low viewpoint for these office blocks in Canary Wharf, London, to emphasize their height, and converted the picture to black-and-white on the computer.
> Canon EOS 1DS, 21mm lens, 1/125 sec, f/11.

In any urban environment, it seems that as soon as a business closes down its frontage becomes covered in advertising posters. I took this very colourful shot in Hong Kong as part of a series of similar views that I am compiling.
> Canon EOS 1DS, 100mm lens, 1/250 sec, f/2.8.

I chose a medium telephoto lens to show the two contrasting sides of housing in Rio de Janeiro. It has brought the more affluent background closer, juxtaposing it with the *favela* in the foreground.
> Canon EOS 1DS MK2, 150mm lens, 1/160 sec, f/8.

## Lenses for urban photography

I have a tendency to favour longer lenses over wide-angle ones for urban photography, although that doesn't mean I don't include one of the latter in my kit. With a longer lens, I find that I can fill the frame and create the illusion of bringing the background closer and compressing the picture, so that the distance between foreground and background appears reduced. I often use a 70-200mm lens for urban shots to give me flexibility, and sometimes I increase the maximum focal length to 400mm with a 2× extender, although this does mean that the maximum aperture is reduced from f/2.8 to f/5.6. The zoom lens and extender are much easier and lighter to carry around than an additional 400mm lens, which would definitely need a tripod to keep it steady.

See also:
**Lenses** pp.19-25
**Lens extenders** pp. 26-7
**ISO (sensitivity)** pp. 37-8
**Viewpoint** pp. 56-7
**Depth of field** pp. 66-7

# Nature

# Plants and flowers

Plants and flowers do not have to be exotic and rare to make great pictures. In fact, those growing in your own garden, window box or flower pot, even cut flowers from the florist, can create marvellous images. There are also no hard-and-fast rules about equipment – the shots on these pages were taken with lenses ranging from fisheye to telephoto.

## Shooting outdoors

There are certain points you need to consider when shooting plants and flowers outdoors. You may want to stop the lens right down to get as much depth of field as possible. As this will mean a slower shutter speed, you might need a tripod.

Even in a light wind, plants are unlikely to stay completely still, resulting in a blurred image. To 'freeze' this movement, the shutter speed may have to be at least 1/250 sec but this, in turn, may mean that you won't be able to stop down as much as you'd like, reducing your depth of field. This isn't such a drawback as you might think. All lenses have an aperture that gives optimum sharpness but this isn't necessarily the smallest one available. The smaller the aperture, the more the light 'bends' as it passes through the lens, and the more it bends, the less sharp the shot. So, although there might be more overall in focus at smaller apertures – greater depth of field – the focus will not be as crisp at the point on which the lens is focused as it would at a wider aperture.

Be on the lookout for large expanses of wild flowers, such as these woodland bluebells. Their delicate flowers are quickly trampled on and their lifespan is quite short, so you should take such shots at the earliest opportunity.
> Canon EOS 1DS MK2, 120mm lens, 1/50 sec, f/8.

*Above:* Shooting this crocus with the sun backlighting the petals intensified their purple colour, which shows up well against the mottled green background. The narrow depth of field was created using a telephoto lens combined with a wide aperture.
> Canon EOS 1DS MK2, 200mm lens, 1/400 sec, f/2.8.

I took this shot of wild garlic with a fisheye lens. It is just possible to make out the curvature created by the lens in the background. The flower was only 10cm (4in) away from the lens.
> Canon EOS 1DS MK2, 15mm lens, 1/1650 sec, f/2.8.

To get in really close to your subject, you will need either to fit an extension tube or use a macro lens, which enables you to focus close enough to provide life-size images. If you're planning to specialize in photographing plants and flowers, investing in both of these pieces of equipment will be worthwhile.

Make sure that you don't cast your own, or the camera's, shadow over the subject by choosing your viewpoint carefully. I prefer to shoot on bright but overcast days when the light is even and there are no shadows – on really sunny days, shadows are too harsh. Also, watch out for shadows cast by surrounding plants or flowers. You may need to bend them out of the way rather than alter your viewpoint.

Shooting with the sun behind a flower, when the light highlights the petals and creates an aura around them, might be beneficial. If you take this approach, you can either expose for the highlights of the petals, which will underexpose the background, or use a reflector to throw light back onto the flower. The reflector needs to be neutral, such as white or silver – a gold one will create a colour cast that will alter the colour of the flower. With backlighting, you need to be alert to light entering the lens, which can create flare. In some situations, though, this might be desirable, creating a romantic atmosphere.

**I am always on the lookout for additional natural phenomena in my shots of plants and flowers, such as droplets of water. To get in this close, I used a No. 2 extension tube fitted between the camera body and the lens.**
> Canon EOS 1DS MK2, 50mm lens, 1/50 sec, f/8.

## Shooting indoors

Another way to photograph plants or flowers is to move them indoors and light them with available light or with flash. The white tulips on pages 2–3, for example, were lit with the sun coming in through a window behind them. Having chosen the viewpoint, I then positioned a white card reflector between the camera and the tulips, and 'bounced' light back onto the flowers. This has created a very high key picture, which means that the tonal range is at the light end of the scale, with the focus centred on just the edge of one flower. I used a 70mm lens and set the aperture at f/8 with a 1/15 sec shutter speed. Shooting indoors meant that I didn't have to worry about the flowers moving in the wind, and I could also position them exactly where I wanted.

I always use studio flash to shoot flowers in artificial light – it gives me complete control over the lighting, which I can position and direct exactly as I please. To take the indoor shots shown on this page, I deliberately kept the light as diffused as possible. I fitted a softbox to the flash head, which emulates sunlight on a hazy day, and positioned it behind the flowers so that they were backlit. I then placed a white reflector on either side and another between the camera and the flowers.

I had the florist arrange these tulips so that they appeared to spread from the centre of the frame. I then placed them directly under the camera mounted on a tripod, and took the shot from above.
> Canon EOS 1DS, 24mm lens, 1/60 sec, f/16.

Flowers make exquisite close-up photographs but they need to be lit very carefully. Make sure the petals don't cast ugly shadows over one another. The same goes for you and your equipment.
> Canon EOS 1DS, 24mm lens, 1/60 sec, f/16.

## See also:

**Lenses** pp. 19–25
**Extension tubes** p. 27
**Studio flash** pp. 118–19
**Reflectors** pp. 184–5
**Close-ups** pp. 198–201

# Wild animals and birds

The DSLR system is so well served with a large selection of telephoto lenses that it is particularly suited to photographing wild animals. Even the most modest lens is capable of getting you in close to the biggest cat or the most timid bird.

## Lenses and budget

Unless you intend specializing in this type of photography, you are probably better off buying a modest telephoto lens, such as a 200mm, or a zoom lens that extends to 200mm. The addition of a 2× extender will increase the focal length to a maximum of 400mm. This is pretty powerful by any standard, and will bring animals that are several metres away close enough to fill the frame. It is important to remember that with any extender you lose speed: an f/2.8 lens will become f/5.6, while an f/4 lens will become f/8. This is why I always recommend buying the fastest, albeit most expensive, lens you can afford.

If you do decide to specialize in this type of photography, you might want to consider an ultra telephoto lens, such as a 400mm. They can be as fast as f/2.8, and the optics are superb. An extender can still be added, so a 2× will, in effect, give you a lens with a massive 800mm focal length.

**Patience is vital when photographing wild animals. I had set up my camera on a tripod and trained it on this alligator. After observing it for about 20 minutes, it suddenly did the most enormous yawn, which made the shot.**
> Canon EOS 1DS, 250mm lens, 1/1250 sec, f/6.3.

Although I used a modest 200mm lens to photograph this leopard in a safari park, I was still able to get in close.
> Canon EOS 1DS, 200mm lens, 1/400 sec, f/4.

Even close to home wild animals and birds flourish. I photographed this cygnet while walking along a river not far from my home in London. This is just one example of why it always pays to carry your camera with you at all times.
> Canon EOS 1DS, 70mm lens, 1/250 sec, f/8.

There are two drawbacks, though, to lenses with such long focal lengths: the cost, which runs into thousands, and the weight. It is virtually impossible to hand-hold them steady, and you will either have to use a tripod or monopod - the latter should be adequate and is a much lighter option. Bear in mind that the addition of such a lens to the rest of your kit will make it a heavy and cumbersome load. Of course, on a safari, you are likely to be in a four-wheel drive, but if you are trekking, it's unlikely you'll be able to cover a lot of ground.

## Locations

Even if you cannot afford something as exotic as an African safari, there are safari parks closer to home, which are a great alternative and not to be compared to zoos, where most of the animals are caged. Remember, though, that wherever you are photographing, the animals are wild and unpredictable, so be cautious when in close proximity to them.

See also:
**Lenses** pp. 19–25
**Accessories** pp. 26–31
**Focal lengths** p. 67

# Pets and domestic animals

Photographing pets and domestic animals should be easier than shooting their wild relatives because you are more familiar with their temperaments and habits. You should also be able to get in closer without the fear of being attacked!

## Automatic programs

All animals can be unpredictable, though, so, in order not to be caught unawares, it is a good idea to set your camera to one of its automatic programs, such as shutter priority, which allows you to select the shutter speed while the camera automatically sets the aperture. This means that you can concentrate on the animal's movements without worrying that you have the correct settings. Of course, if there is not enough light, even when the camera chooses the widest aperture, you will either have to select a slower shutter speed or increase the ISO to a higher rating. Whenever I have the camera set to one of its auto modes, I always do a small series of test shots first. This is because I often find it necessary to fine tune what the camera predicts and have to use the compensation adjustment, 1/3 of a stop either over or under.

### Professional tips

- Try to photograph smaller animals from a low viewpoint or vary your viewpoint, otherwise you will have a boring series of shots that all look down on the animal.

- Remember that the depth of field when you get in close will be at a minimum, even when the lens is stopped down, so that if you focus on a cat's nose, for instance, the eyes may be out of focus.

- When you are shooting at close quarters, even an animal you are familiar with may become irritated by your presence and lash out or bite your hand.

**Caution is needed when photographing animals with their young, even if they are familiar to you. This mare was very wary of my intentions and instinctively kept her foal at a distance.**
> Canon EOS 1DS, 150mm lens, 1/250 sec, f/8.

To get in really close to this cat without upsetting her, I used a No. 2 extension tube. Being so close has reduced the depth of field so that only half of her face is in focus.
> Canon EOS 1DS MK2, 70mm lens, 1/100 sec, f/5.6.

*Below:* I kept my distance from this dog so that I could include its body, which I made sure was slightly out of focus. This places the emphasis on its face and unusual green eyes.
> Canon EOS 1DS, 70mm lens, 1/100 sec, f/11.

## Lenses and light

Most of the time I use my 24–70mm zoom lens to photograph pets and domestic animals. It gives me the choice of either getting in close to the subject or pulling back for a wider shot. It also works very well with extension tubes, which allow me to get in even closer. I prefer to work in available light, and avoid flash as much as possible because it can upset animals, making them more unpredictable than usual.

See also:
**Lenses** pp. 19–25
**ISO (sensitivity)** pp. 37–8
**The shutter** pp. 68–9
**Close-ups** pp. 198–201

# People

# Portraits: outdoors

The human face and body are probably the most popular subject for photographers. Although the majority of outdoor portraits will be of people you know, you'll probably also shoot complete strangers, especially if you are travelling abroad.

## Useful kit

A medium telephoto lens – anything between 70 and 200mm – is ideal for outdoor portraits, whether they're headshots or full-length portraits. With it, you can get in close and fill the frame and, if you are using a wide aperture, you can put the background out of focus, too, so that the emphasis is firmly on your subject. For candid shots, a 200mm lens is perfect.

You can take excellent portraits with lenses of other focal lengths but it is only by experimenting with a range of different lenses that you will arrive at a choice that suits your particular style of photography. Extension tubes are also useful. Combined with a 100–150mm lens, they enable you to get in really close but not physically close so that you risk casting your shadow over the subject.

A reflector or flashgun allows you to direct light to the face, soften shadows that might be heavy around the eyes and under the nose and chin, and alter the quality of light by making it cooler or warmer. Of the

*Far left:* **In this shot, the face of the traditional Thai dancer is in too much shadow and her costume appears rather dull.**

*Left:* **To rectify this, I asked her to hold a reflector silver side up and out of frame and angle it according to my instructions. I could see its effect on the lighting immediately, which wouldn't have been possible with flash. Her costume is now evenly lit and more colourful. The shadows have been lifted from her face, the skin tones are more pleasing and the reflector has been caught in her pupils, giving an additional sparkle to her eyes.**
> Canon EOS 1DS, 50mm lens, 1/320 sec, f/2.8.

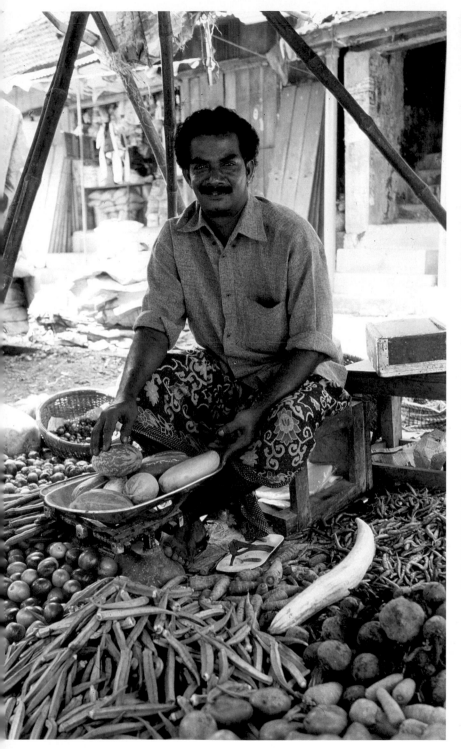

*Above*: I felt that there was too much clutter in this shot of a Madras market, such as the roof canopy and vendor in the background, and that the framing could be improved.

*Left*: By zooming in and tightening the image, I cropped the background vendor, roof and some of the foreground produce out of the shot. My subject is now undeniably the centre of attention and doesn't look so lost in the frame. He was delighted to have his picture taken and insisted that I accept a banana.
> Canon EOS 1DS, 50mm lens, 1/100 sec, f/8.

Although a 400mm telephoto lens combined with a wide aperture may seem an extreme choice for a portrait, it has produced a flattering shot with a bright yet muted background. I used a monopod to help support the weight of the camera and lens.
> Canon EOS 1DS MK2, 400mm lens, 1/50 sec, f/5.6.

Sometimes a face is so strong that it just has to be photographed. This 90-year-old woman was full of vitality and needed very little posing or instruction. The muted colours of the background and her clothes help to highlight her features.
> Canon EOS 1DS, 50mm lens, 1/1000 sec, f/4.5.

two, I prefer the reflector, and always have one folded up in my kit bag. It has a silver side for a cool light and a gold side for a warmer effect. With flash, try not to overlight the subject, as the result will appear unnatural.

## Positioning your subject

Daylight is not as easy to work in as you might think. One reason for this is that you can't move it like you can studio lights, so you need to position your subject very carefully. When you start shooting, take a good look at how the light is falling on the face and if there are any harsh shadows. If the contrast is too great, consider moving your subject to an area of overall shade, or turn them around so that they are backlit. Although backlit portraits can create an attractive halo of light on the hair, be careful that the light doesn't cause flare by shining directly into

the lens – even a lens hood or shield doesn't always prevent this. Shadows, such as those created by a parasol, can cause uneven illumination that will ruin your portrait. The solution may be as simple as moving your subject or changing your viewpoint slightly. If your subject is backlit, take your exposure reading for the shadow area.

## Photographing strangers

In an unfamiliar place abroad, you may grab the first shot you can of a stranger and quickly move on, probably because you're unsure of their reaction to being photographed and too shy to ask for permission. Most people would be flattered, though, by such a request and be much more co-operative than if they catch you trying to photograph them unawares.

## Calculating exposure

As DSLR cameras come with a built-in metering system, it should be quite easy to take a selective reading from the subject's face using the spot or partial metering method. Even though these systems are sophisticated, many professional photographers still use a hand-held meter for readings. With these you can use the incident light reading method, where you read the light falling on the subject, which is extremely accurate. A built-in metering system, on the other hand, calculates the exposure with the reflective light reading method, where you read the light reflecting off your subject, which isn't so precise. Although there are accessories that fit over the camera's lens to emulate the incident light method, they are fiddly and time-consuming to use. Your money would be better spent on a modest hand-held meter.

Backlighting can produce a soft halo on the hair. In this shot, I turned the subject so that the late afternoon sun was directly behind her. I then used a white reflector to bounce light back onto her face, which has created a very evenly lit portrait.
> Canon EOS 1DS, 200mm lens, 1/125 sec, f/5.6.

A low viewpoint accentuates the height of this model, making her legs appear particularly long. The railings lead the eye into the shot, while the building behind serves as a backdrop. Since the sun was slightly behind the subject, I used a hand-held meter and an incident light reading to calculate the exposure.
> Canon EOS 1DS, 50mm lens, 1/125 sec, f/3.5.

See also:

**Flare** p. 21
**Accessories** pp. 26–31
**Exposure** pp. 44–5
**Viewpoint** pp. 56–7
**Portraits: indoors** pp. 114–17
**Fill-in flash** pp. 182–3
**Reflectors** pp. 184–5

# Portraits: indoors

There are a range of different light sources for indoor portraits, including available daylight, flash, reflected light and candlelight. As much of the information given for photographing the nude indoors also applies here, please also refer to pages 126–9.

## Available daylight

Window daylight is my favourite indoor light source for portraits because it produces the most natural effects. However, it is changeable and does need to be managed effectively, which takes practice.

**Professional tips**

- Have a range of reflectors to hand and experiment with their effects.

- Long exposures might increase the level of noise – select the noise reduction function before you shoot.

- If using flash, try to diffuse or bounce it to lessen the harshness of the light.

- Have muslin, tracing paper or some other translucent material available to soften the shadows when using daylight through a window.

- Select the camera's white balance (WB) carefully; avoid using auto white balance (AWB), which can neutralize the ambience.

I kept the light coming through a window as directional as possible to create strong but acceptable shadows on one side of the face. Shooting in black and white meant that I didn't have to worry about colour casts caused by the very reflective piano cover.
> Canon EOS 1DS MK2, 70mm lens, 1/160 sec, f/2.8.

*Right:* A window, covered with muslin to diffuse the light, formed the background in this shot. The addition of two reflectors either side of her face and another under the chin has resulted in a very soft, flattering portrait.
> Canon EOS 1DS MK2, 140mm lens, 1/40 sec, f/2.8.

*Top:* For this first portrait, I used a combination of flash and daylight. Although the shot is perfectly acceptable, the lighting is a little too hard.

*Above:* The second shot, taken in only daylight with muslin at the window to soften the light, is a much more alluring portrait. I exposed for the skin tones of the face, which has slightly burnt out the hair, but not to the detriment of the picture.
> Canon EOS 1DS MK2, 50mm lens, 1/60 sec, f/4.

If your subject is seated near a window, take time to observe the quality of the light coming into the room. If the light is harsh, you could diffuse it by covering the window with a translucent material such as muslin. This will even out the light and remove any strong shadows, but the light will still be directional. If the light is still too bright on the window side of the face, you can introduce a reflector to bounce light back into the shadows.

On the other hand, if the sun, even though bright, is not coming directly through the window, the light will be softer and without any harsh shadows. This is the type of indirect light favoured by painters, who refer to it as a 'north light' and have their studios built with, typically, a large, single window that faces north. Of course, for the southern hemisphere, the opposite is true.

## Reflectors

If the light is still too bright on the window side of the face, even with a translucent covering such as muslin at the window, you can then introduce a reflector to bounce light back into the shadows. Look carefully at your subject and notice that the nearer you move the reflector to them, the more the shadows are reduced, while the further away it is placed, the less it 'fills in' the shadows.

Remember that if you are shooting in colour, the reflector might create a colour cast, unless it is pure white or silver (the silver side gives a cooler light than the white), and you will need to adjust the white balance. Custom-made reflectors are very portable and fold up into a small package. Normally they are supplied with a double-sided covering, so that you have the choice of either white and silver, or white and gold, or many other reflective surfaces. Reflectors can be made out of anything, though, such as a piece of white card or paper, a bed sheet, even kitchen foil stretched over a board. For a really soft light, you might want to use more than one reflector, perhaps positioning one to the side of the face and one under the chin.

I wanted this man and the background to be equally sharp because the wall, covered in family pictures from several different generations, was an integral part of the shot. I lit him by daylight coming in through a doorway and then placed a large white reflector to bounce light back into the shadows. As the light was still low, I rated the ISO at 1250.
> Canon EOS 1DS MK2, 35mm lens, 1/40 sec, f/2.8.

## Artificial light

For domestic tungsten lighting, you will need to adjust the camera's white balance (WB), otherwise your shots will come out with a distinctly orange cast. Change the Kelvin (K) setting to 3500K or adjust the WB to AWB (auto white balance). Except in exceptional circumstances, I avoid the AWB setting because it can 'neutralize' the light to such an extent that all the ambience is lost. Whatever the setting, always check the LCD and the histogram.

The other common type of domestic lighting is fluorescent, which creates a greenish cast if the WB is set on daylight. There are so many different types of fluorescent light that it is impossible to set hard-and-fast rules about which setting to use – trial and error alone can guide you.

## Flash

Most people when they start shooting indoor portraits opt for flash if there is insufficient natural light. However, flash is never my first choice for the reason that the majority of flashguns are too underpowered and the light that they produce is too harsh. However, if for some reason using flash is unavoidable, I always try to 'bounce' it off another surface, such as a white ceiling or wall. This creates a far softer light than direct flash but the downside is that it can cause deep shadows in the eye sockets and under the chin. A flashgun with a smaller flash under the main flash to act as a fill-in does go some way to eradicate this problem, although I find that placing a small reflector under the chin at about chest height does the job much better. As with daylight, any reflector used with flash creates a colour cast unless it is pure white, so you will need to adjust the white balance.

## Mixed lighting

If you are working with mixed lighting indoors, then choosing the WB can be problematic. This is where I might rely on the camera's AWB or I might go for the strongest light. For example, if it's a choice between daylight and tungsten, I would ascertain which of these is the dominant source. If the daylight is the stronger, then I would try to frame my shot tightly, thereby reducing the area that will be lit by tungsten light, which would come out with a distinctly orange cast. On the other hand, if you go for the tungsten light and there is a window included in your shot, this will come out blue.

In either case, these types of cast can be made to work to your advantage and create a stronger ambience by adding warmth or coolness to your shot. Of course, if you are shooting in black-and-white, you don't have to worry about the different colour temperatures of light.

This portrait taken in a Moscow apartment was lit entirely with available light without reflectors. The pink-coloured wall to my right was light enough to soften the shadows and it also blended in with the man's flesh tones.
> Canon EOS 1DS MK2, 50mm lens, 1/30 sec, f/5.6.

## See also:
**Flash** pp. 29–30
**ISO (sensitivity)** pp. 37–8
**White balance** pp. 38–9
**Kelvin scale** pp. 39–40
**Portraits: outdoors** pp. 110–13
**The body: indoors** pp. 126–9
**Reflectors** pp. 184–5

# Portraits: studio

Many people are daunted by the idea of taking portraits in a studio, primarily because they see it as a hugely complicated process requiring several years of experience to master. Nothing could be further from the truth and, in some ways, portraits are easier to shoot in a studio than in daylight.

## Studio flash

Without doubt, the most popular studio lighting is flash. Unlike the flash that fits into the camera's hotshoe or onto the side of the camera body, studio flash comes with a power pack and a separate head. The power pack is plugged into the mains and transforms the electricity into a

I used a single head fitted with a soft box for this shot, positioning it quite high to light the hair, and placed a large white reflector to the model's left. The background of black velvet has produced a richer tone than one of paper.
> Canon EOS 1DS MK2, 140mm lens, 1/30 sec, f/8.

**Professional tips**

- Invest in one power pack and one or two heads and stands to start with.

- Although these units are often referred to as studio flash, they are very portable so can be used away from a studio.

- Many manufacturers supply cases with their monoblocs, which can take up to three heads, reflectors, leads and accessories.

For these three pictures, I experimented with a single flash head but different attachments to illustrate how an image can be altered.

*Above left:* A beauty dish with a honeycomb placed over the reflector creates a very strong, harsh and directional light.

*Above centre:* Without changing the position of the light, I replaced the honeycomb with a diffuser. This has resulted in a softer light, with far more detail in the eyes and shadow areas.

*Above right:* Keeping the diffuser over the reflector, I added a white reflector under her chin, which has softened the light even more.
> Canon EOS 1DS MK2, 165mm lens, 1/60 sec, f/11.

powerful light. Studio flash also has a relatively low heat output, which makes for a comfortable working environment.

Normally you can plug several heads into one power pack. Some of these split the power equally between the different heads, while others allow you to vary the power through each one. Each head has a modelling light to give an indication of what the light will look like when the flash fires. They can be used at either full, low or proportional to simulate the output of the flash. Several units can be synchronized together and different lighting reflectors attached to the various heads.

Interesting effects can be produced by placing coloured gels over any of these heads, as well as using flags and reflectors or barn doors to control the spill of light or direct it to areas that need 'filling-in'. You can also create a range of different lighting effects with many various attachments, such as softboxes, umbrellas, satellite dishes, snoots, honeycombs and beauty dishes, to name just a few.

Studio flash units known as monoblocs come at the cheaper end of the range. These have the power pack built into the head. They have far less power than a unit with a separate pack and can't take the full range of reflectors and attachments just described.

## Continuous lighting

The advantage of continuous (HMI) lighting is that what you see is what you get. This means that you can direct the light precisely in the knowledge that this is how the lighting will look when you take your shot. Like flash, the lamps are balanced for daylight. The downside is

As I wanted as much detail as possible in this shot, I used several lights. The key light was to my right and angled down onto the face, with a fill-in light to the left. I used a light fitted with a snoot for the hair and placed another one quite low to my right, pointing up to the face.
> Canon EOS 1DS MK2, 100mm lens, 1/60 sec, f/11.

that continuous lighting is expensive, runs hot, uses lots of electricity, and will probably need a three phase supply. It also requires a heavy unit called a 'ballast', which takes the power from mains electricity and delivers it to the head to maintain a flicker-free light.

## Lighting set-up

For a really simple lighting set-up for a portrait, start with one light, called the key light, fitted with your chosen reflector. (Experience will show you what the different reflectors do: for example, a silver umbrella produces a harsher light than a softbox.) Having posed your model, place

the key light to the right of your camera position and angle it down slightly so that a shadow is formed between the nose and top lip.

Place another light – the fill-in light – to the left of the camera. This should be at a lower output than the key light because its function is to soften the shadow formed by the key light – what you don't want is a double shadow on the nose, which is what would happen if both lights were evenly spaced and on the same power. A similar effect can be created with a reflector.

Now you might want to add a hair light to give a sheen to the hair. The best way to do this is to fit the flash head to a boom. This is a lighting stand with a long counterweighted bar attached that allows the light to be suspended directly over your model without the stand getting in the way. Depending on how harsh or soft the overall desired effect, you can use other lights or reflectors. If you want a pure white background, you will need to light this, too. As well as reflectors, it is useful to have barn doors or black card to flag the light, that is, stop the light from going where you don't want it to go.

As you gain more experience, you will become more adventurous with how you use your studio lighting, making it more directional to create backlighting as well as rim lighting effects, where the light looks as though it is painted just along the outline of the face or body.

## Honing your skills

Of course, no one would buy all this kit without first understanding how to use it and seeing what it does. If you know a professional photographer, ask if you can assist them. Alternatively, hire an equipped studio and experiment – most large towns have these, and many provide tuition and models as well. You could also join a camera club or go on a course.

I wanted to keep the light very pure for this shot. I directed two heads on the background and put one, fitted with a soft box, on a boom so that it was just slightly above the model's head and angled downwards. I then placed a reflector on each side and one under the chin. This has given a very soft and shadowless light.
> Canon EOS 1DS MK2, 120mm lens, 1/60 sec, f/8.

For this shot, I pointed two lights at the background and then placed two large reflectors either side of the model to bounce light back onto her. This has created two highlights on either side of her face and kept the overall appearance of the shot quite soft.
> Canon EOS 1DS MK2, 150mm lens, 1/60 sec, f/11.

See also:
**Portraits: indoors** pp. 114–17
**Reflectors** pp. 184–5

# Children: indoors

Getting children to relax in front of the camera requires enormous patience. If you are not prepared to give the amount of time that might be necessary to achieve this, then you're not going to get the best and most natural shots.

## Planning your shots

Children are usually very lively and won't want to stay in one place for too long, so it's best to think ahead about the kind of shot you want to take. For instance, if you are working with available light, you will need to use as fast a shutter speed as possible to capture any movement the child might make. Failure to do so might result in an unacceptably blurred picture. To this end, think about increasing the ISO, which will enable you to work with a fast shutter speed. If you combine this with a fast lens and use the widest possible aperture, you should be able to shoot in any situation.

## Natural and artificial light

When shooting in available light, take time to observe it properly. If it is daylight coming in through a window, make sure that it is not too harsh and that the glazing bars, for example, don't create strong shadows. If you're shooting in artificial light, such as tungsten, remember to set your camera's white balance accordingly. If you don't, all your shots will end up with an orange cast; in fluorescent light, they will have a green cast.

Black velvet created a rich and even background. A flash to the left was directed at right angles to the background and my camera viewpoint; a large white reflector to the right bounced light back onto the child. The power of the flash and its quick recycling time made it possible to shoot rapidly.
> Canon EOS 1DS, 70mm lens, 1/60 sec, f/8, 200 ISO.

For this simple set-up, one flash was directed towards the white background and another, with a softbox attached, was fixed to a boom. This meant that I could work close to the light source but unhindered. I sat the child on a white sheet to bounce as much light back up as possible.
> Canon EOS 1DS, 70mm lens, 1/60 sec, f/22, 100 ISO.

*Below:* A wide aperture helps keep the background blurred, so that the focus of attention is on the child. The exposure was taken from the shadow side of the face. While the highlights are quite strong, they give a nice amount of modelling.
> Canon EOS 1DS MK2, 200mm lens, 1/200 sec, f/2.8, 100 ISO.

## Flash photography

As mentioned on page 117, when using flash, think about bouncing it off a white surface, such as a ceiling or wall, instead of using direct flash. This will create a softer light, but make sure that it doesn't create dark shadows under the eyes and chin. Some flashguns have a small additional flash underneath the main one to act as a 'fill-in' for softening any shadows. Alternatively, place a small white reflector under the chin.

See also:
**Flash** pp. 29–30, 182–3
**ISO (sensitivity)** pp. 37–8
**Portraits: indoors** pp. 114–17
**Portraits: studio** pp. 118–21
**Children: outdoors** pp. 124–5

# Children: outdoors

As with photographing children indoors, shooting them outdoors in familiar places has distinct advantages, but there are additional issues that have to be taken into consideration. Some of the information given for outdoor portraits is also applicable here, so please also refer to pages 110–13.

## Working in sunlight

In familiar surroundings, children outdoors will quickly take up their favourite pursuits, such as climbing trees, and not be too concerned by you and your camera. Bright sunlight can be a problem, though, and you will need to keep an eye open for harsh shadows that might ruin an otherwise great shot. Once children are absorbed in whatever activity takes their fancy – and remember, that probably won't be for long – take stock of the light. If the child is predominantly backlit, check whether the face is in too much shadow or the light is creating too much flare. If this is the case, decide whether you can move him without disrupting his play to an area that is more evenly lit. Alternatively, it might be best if you used a reflector or fill-in flash.

Mottled light filtered through the branches of a tree can create attractive patterns and pools of light on the skin. However, if these pools of light are falling on the wrong part of the face, they can create ugly highlights. Of course, children are not going to keep still, so in a situation

### Professional tips

- Children tire quickly so photograph them as fast as you can.

- Using a low viewpoint to get down to the child's level can create very interesting shots.

- Break down the inhibitions of older children by involving them in your photography, such as letting them hold your camera.

- Use a fast shutter speed to freeze movement and a large aperture to blur the background to prevent it being a distraction.

*Far left:* **The mottled light falls in an unattractive way on the child's face, almost burning out the detail of her eye.**

*Left:* **By shifting to a slightly higher viewpoint and to the left, I have kept the mottled lighting effect but the pools of light now fall in a more appealing way.**
> Canon EOS 1DS, 70mm lens, 1/100 sec, f/5.

I chose to backlight this boy on his bicycle, which has resulted in a pleasant highlight on his hair. A white reflector has bounced light back into his face, creating two highlights in his eyes.
> Canon EOS 1DS MK2, 115mm lens, 1/640 sec, f/2.8.

like this you will need to keep one eye on them and one on the light in order to get the best possible shot! The benefit of shooting with a DSLR is that you are looking at the children through the lens, so there can be no discrepancy between what you see in the viewfinder and what the lens sees, as is the case with a compact camera.

## Reflectors

Backlight produces a pleasant halo of light in the hair but if it is strong, your subject could come out as a silhouette or very dark. In such a situation, you can use a reflector to bounce light back onto the face. As it might be difficult to position the reflector in the right spot if the child is moving, it would be useful to have someone to hold it for you. The effect produced by a reflector appears more natural than fill-in flash.

## Candid shots

When shooting outdoors, a telephoto lens will help you to get in close without intimidating the child or making him feel self-conscious. By observing the child from a reasonable distance you'll be able to get candid rather than posed pictures. A 70-200mm lens is the perfect zoom for this type of photography.

For this relaxed portrait, I used a children's play house as a prop. The girl was leaning through the window, which made a natural frame to the picture. The yellow walls contrast well with the colour of her clothes.
> Canon EOS 1DS MK2, 145mm lens, 1/250 sec, f/3.2.

See also:
**Lenses** pp. 19–25
**Children: indoors** pp. 122–3
**Reflectors** pp. 184–5

# The body: indoors

Getting the lighting and the pose of your model right are crucial. Much of the advice given for indoor and studio portraits is applicable here, so please also refer back to pages 114–21.

## Advantages of shooting indoors

Indoors, you have the option of different lighting set-ups. Apart from available light, either daylight or artificial, you can also use flash or continuous lighting. You also have complete privacy, the temperature can be controlled and all your props are to hand.

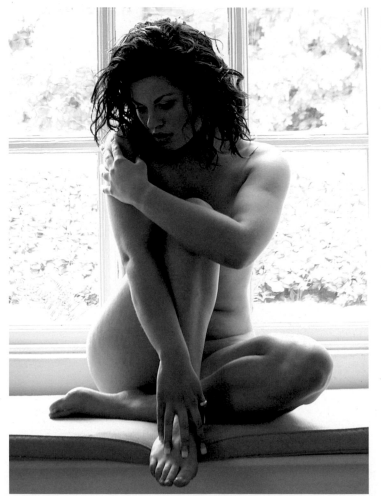

### Professional tips

- Know in advance the type of shots you wish to take, and get your equipment ready before your model arrives.

- Make sure that the environment is completely private and a comfortable temperature. Have plenty of refreshments available.

- Advise your model to wear loose clothing to the session; tight clothes mark the skin and can take hours to fade.

- Always have a range of reflectors with different surfaces to hand.

With the model posed on the window seat so that she was entirely backlit, I then placed two large reflectors either side of her to bounce light back onto her body. To keep the soft feel, I deliberately overexposed the background.
> Canon EOS 1DS MK2, 48mm lens, 1/4 sec, f/5.6.

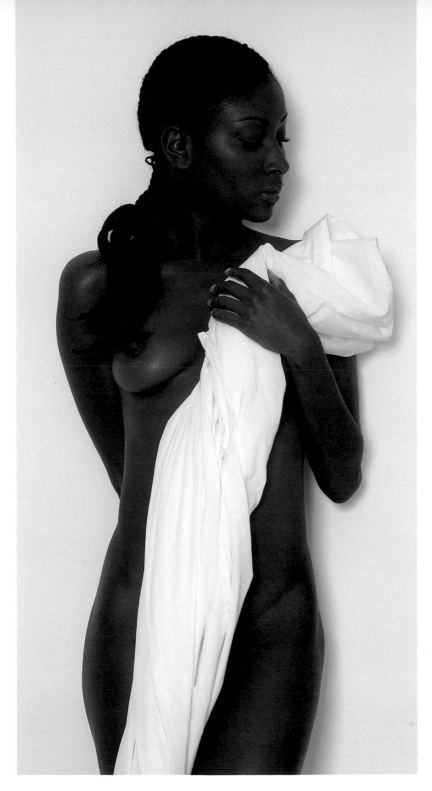

I used a studio flash unit fitted with a satellite dish for this shot and placed it to the left of the model. The harshness of the light has been softened by a white reflector positioned to her right.
> Canon EOS 1DS MK2, 70mm lens, 1/60 sec, f/11.

*Left:* I positioned just one studio light coming from the left-hand side and then used several reflectors to bounce light back carefully onto the model. A flag shielded light from the background so that it graduated to black.
> Canon EOS 1DS MK2, 200mm lens, 1/60 sec, f/11.

After positioning my model, I surrounded her with candles. I had the camera mounted on a tripod, so it was easy to adjust their position and refer back to the viewfinder. A small amount of fill-in flash completed the lighting set-up.
> Canon EOS 1DS MK2, 170mm lens, 1/2 sec, f/16.

## Lighting

When shooting in available light, have a selection of reflectors to hand, as they might be necessary to reflect light back into the shadows. Different surfaces – white, gold, bronze and silver, for example – will alter the quality of the light reflected back, and gold and bronze will create a definite colour cast on the skin. Remember that daylight at the beginning and end of the day is 'warmer' than at midday.

Candlelight is particularly suited to nude photography, creating an evocative warm cast. As you will need to shoot at quite slow shutter speeds, use a tripod. Make sure that your subject can hold the pose, otherwise the results will be blurred. I find that 1/8 sec will record the flame of a candle correctly if you are combining it with flash.

With flash, you have complete control over your lighting and are not at the mercy of daylight hours. This means that you can do quite a lot of setting up before your model arrives, saving on shooting time and model fees. Flash units either fit on the camera's hotshoe or on a bracket on the side of the camera. Many of them have a 'slave' facility whereby you can synchronize a number of units to go off at the same time.

Studio flash is more powerful than these units but still portable. It is probably the most popular light for indoors and relatively inexpensive to

buy and to run. It also gives you the flexibility of different lighting effects using various attachments and coloured gels. As the lights don't run too hot, the environment will be more comfortable for your model. Both types of flash are balanced to daylight, so can be used together.

Continuous lighting is also balanced to daylight. Its great advantage is that how you direct your light is how it will look in your shot, but this can be outweighed by the price of the lamps as well as running costs.

## Posing

Look carefully each time your model adopts a new pose. Are there ugly folds of flesh that could be eliminated if the model just stretched a little one way or another? Make sure that the hands aren't hanging limply down by their sides. For a soft effect, use a soft focus filter over the lens or buy a soft focus lens. Alternatively, improvise by smearing petroleum jelly over a UV or skylight filter, but don't put it on the lens! If it's your first time photographing the body, it might help to have some tear sheets from magazines to refer to for ideas.

This and the shot below show how you can alter the ambience of a picture simply by changing the background. In both shots, the light is coming from a window directly behind the model, and two large reflectors placed either side of the camera bounce light back onto her body. The white sheet background has created a very high-key feel with the tonal range of the shot at the light end of the scale.
> Canon EOS 1DS MK2, 65mm lens, 1/5 sec, f/8.

A background of black velvet, which needed an increase in exposure, has created a more low-key picture.
> Canon EOS 1DS MK2, 65mm lens, 1/3 sec, f/8.

See also:
**Accessories** pp. 26–31
**Portraits: indoors** pp. 114–17
**Portraits: studio** pp. 118–21

# The body: outdoors

Photographing the body outdoors can present several problems that aren't evident when shooting indoors: unreliable weather, temperatures not conducive to posing naked, and changeable light. Then there is the possibility of prying eyes.

## Planning ahead

On location you can't suddenly put your hands on a different lens or a prop if you haven't brought them with you. At the same time, you can't carry everything you think you might need unless you have several assistants. It's therefore best to have a plan of the style of pictures that you intend to shoot and pack your kit accordingly. The essentials, other than camera body and lenses, are a couple of reflectors, flash, spare batteries, memory cards, a tripod, basic make-up kit and a towel. If you are going to shoot anything requiring special equipment, such as infrared, pack the appropriate filters. If you're shooting at or near the sea, have a couple of plastic bags to protect your camera and lenses from sand.

Research your location well beforehand so that you don't waste valuable shooting time searching for one on the day. Once you've made your choice, confirm that it is reasonably accessible – you don't want to have to clamber over rocks for several miles so that your model arrives exhausted before you've taken a single shot. If your shoot is abroad, find out the country's attitude to nude photography and respect it.

These shots are typical of how a session develops when I am photographing the body. Having developed a rapport with my model, she instinctively moves into different poses and positions as the shoot progresses. Her input is as vital as my direction.
> Canon EOS 1DS MK2, 145mm lens, 1/250 sec, f/6.3.

## On the day

Having arrived at your chosen location, run through the style and theme of your shoot. Talk to your model about the poses you'd like to help get the session off to a good start and not waste time. This will also help develop an understanding between you and your model. If you act as if you know what you want, it will give you an air of confidence and this, in turn, will help to give your model confidence. With such assurance, models usually start suggesting poses themselves; then you know you have established a rapport and the start of a good working relationship.

## Dealing with the light

If the sun is very bright, look carefully at your model to see whether there are any ugly shadows under the eyes and elsewhere. If there are, can you move the model to an area of overall shade? If not, can you turn the model around so that they are backlit? Backlight can be very flattering, and you don't always need a reflector or fill-in flash. When using a reflector, make sure that the light bounced back is appropriate for the model's skin tone. Remember that a gold reflector will create a colour cast, which must be even. Reflectors can be just as dazzling as direct sun, so careful positioning is vital if your model is not to screw up their eyes.

If you intend using fill-in flash, make sure that you are familiar with it before you start. Although many units come with the claim that they can calculate the required flash automatically, I often find that they are too powerful and overlight the scene. If this is the case, then shoot with the unit in manual mode and decrease the power by a couple of tenths until you get the right balance.

Although the low, late sun has created a lot of contrast, it emphasizes the model's body well. Using a wide-angle lens with a low viewpoint has also contributed to the model's strong presence.
> Canon EOS 1DS, 28mm lens, 1/250 sec, f/7.

I was particularly attracted to the colour of these rocks and the model's skin tone – at first glance, he could be mistaken for a boulder in the rock formation. The peaks of the rocks make interesting shapes that are echoed by his pose.

> Canon EOS 1DS, 70mm lens, 1/320 sec, f/11.

## See also:

**Accessories** pp. 26–31
**Water** pp. 86–9
**Portraits: outdoors** pp. 110–13
**The body: indoors** pp. 126–9
**Fill-in flash** pp. 182–3
**Reflectors** pp. 184–5
**Infrared** pp. 186–9

# Events

Few of us live such ascetic lives that we never take part in an event, perhaps a birthday party, wedding, carnival or religious festival. As a photographer, you will want to capture the essence of the event, its size and the isolated details that make up the pleasure of the experience.

## Be prepared

For a large public event, such as a carnival or music festival, first of all consider your security. Keep all the kit that you are not using securely hidden away. This is especially true if you are using a backpack. If you can, fasten the zips with a lock. Alternatively, wear the backpack on your chest, so that you can keep an eye on it at all times. Worn in this way, the pack also gives you ready access to additional lenses and equipment that you might need. If you're shooting with a long lens, you're hardly likely to set up a tripod in the middle of hundreds of people, so use the backpack as a brace and rest for the camera.

**For this shot of the carnival in Rio de Janeiro, I was fortunate to be close to the action and could use a 24mm wide-angle lens to capture this dancer. The fairly slow shutter speed blurred the image just enough to demonstrate the exuberance and movement of the occasion.**
> Canon EOS 1DS MK2, 24mm lens, 1/30 sec, f/2.8.

To convey the speed at which these carnival dancers were moving, I found somewhere I could brace the camera and used a very slow shutter speed. I reviewed the shots regularly to make sure that they weren't so blurred as to be unreadable.
> Canon EOS 1DS MK2, 150mm lens, 1/12 sec, f/11.

## Capturing the moment

I am always on the lookout for the spectacular - something to fill the frame with a blaze of colour and really sum up the extravagance of the event. I tend to take such shots with a telephoto lens, which allows me to get in close and fill the frame. Being jostled in the crowd is inevitable, which makes a lens with an image stabilization facility a distinct advantage. Since many carnivals happen at night, you can always increase the ISO to a higher rating to compensate for the low light levels, or open up the aperture so that you can increase the shutter speed.

An interesting face in the crowd - someone who is completely absorbed in the whole experience - is another attraction for me.

To compensate for the low light levels for this night-time shot of the carnival, I rated the ISO at 400. With a 200mm lens, I could get in close and fill the frame with a shot vibrant with colour and pattern.
> Canon EOS 1DS MK2, 200mm lens, 1/50 sec, f/2.8.

Depending on how close you are to the action, a medium telephoto is probably the best for this kind of shot, although I have had excellent results with a wide-angle lens. With a carnival, for example, much of the action takes place so quickly that you need to be on the alert, but as one float or troupe usually follows a similar route to another, you can generally be prepared and in position when your subject matter passes by. For the candid shot, you also need to be ready to shoot in an instant. Make the most of the crowd, letting it give you a certain amount of cover, so that your subject is unaware of your photographing them.

## Formal events

There is generally an official photographer at formal events like weddings, which can work to your advantage – as a guest, you'll be able to take pictures that they wouldn't consider. Distance yourself from official photographers – they have a job to do and it's important not to get in their way, but also there's no point taking the same shots as them. Look for the different angle and viewpoint. Remember that when official photographers are taking group pictures, they are probably doing it from eye level, so ask yourself what you could do from a high or low viewpoint. Observe the position from which other guests are taking their pictures and try to find the reverse angle. This can often result in unusual but very attractive shots.

At huge public events like Trooping the Colour in London, I am always on the lookout for candid pictures. I noticed this scene through the crowd and thought that the policeman deep in thought made an excellent contrast with the back of the soldier in his bearskin.
> Canon EOS 1DS MK2, 150mm lens, 1/400 sec, f/2.8.

Make sure that you have a good position and are prepared for the finale, which in this case was a flyby of aircraft with coloured smoke trails over The Mall in London. You will get only one chance at a shot like this.
> Canon EOS 1DS MK2, 24mm lens, 1/320 sec, f/11.

At weddings, I always try to find a different angle from everyone else for my shots. I noticed the official photographer taking a shot of the bride and groom, and thought his body language lent humour to the event.
> Canon EOS 1DS, 70mm lens, 1/60 sec, f/5.

## See also:

**Lenses** pp. 19–25
**Camera bags** p. 31
**ISO (sensitivity)** pp. 37–8
**Viewpoint** pp. 56–7

# Architecture

# Buildings

Wherever we live, buildings form the common thread of our existence. What makes them such a rich subject for photography is their diversity, not only from one country to another but also from one part of town to another.

## Changing light

Many people tend to stop noticing local buildings that they walk by every day, assuming that they will always look the same. But, as a photographer, you know that the appearance of even the most familiar object alters according to the light: as the sun shifts its position on a daily basis, so the way in which the building is lit changes. Since most buildings are permanent fixtures, you have the opportunity of viewing them at different times of day and through the various seasons. If you put off shooting a particular building on a particular day, you can't be sure that it will look the same the following week. On the other hand, you can assess where the light might be at a later date and, weather permitting, plan your shoot for the time when the light is at its optimum.

In addition to the quality of the light, there is another reason for getting up early: other people can ruin your shots. I took this shot of a temple in Bangkok shortly after dawn, but a couple of hours later it was swarming with tourists and there wasn't a clear view of the temple to be had.
> Canon EOS 1DS, 24mm lens, 1/320 sec, f/16.

*Above*: The twilight hour, as it's known - about half an hour after sunset and lasting for about 20 minutes - is my favourite time for photographing buildings, such as these in downtown Miami, at night. Any later and the skies are too black, reproducing with an unattractive heaviness.
> Canon EOS 1DS MK2, 80mm lens, 1/40 sec, f/11.

*Left*: When shooting buildings, I try to find a viewpoint that sums up the environment. I chose this viewpoint in Canary Wharf, London, because I liked the way the curve of the bridge contrasted with the strong angularity of the buildings. Using a shift lens has removed the converging verticals.
> Canon EOS 1DS MK2, 24mm shift lens, 1/85 sec, f/22.

## Compressing distance

With a DSLR, you have the advantage of a wide range of lenses, which gives you great flexibility when shooting buildings. The picture of San Francisco on pages 138–9 shows what can be done with a 200mm telephoto lens. I chose my viewpoint in the original part of the city and framed it so that the old terrace of buildings was firmly in the foreground, with the financial district, or downtown, in the background. The distance between these two districts is probably about 9–11 kilometres (6–7 miles), but the lens, in compressing the picture, has created the illusion that they are much closer together. Remember that even a slight haze will be magnified by a telephoto lens, resulting in a quite murky background.

## Converging verticals

There are occasions when the only way to get all of a tall building in the frame is to tilt the camera upwards, but then the building starts to taper towards the top. This effect is known as converging verticals, which are

**Wild skies and directional sunlight can really enhance a shot, but quick reactions are essential. Here, the parliament building in Brasilia was soon in shadow as the storm clouds obscured the sun.**
> Canon EOS 1DS MK2, 40mm lens, 1/500 sec, f/8.

I wanted to emphasize this row of classical columns that forms part of the National Maritime Museum in Greenwich, London. I waited for the sun to move around the building so that it shone through the columns, casting long shadows. This has helped to give the picture depth, and added interest to the otherwise diffused lighting.
> Canon EOS 1DS MK2, 70mm lens, 1/250 sec, f/5.

even more apparent with a wide-angle lens. Converging verticals can add dynamism to shots of modern buildings but if it's an effect that you would like to avoid, use a shift lens to include the entire building and keep all the verticals true.

A shift lens is also useful if you are photographing a highly reflective building where you and your tripod are clearly visible in the shot. By moving to one side so that you are no longer reflected, you can use the shift facility in its horizontal mode to bring the building back to the centre of the frame but without you appearing in it.

I wanted to sum up the increasing modernity of Buenos Aires with this shot. By walking to the other side of the dock and changing my viewpoint, the tall, modern buildings formed a backdrop to the old, low-level warehouses.
> Canon EOS 1DS MK2, 24mm lens, 1/125 sec, f/8.

## Avoiding flare

Modern buildings that are highly reflective can cause flare to enter the lens, especially on bright days when the sun reflects back from the metal or glass surface. Normally a good lens hood or shade will prevent this from happening, but if it persists, you will have to change your viewpoint. Explore all the possibilities rather than let flare ruin the shot, especially as a suitable new viewpoint may be only a short distance away.

See also:
**Lenses** pp. 19–25
**Lens hoods** p. 26
**Viewpoint** pp. 56–7
**Shift and tilt lenses** pp. 176–9

# Interiors

Photographing interiors can be one of the most challenging subjects that you tackle with your DSLR, but don't let that put you off because it can also be one of the most rewarding.

## Ideal light

The challenge comes in making the most of the lighting you have with you and balancing it with the types of illumination already present, such as daylight, fluorescent, tungsten and flash, even candlelight.

For this unusual view of the atrium of the Blue Trees hotel in Brasilia, with three levels of floor extending up the sides of the shot, I used a 17mm wide-angle lens. As the tungsten light was minimal, I used the available daylight as the source.
> Canon EOS 1DS MK2, 17mm lens, 1/6 sec, f/6.5.

Probably the easiest type of light to work in when shooting interiors is available light, but this is not without its problems. For instance, imagine shooting the interior of a church and your viewpoint is looking straight down the aisle. On a bright day, there is a strong possibility that the sun will be shining through the windows on one side of the church, drenching one half of the church in harsh pools of light, while the opposite side is in shadow. I always try to take such shots on a bright but overcast day, so that the sunlight is diffused and the interior more evenly lit. Alternatively, I wait until midday to see whether the sun will be directly overhead, with both sides of the interior evenly lit.

## Colour balance

If the interior is lit by tungsten light, I always check whether I will have to supplement it with flash – this would be necessary for large areas of shadow. If the light is even, I would set the WB (white balance) to 3400 Kelvins (k) or choose the tungsten setting from the WB menu. In either case, I would do a test shot and make any necessary adjustments to the WB setting. If the exposure required was going to be a long one, I would select the long exposure setting from the menu.

Fluorescent light can be difficult to work with because there are so many different types of tube – white, warm white, cool, daylight and so on – that getting the right colour balance can be difficult. As with any interior photography, I would take a test shot and either have the WB on the fluorescent setting from the menu or use the AWB (automatic white

**To light the interior of this theatre in Buenos Aires I used every available house light. After several tests, I set the WB to 3550K, and selected a long exposure and the mirror up mode from the camera's menu.**
> Canon EOS 1DS MK2, 17mm lens, 5.2 secs, f/5.6.

**I always try to find a different angle when photographing interiors. For this view of the Painted Hall in Greenwich, London, the pillar acts as a visual tool, leading the eye into the shot. This adds drama to the composition and emphasizes the decorative ceiling.**
> Canon EOS 1DS MK2, 24mm lens, 1/25 sec, f/2.8.

balance). However, I have always found that while the AWB gives an adequate assessment of the correct colour balance, I always have to tweak it using the K setting.

When photographing stained glass, the most important light is that behind the glass – it is this light that gives you the detail. If, for example, the light outside isn't as bright as the light on the inside, the window will come out underexposed and without any detail. The only time that you should consider using flash is if you want to see the surrounding detail of the room that the window is set into. In this case, the calculation needs to be a perfect balance between ambient light – what is coming through the window – and flash – what is lighting the interior.

When an interior is lit by various sources, the trick is to get the right mix of the different light sources so that there is no colour cast. I would ascertain what will be the dominant light source. If, for example, the light sources are daylight, tungsten and flash, I would probably go with the daylight, as flash and daylight have the same colour balance, and set my WB accordingly. Although the tungsten might come out slightly warm, giving an orange cast, this can add ambience to the picture. If the tungsten is too warm, you could either use light balancing gels on the lights or change all the bulbs to blue daylight balanced bulbs. However,

**I took this shot with a hand-held camera while on an underground travelator. A slow shutter speed has created a degree of blur that is visible to the sides of the tunnel. I balanced the camera to the fluorescent light source.**
> Canon EOS 1DS, 17mm lens, 1/5 sec, f/2.8.

This shot for a hotel brochure is lit with a combination of flash, tungsten and daylight. It was important to include the view through the window but light the room at the same time. I used fill-in flash in the foreground and left the desk light on.
> Canon EOS 1DS, 17mm lens, 10 secs, f/16.

unless achieving this balance is absolutely critical, such an approach would be extreme. If, on the other hand, the dominant light source is tungsten and some fill-in flash was all that was needed, I would cover the flash head with a light balancing gel to balance it to the tungsten. For a dominant fluorescent light source, I would use the appropriate green gel over the flash to balance it with the fluorescent light. Again, I would always do some test shots to make sure I had the right balance.

In some cases, an interior might be so large that it's impossible to add enough light to achieve the right colour balance. For example, if the light is daylight filtering through windows of stained glass, the chances are that the interior will be bathed in the predominant colour of the glass. Provided that this cast created the right ambience, I would accept it rather than not take the shot at all.

See also:
**Lenses** pp. 19–25
**White balance** pp. 38–9
**Kelvin scale** pp. 39–40

# Architectural details

As well as being shot in their entirety, buildings also lend themselves to being photographed in detail. Even the most minimalist modern building can make great photographs and form the basis for stunning abstract shots.

## Getting in close

Photographing details of buildings can mean going in quite close, but as the detail might be high up or inaccessible in the distance, a telephoto lens is an advantage. To keep the detail sharp, you may have to stop the lens down to achieve the maximum depth of field, although this doesn't necessarily mean your shot will have overall sharpness.

With a lens longer than 200mm, it's probably best to mount the camera on a tripod and use a cable release to prevent camera shake. This is especially true when shooting indoors with relatively low light that requires long exposures. To avoid having a very long exposure, you could increase the ISO setting instead. Depending on your camera, though, this could increase the noise to an unacceptable level, which, as you are photographing detail, could ruin the shot. In any case, it is wise to program your camera with the noise reduction facility.

**Professional tips**

- Don't be afraid to go in close to your subject and crop out any unnecessary detail.

- Include a set of extension tubes in your kit for really close-up work, and always carry a tripod.

- Look for abstract qualities in your composition.

**Many modern buildings are covered with interesting details, such as pipes and ducting. At first sight, these pipes look like part of the external decoration but, in fact, they carry ventilation to the offices.**
> Canon EOS 1DS, 58mm lens, 1/100 sec, f/2.8.

## Indoor light

Shooting detail inside a building means that you need to consider the light carefully. In available daylight, check whether the light is too sharp, creating strong shadows that obscure some of the detail you are trying to bring out. Ask yourself whether it would be better to take the shot later in the day or to come back earlier on another.

Most churches provide the photographer with a wealth of detail. This sculpture of the Virgin Mary was lit with daylight entering from a window high up to the right. It emphasizes perfectly the intimacy of the moment and spotlights the figure in gentle relief against the austere block wall.
> Canon EOS 1DS MK2, 100mm lens, 1/400 sec, f/2.8.

On the other hand, simply changing your viewpoint might alter the way the shadow is falling and be more acceptable. In artificial light, make sure that you adjust the camera's WB (white balance) accordingly, so that your shots don't come out with a colour cast.

## Composite images

Many shots of architectural details are perfect ingredients for making composite images using Photoshop or similar computer software. After downloading your image, you can then flip it to make a reversed image butted up to the original. Replicate this as many times as you like for an intriguing kaleidoscopic image for printing and framing.

*Above:* **To make a composite image of the vaulted ceiling at Bath Abbey, I first downloaded the original image in Photoshop and made a duplicate, which I flipped and butted up to the original. I then kept on repeating the process until I had produced a kaleidoscopic effect.**
> Canon EOS 1DS MK2, 28mm lens, 1/40 sec, f/2.8.

*Left:* **The finished composite image of the vaulted ceiling.**

You might want to make your composite out of several different shots with the same theme, such as doorways or tiles of a particular style that you have shot over a period of time. The more you put together into a single overall image, the greater the kaleidoscopic effect. If you have a collection of shots of various arches, you could use one of them as the frame to a picture, with the view from another shot acting as the view through the frame. Such composites often produce a surreal effect and make the viewer look twice before realizing the deception.

## Fisheye lens

Although it might seem a contradiction in terms because of its extreme angle of view, the fisheye lens can be used to great effect when shooting architectural details. It can create unusual ceiling patterns, especially in churches or cathedrals. A vaulted ceiling, for example, can look stunning and quite abstract when the entire expanse is included in the frame.

Fisheye lenses can create unusual ways of looking at the ordinary. Here, I managed to include the entire ceiling of this Wren chapel, and although it curves at the edges, this adds to the dynamics of the shot.
> Canon EOS 1DS, 15mm lens, 1/60 sec, f/5.6.

See also:
**Lenses** pp. 19–25
**ISO (sensitivity)** pp. 37–8
**White balance** pp. 38–9
**Exposure** pp. 44–5
**Close-ups** pp. 198–201

# Still life

# Still life: outdoors

Many photographers prefer the confines of their studios for still-life shots because they can control the light and don't have to contend with unpredictable weather. However, many excellent still-life pictures can be taken outdoors, provided you plan ahead and have a clear vision of your final shot.

## Changing light and weather

Still-life pictures can take a long time to set up, so your first consideration should be the light. If you find a suitable location in terms of surface, background and light, remember that the sun is constantly on the move and that your location will look quite different in a couple of hours. For example, if you start setting up in the early morning, when the sun has just risen, the colour balance of the light will be warm and the shadows long, but as the day goes on, the colour balance will become cooler and the shadows shorter. As it might have been the warmth of the light that attracted you to the shot in the first place, you will need to work quickly if you are to retain this aspect of the shot.

Outdoor lighting can also be problematic if there are any clouds in the sky. You might have worked quickly to get the study set up, then, just when you are about to photograph it, a cloud obscures the sun. By the time the cloud has moved away, the sun could be in a totally different position, making the angle of the light unsuitable for your shot. Clouds can also mean rain, so you have to be prepared to change your set-up or delay the shoot.

**Professional tips**

- Plan ahead when shooting outdoors: the light moves quickly and the weather can change dramatically in a short space of time.

- Have some reflectors at hand to bounce light back on to your subject.

- Work on a tripod with a cable release so that you can tweak your arrangement and keep referring to it from a fixed point.

- Always be on the lookout for a 'ready-made' still life.

**Texture is paramount in this 'ready-made' still life of a rope tied around weathered timber. The slightly hazy sun was quite low in the sky, which gave the shot just the right amount of directional lighting.**
> Canon EOS 1DS MK2, 70mm lens, 1/125 sec, f/8.

The sun was coming at right angles to my viewpoint for this shot and was quite strong. To soften it, I positioned a large white reflector to the left and just out of shot.
> Canon EOS 1DS, 100mm lens, 1/400 sec, f/8.

I set up these flower pots on a patio and diffused the sunlight through muslin to give an even light. Even so, there is a nice highlight on a couple of the pots in the background. I added grain in Photoshop to enhance the overall effect.
> Canon EOS 1DS MK2, 120mm lens, 1/60 sec, f/5.6.

Having settled on your subject matter, decide on the most suitable time of day for the shoot. If the light tends to be consistent from day to day, you will be able to set up in advance; with non-perishable components, this could be the day before the shoot. However, if you do this and plan to shoot first thing in the morning, remember to cover your set-up so that it doesn't get covered with dew.

You might want to consider diffusing the sunlight. The easiest way to do this is to stretch some translucent material, such as muslin, over the set-up, to give an even, soft light. Mottled lighting, which is when the sun is filtered through the branches of a tree or other foliage creating a pattern over your subject, is also attractive. You will need to work quickly with mottled lighting, as you don't want pools of harsh light to fall on a delicate area of your shot or there to be a detrimental strong shadow.

## Food shots

A certain amount of speed is also desirable when photographing food. I usually approach a food shoot with an idea of what the finished dish will look like and then set up the shot with an empty plate and any other props that won't wither under the sun. As soon as I've set up everything I can, I place the main dish with the food in position. Because of all the preparation, the dish normally requires only a small amount of tweaking to get it the way I want it. For food shots, I usually have my camera tethered to the computer, so that as soon as I take the shot I can review it on screen. (I discuss this further on pages 158–61.)

## 'Ready-made' still life

I am always on the lookout for still-life pictures that don't need to be set up, such as an old piece of farm or garden equipment rusting in the grass or just a length of old rope. It is amazing what you can find if you keep your eyes open, even in a location that you are familiar with.

*Above:* I set up this shot minus the food, so that it didn't look tired by the time I was ready to photograph. Even so, I worked quickly, as I didn't want to lose the mottled light falling on the background, plate and skin of the sea bass. A No. 1 extension tube allowed me to get in really close without casting my shadow over the shot.

> Canon EOS 1DS MK2, 120mm lens, 1/320 sec, f/5.6.

*Left:* I took full advantage of the bright summer sun for this still life. I set up the ingredients so that they were almost backlit and then positioned two mirrors to bounce light back into the foreground. This has given a real zing to the oranges.

> Canon EOS 1DS, 200mm lens, 1/200 sec, f/20.

## See also:
**White balance** pp. 38–9
**Still life: indoors** pp. 158–61
**Close-ups** pp. 198–201

# Still life: indoors

Shooting still lifes indoors on location or in a studio where all your equipment, such as lighting, cameras and props, is to hand should be easy compared with photographing outdoors with the ever-changing light and variable weather.

## On location

Much of my still-life work takes place on location in hotels and restaurants or on boats. This is often not through choice but because it is impractical to have the shoot anywhere else. Even though working in a studio is more convenient, it is still possible to get great shots on location and, in certain circumstances, they can be more successful.

This shot was taken using a single backlight mounted on a boom, together with a small mirror to bounce light back into the shot. I had to work quickly otherwise the ice cream would have started to melt, ruining the shot.
> Canon EOS 1DS, 200mm lens, 1/15 sec, f/2.8.

**Professional tips**

- Keep the lighting simple – often one light is sufficient.
- Experiment with different reflectors: mirrors, for example, give a harsher light than white card.
- Try different camera angles: tilting the camera can add dynamism to your finished shot.
- Pay attention to details: for example, remove finger marks on glasses before shooting, as they can take hours to retouch on the computer.
- Food can look tired very quickly, so have your shot set up in advance before placing it on the set.

Getting these glasses precisely positioned was made easy with a grid viewing screen. For the liquid to appear translucent, I needed to backlight the glasses; if I had lit them from the front, the liquid would have been opaque.
> Canon EOS 1DS MK2, 200mm lens, 1/60 sec, f/5.6.

## Still-life lighting

My preferred artificial lighting is studio flash. It's extremely portable, so can be used both on location and in the studio and, as it runs cool, it's comfortable to work under, which is particularly important when photographing food (see also page 156). It's also versatile, coming with an almost endless range of different heads, reflectors, stands and attachments. Studio flash is balanced to daylight, which means that they can be used together.

## Setting up the shot

When setting up a still life, I always give myself as much space as possible in which to work. The reason for this is that it might be necessary to place a light, flag or reflector near to the subject, which, in a confined space, may be awkward or impossible without them getting in the way of the camera or the scene itself. Another reason for giving

yourself more space is that you can use a longer lens, allowing you to get in close to the shot but not physically on top of it.

Setting up your still life on a large, freestanding table means that you can vary your viewpoint from high to low, as well as shooting straight on. A table also allows you to put in place a variety of backgrounds, and backlight the shot should you wish to.

Once I have settled on the basic composition, I mount the camera on a tripod with a cable release and choose the viewpoint. A tripod allows you to look at the set-up through the viewfinder and then alter it, knowing that the viewpoint won't change – sometimes just a few millimetres one way or another can make all the difference. If the camera isn't in a fixed spot, you won't be able to place the objects accurately.

With the composition to my liking, I then position the lights – often this will be just a single head with whatever reflector I choose to create the desired mood. A light mounted on a boom directly behind the set-up means that I can then use a variety of reflectors to bounce light back into the shot. Controlling the light in this way allows you to place the light exactly where you want it. Mirrors produce a harsher light than white card reflectors, but this can be varied by altering the angle of reflection or

Not all indoor shots need to be lit with flash or other artificial light sources. I took this still life with available light coming in through a window, and diffused it with tracing paper. I used two reflectors to control where the light fell.
> Canon EOS 1DS MK2, 150mm lens, 1/40 sec, f/2.8.

I placed these roses on a Perspex table, which allowed me to light the shot from behind to give a very pure white, shadowless background. I then used one light from the side and a reflector opposite to light the flowers.
> Canon EOS 1DS MK2, 70mm lens, 1/60 sec, f/8.

the distance the mirror is from the subject. Shaving mirrors are ideal for this type of work, as their accuracy in pinpointing light is extremely good.

Having established the set-up and lighting, I then work out the exposure and take a shot. If I am shooting to a compact flash card, I examine the histogram on the camera's display and make any necessary adjustments. For still-life pictures, I prefer to work tethered to my computer so that I can see the shot directly on the computer's display. Depending on the capture system I am using – Capture One, Adobe Bridge or Apple's Aperture, for instance – I can then make an extremely accurate adjustment to the colour balance, exposure and contrast, as well as tweaking the subject and adjusting the lighting.

In addition to being able to see the picture I have just taken large on the computer screen, being tethered allows me to view two or more pictures together and compare the nuances of the changes I have made for each shot. Although this can be done on the display of many DSLR cameras, the images are so small that an accurate assessment of each shot is virtually impossible.

For some shots I might want to pick up some ambient light, perhaps from a table lamp or a candle, and will need a longer shutter speed than if I were lighting the subject with flash. In this case I would use the mirror up facility and set the camera to self-timer, which is the most accurate way to achieve a shudder-free exposure.

See also:
**Focusing screens** p. 27
**Viewpoint** pp. 56–7
**Studio flash** pp. 118–19
**Still life: outdoors** pp. 154–7
**Reflectors** pp. 184–5

# Action

# Capturing the moment

If you go to any sports meeting, from athletics to motor racing and winter sports, have a look at the cameras that the professionals are using. Chances are they will all be DSLRs.

## Why so popular?

Not only does the DSLR have a range of lenses ideally suited to action photography, but the rapid rate of firing means that you can shoot a sequence of pictures without missing any of the action. In contrast, many compact cameras, especially at the low end of the range, have fundamental problems when shooting action.

## Shooting speeds

The time that elapses between pressing the shutter release and the camera taking the picture is known as shutter lag. In some compacts this can be so slow that for a fast-moving sports shot the action could be over before the shutter fires, losing you the shot. At the top end of the DSLR range, though, this is not a problem because the picture is taken as soon as the shutter release is depressed. In addition, the motor drives in these cameras are extremely efficient: the Canon EOS 1DS MK2, for example, has a continuous shooting speed of approximately 4 shots per second.

**Professional tips**

- Experiment first with all the different focusing modes on your DSLR to determine which one will best suit the event you are shooting.

- Blurred images can be more effective at capturing a sense of speed.

**Not all shots have to freeze the action. Here, I chose a slow shutter speed and 'zoomed' the lens as I took the shot. The result is a car that looks as if it is moving at very high speed.**
> Canon EOS 1DS MK2, 170mm lens, 1/15 sec, f/20.

The best way to shoot movement is to see where most of the action takes place, then take up a safe position and wait for the participants to come into your line of vision.
> Canon EOS 1DS MK2, 70mm lens, 1/2700 sec, f/5.

DSLR cameras also have a rapid buffering rate, which is the amount of time it takes the camera to write the image information to the compact flash card (memory card). If the buffering rate is slow, there will be only so many shots that you can take in rapid succession (bursts) before the camera won't let you take any more shots until the buffering is complete.

The maximum burst is also dependent on the size of file you are shooting and the type of compact flash card. If you save your images to the flash card as RAW files, the maximum burst will be less than if you save them as JPEGs because RAW files are bigger. With my Canon EOS 1DS MK2, the maximum burst with RAW files is about 11 frames, but with JPEGs I could capture up to 32 shots in one burst. I prefer shooting RAW, though, because you get the greatest possible quality. RAW is like the negative in film photography – it has every scrap of information on it. JPEG is an interpretation of the information and as much as 20 per cent of it is discarded by the camera. Once it does this, it has gone forever!

Compact flash cards vary, too. The first 1GB cards I bought about five years ago had a write speed of 16×, whereas on my latest 1GB card the speed is 133×. This means that the information is written so rapidly that I very rarely suffer from any delays in shooting action.

## Focusing

DSLR cameras have the advantage of different focusing modes. As well as manual focusing, which, as its name suggests, is where you focus the lens by hand, there is also the single shot mode, which retains the focus for as many shots as you like, and continuous auto-focusing, where the camera tracks the subject and constantly assesses the focus (this is

*Far left*: Continuous auto-focusing can get the focus wrong if the sensor loses the subject.

*Left:* Its accuracy, however, is evident in this shot, where the athlete is completely sharp against a blurred background.
> Canon EOS 1DS MK2, 200mm lens, 1/600 sec, f/2.8.

Using the predictive focus mode, I focused on this part of the track before the race began and logged it in the camera's memory, which left me free to shoot elsewhere as normal. As soon as the action returned to the predictive focus point, I pushed the PF button and the lens automatically refocused.
> Canon EOS 1DS MK2, 600mm lens, 1/800 sec, f/8.

A shutter speed of 1/600 was fast enough to freeze the action of this pole vaulter with precise sharpness.
> Canon EOS 1DS MK2, 200mm lens, 1/600 sec, f/5.6.

known as AI Servo with Canon cameras). In sports photography or where the subject is coming rapidly towards you, this is a great asset, as the camera will keep the subject sharp, no matter how quickly it is moving.

Some DSLR lenses also have a predictive focus mode. Imagine you are opposite the goal at a football match. You could focus on this area and preset the focus, then concentrate on the action elsewhere on the field. When the action returns to the goalmouth, pressing the preset button makes the lens automatically reset the focus for that area. The advantage of this over auto-focus is if you are about to shoot the goalkeeper making a save but another player crosses your line of vision, the auto-focus can be distracted, and by the time it has refocused on the goalkeeper, the moment could have passed.

Lenses with IS (image stabilization) are an additional benefit when shooting action scenes with a hand-held camera. Any shake is detected by two built-in gyro sensors that then rectify the angle and speed of the camera shake.

See also:
**Using auto-focus** p. 46
**The shutter** pp. 68–9
**Processing RAW files** pp. 213–15

# Panning the camera

Although some DSLR cameras have shutters that fire as quickly as 1/8000 second, a very fast shutter speed doesn't necessarily produce the best action photographs. In some situations, panning the camera may be more effective.

## Creating a sense of speed

The advantage of a camera with a range of different shutter speeds is that you can 'freeze' the action. In certain situations, this is desirable, even necessary, for a first-rate shot. However, it can ruin the appearance of some shots and erase any sense of speed.

For example, if you photograph a fast-moving car the moment it is directly in front of the lens with a shutter speed of 1/60 second, it will

**While a fast shutter speed might 'freeze' the action, it can take the drama out of a shot. Look at the wheels of this car – it is difficult to tell whether they are moving or not.**
> Canon EOS 1DS MK2, 200mm lens, 1/800 sec, f/4.

*Below:* **Choosing a slower shutter speed and panning the camera with the car has created a much better sense of speed. Notice how the car is sharp but the wheels now appear as if they are turning.**
> Canon EOS 1DS MK2, 200mm lens, 1/60 sec, f/16.

come out as a blurred streak with few of its features readable. On the other hand, if you were to increase the shutter speed to, say, 1/1000 second and take the shot when the car is directly in front of the lens, the camera will record the car perfectly and all of its detail will become visible. In this shot, though, it will be very difficult to tell whether the car is stationary or moving. In other words, any sense of speed or action will be lost and all that you will have captured is a static image of a car. The way to avoid this is to 'pan' the camera.

Panning is a term commonly used in the film world where the camera moves across a scene or tracks a moving object. In still photography, the technique is employed to give a sense of speed. It might take some practice but is well worth the effort. Instead of using a fast shutter speed, you need to select one around 1/60 second. Point the camera to where the car is coming from and follow its path (pan) in the viewfinder. When it is directly in front of the lens, gently squeeze the shutter and take the shot, following through with the panning action in much the same way as a golfer does after hitting the ball. What you will have is a car that is sharp against a blurred background, giving a true sense of movement that is far more evocative than 'freezing' the action.

## Vertical movement

Remember that a sharp and well-defined subject is possible only when the movement is along a horizontal plane, such as when a car is racing. If there is any vertical movement, such as the up and down action of an athlete's legs, these areas will not be sharp, although they will give an increased sense of speed.

This runner is moving on both a horizontal and vertical plane, so although the camera was panned with him, it was not possible to keep him pin sharp.
> Canon EOS 1DS MK2, 200mm lens, 1/60 sec, f/4.5.

See also:
**The shutter** pp. 68–9

# Getting more from your DSLR

# Filters

If there is one drawback with digital photography, it is the tendency to leave everything to the computer and not concentrate on getting the shot right in the first place. This is particularly true when it comes to using filters.

## Polarizing filters

Many photographers don't bother with filters at all, thinking that they can replicate their effects in post-production, but this isn't always wise. It is likely to lead to a build-up in work that will never get done and, when it comes to filters, the effects achieved in post-production will be a poor imitation of the real thing. This is especially true of the polarizing filter, which should be a permanent part of the DSLR kit.

Polarizing filters have several functions: darken blue skies and make clouds stand out with greater clarity; enhance the quality of water; and reduce reflections on shiny surfaces. There are two types of polarizing filter – circular and linear – but it is only the former that you should buy. (Your camera's auto-focus and metering systems will become ineffective with the linear polarizing filter, which is a pity because they are the cheapest to buy.)

For a polarizing filter to be really effective, you need to be careful about the time of day that you take your shots and the angle that you are to the sun. The best time is usually a couple of hours before and after midday, and it's important to keep the sun at right angles to the

*Far left:* **Although there's nothing actually wrong with this shot taken without a polarizing filter, it does look quite flat and plain.**

*Left:* **Using a polarizing filter has improved the shot considerably: the sea has increased definition and the sky more depth.**
> Canon EOS 1DS, 50mm lens, 1/60 sec, f/9.

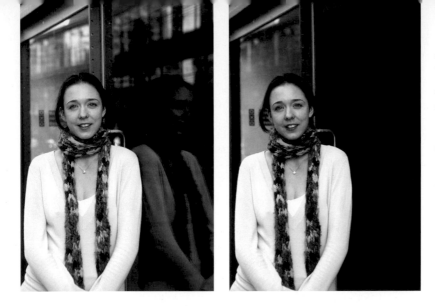

*Far left:* Polarizing filters are excellent for removing reflections. Without a filter, the girl and the building on the opposite side of the road are reflected in the glass.

*Left:* With a filter, the reflections have all but disappeared.
> Canon EOS 1DS MK2, 70mm lens, 1/40 sec, f/5.6.

direction that you are shooting in. If you shoot with the sun directly behind you, the filter will have no effect at all on your images.

Be careful when using a polarizing filter with a wide-angle lens. As the filter is quite thick, it is easy for vignetting to occur, with the corners of the frame coming out dark. With lenses wider than 28mm, the effect of a polarizing filter will be uneven across the frame because the degree of polarization changes across the vista. This shouldn't stop you experimenting with this combination, though, especially as a DSLR allows you to see the effect directly through the viewfinder.

Once you've attached a polarizing filter to your lens and chosen your viewpoint, turn the filter (it is, in effect, two filters on top of one another and the outer one revolves). As you continue to turn the filter, you will see the sky darken and then become lighter. The trick is to get the sky as dark as possible and then turn the filter back slightly to reduce the degree of polarization, giving a more natural effect.

*Below left:* Polarizing filters are best known for the way they can enhance a sky. Without a filter, the sky in this shot has a reasonable amount of definition but it could be enhanced.

*Below right:* With a polarizing filter, the clouds really stand out and the sky is a richer blue.
> Canon EOS 1DS, 50mm lens, 1/125 sec, f/11.

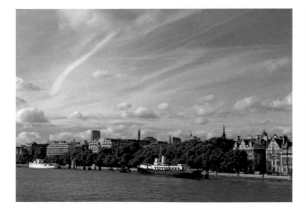

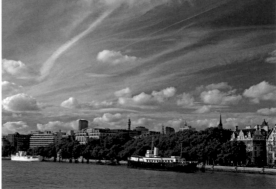

A polarizing filter can also change the colour of water, as well as reducing any reflections – be aware, though, that this could have a detrimental effect on the overall composition if the reflections are a vital ingredient of the shot. This ability to reduce reflections is particularly useful when photographing objects with highly reflective surfaces, such as glass and metal. It is important to remember that a polarizing filter will need approximately one and a half stops more exposure, so in certain circumstances a tripod might be essential.

## Graduated neutral density filter

Also very useful is the graduated neutral density (ND) filter. Rectangular in shape, it slides into a special holder attached to the front of the lens. It is clear glass or plastic at the bottom, and then from halfway up looks like a band of grey coating. This grey coating comes in various strengths and cuts down the amount of light entering the lens without causing a colour cast. This means that you can control different areas of your shot that require a different exposure, such as the sky and the foreground. The difference in this case might be as much as one stop, and if you don't correct it, the sky will come out overexposed and without detail, or the foreground will come out underexposed and also lack detail. As with the polarizing filter, you can see the effect as you look through the viewfinder, but you must take your meter reading before sliding the filter into position, otherwise your shot will be overexposed.

## Filters for black-and-white photography

If you can shoot black-and-white images with your DSLR, you might find it useful to have a set of filters: yellow to give greater clarity to clouds; red to darken blue skies considerably; and green to lighten foliage and heighten features such as lips in portraits. However, if you shoot in black-and-white, you won't be able to change your pictures to colour later; if you shoot in colour as well, you will have both options covered.

*Below left:* **Without a graduated ND filter the sky in this shot looks reasonable enough, and it would be possible, although time-consuming, to enhance it in Photoshop.**

*Below:* **Using a filter has improved the shot immediately. Less exposure has been given to the sky, preserving more detail, while the correct exposure has been retained for the foreground.**
> Canon EOS 1DS, 24 mm lens, 1/250 sec, f/11.

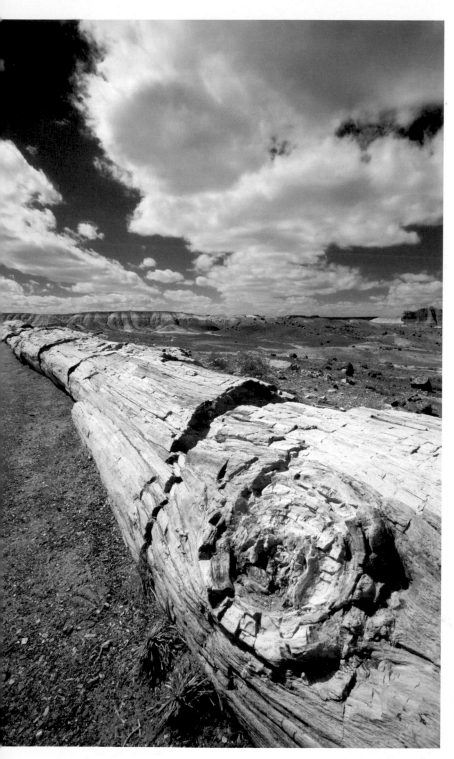

If you are shooting in black-and-white, certain filters will enhance your shots. The yellow No. 12 filter, which I used here, has given great clarity to the sky.
> Fuji FinePix S2 Pro, 21mm lens, 1/60 sec, f/8.

See also:

# Shift and tilt lenses

There are now a variety of shift and tilt lenses available that emulate nearly all the movements found in large-format cameras. The benefits of these lenses are far-reaching and applicable to many situations where a 'normal' lens would be inadequate, such as in architectural photography.

## Architectural photography

When photographing buildings, especially tall ones, it is often difficult to fit the entire structure in the shot without tilting the camera upwards, but this results in 'converging verticals'. In other words, the building tapers towards the top and appears to lean inwards. In certain situations this can be used to good effect, while in others it can give a distorted view of the building, which would be unacceptable to an architect or surveyor.

There are two ways you can try to resolve this using a normal lens: find a higher viewpoint or correct the perspective in Photoshop. The problem with the former solution is that it might be impractical to find a higher viewpoint and, in any case, the picture might look odd taken from such a height as opposed to ground level. On the other hand, correcting the perspective in Photoshop comes with the disadvantage of losing image quality as the pixels are 'stretched', which will show up if a large-format print is made, and some of the picture will be lost as the image is cropped at the sides.

**Professional tips**

- Use a tripod with a shift and tilt lens for the best results.

- With TTL (through the lens) metering, take the reading before using the shift facility.

- Practise with the tilt facility to understand its capabilities fully.

- 'Tilt' refers to the movement in the horizontal plane; the movement in the vertical plane is known as 'swing'.

*Far left:* **Using a conventional lens and pointing the camera upwards in order to get the entire building in the shot has created converging verticals, making the building look as if it is toppling backwards with its sides tapering towards the sky.**

*Left:* **Taking the shot using a normal lens with the sensor plane parallel to the subject plane has kept the sides of the building vertical but cropped the higher floors out of the frame. There is also a lot of unwanted foreground detail.**

A shift and tilt lens has brought the upper floors of the building into the frame and cropped out excessive foreground detail. The sides of the building are also completely vertical so that it appears upright.
> Canon EOS 1DS MK2, TS-E 24mm f/3.5 Canon lens, 1/85 sec, f/22.

## Correcting the verticals

With a DSLR camera and an appropriate shift and tilt lens, however, you can take your shot from the desired viewpoint and correct the converging verticals so that the sides of the building appear straight. There is a simple rule to follow: if the subject plane or building and sensor plane are parallel to one another, then the sides of the building will appear perfectly vertical. However, with the shift lens in its centred position, the top of the building will still be cropped out of the frame. To bring the top of the building into the picture without having to tilt the camera upwards you will need to shift the axis of the lens in relation to the sensor plane.

*Above:* **When shooting with a fixed lens towards a highly reflective surface, such as a mirror, it's impossible to prevent your reflection without changing your viewpoint. With a shift and tilt lens, though, you can.**

*Right:* **By shifting the camera position to the left of the mirror for this shot, I used the shift facility in the horizontal position and extended it until the mirror was centred.**
> Canon EOS 1DS MK2, TS-E 45mm f/2.8 Canon lens, 2 secs, f/11.

## Removing reflections

The shift facility of most perspective control (PC) lenses is variable in click-stop increments through 180°. This means that you can employ the shift facility in a variety of different positions from horizontal to vertical. Imagine that you're photographing a highly reflective subject and that it's impossible to find a viewpoint without you and your camera reflected in it. This could be a building, a car or a room interior where a mirror, for example, is bang in the middle of the frame. Having composed and studied your picture, move the viewpoint to one side and recompose – obviously, the middle of the original composition will now be off-centre. With the lens set for a horizontal shift, focus the subject and then turn the small dial to start shifting the lens so that the subject centres itself in the frame. You will find that you can re-create your original composition but without you in it.

*Below:* In this shot, the camera was angled downward and the lens focused on the front cup and saucer. You can see clearly that the focus falls off dramatically towards the rear of the shot. Even if I had stopped down to f/22, the cup and saucer furthest away would still be out of focus.
> Canon EOS 1DS MK2, TS-E 45mm f/2.8 Canon lens, 1/30 sec, f/5.6.

## Tilt facility

Once the preserve of large-format cameras, the tilt facility can now be replicated with your DSLR. Basically, it allows you to create maximum sharpness throughout a shot without having to stop the lens down. It follows the principle of the Scheimpflug rule that states that when all the planes (subject plane, lens plane and sensor plane) are parallel to each other, then the image will be sharp all over. However, if you incline (tilt) the lens plane, the area of overall sharpness will be only the point where the two other planes meet at a common point with that of the lens plane.

To use the tilt facility, look through the viewfinder after you have composed your shot and focus the lens for overall sharpness. Then, still looking through the viewfinder, tilt the lens slowly so that the point of sharp focus begins to extend itself throughout the shot. With practice, you will not have to stop down as much as you would with a fixed lens.

Using the tilt facility on the lens and adjusting the lens down by only one stop, I was able to get this shot, which is completely sharp all over.
> Canon EOS 1DS MK2, TS-E 45mm f/2.8 Canon lens, 1/15 sec, f/8.

## See also:
**Depth of field** pp. 66–7
**Architecture** pp. 138–51
**Digital perspective** pp. 180–1

# Digital perspective

If you intend doing a lot of photography that would benefit from a shift and tilt lens, do consider making the investment so that you can make your images perfect in camera. A less expensive way of correcting perspective is to do it at a later date on the computer but, be warned, there are drawbacks to this solution.

## Converging verticals

As demonstrated on pages 176–7, probably the only way to include all of a tall building in your shot without a shift and tilt lens is to point the camera upwards, but this results in converging verticals. The distance the photographer stands back from the building, the lens used and the degree to which the camera is angled upwards are all determining factors in the severity of the convergence.

## Correcting perspective in Photoshop

By downloading the image into Photoshop, you can use the cropping tool to 'stretch' the pixels to control the degree of slant or slope in the walls of a building, thereby correcting the convergence. Naturally, stretching the pixels has an effect on the final quality of the finished image, and the

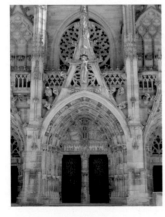

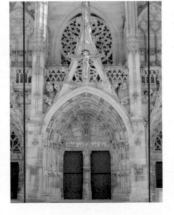

It is often necessary to point the camera upwards to include all of a tall building in a shot. This results in converging verticals, where the building tapers towards the top.

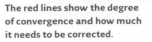

The red lines show the degree of convergence and how much it needs to be corrected.

In Photoshop, select the crop tool from the palette and click on the perspective box in the tool bar. Move the crop tool so that the verticals are aligned with the verticals of the building.

Pull the crop marks out to the limit of the frame and crop the picture. The verticals are now straight and the perspective has been corrected. However, notice how a certain amount of the image has been lost on either side.

larger the size of the final print, the more visible this loss of quality will be. As each pixel is stretched, it loses tone and colour information and ends up with holes where there is no information present. Fortunately, the program interpolates these discrepancies and fills in the holes by adding more pixels. It is able to do this by reading the information in each of the surrounding pixels and then making a judgement on what the correct tone and colour balance of the missing pixels should be.

When using this method of correcting perspective, remember that a certain amount of the sides of the original image will be lost as the pixels are stretched. To prevent this, make sure when composing your shot that there is sufficient 'non-crucial' information at the sides of your image that will not be missed when they are cropped out in the finished version.

Photoshop has been used on the nearest detail above to correct the converging verticals. You can see how it has stretched the pixels, widening the image with some loss of detail at the sides. A shift and tilt lens would not have caused such distortion.

See also:
**Shift and tilt lenses** pp. 176–9

# Fill-in flash

Using flash outdoors on a bright day may seem an anomaly but it can greatly improve the quality of your shots. So why would you want to use flash on a well-lit, sunny day?

## When to use fill-in flash

Fill-in flash is useful when bright sun causes unattractive shadows under the eyes and chin, and when your subject has their back to the sun and their face in shadow. By using a small amount of fill-in flash, these shadows can be eliminated or softened. You can also use fill-in flash when your subject is in shadow but the background is in bright sun and you want to retain the detail of the background. If you expose for the background, the person will be underexposed and come out as a silhouette. On the other hand, if you expose for the person, the background will be overexposed and all the detail burnt out. Instead of fill-in flash, you can use reflectors.

## How to use fill-in flash

It is important to know how your flash performs. Practise using it and tailor it to this type of photography – many flash guns overexpose and give an unnatural appearance to portraits, often burning out detail and making the shot worse than it was originally.

*Far left:* **The sun was too bright to photograph this model facing the sun without her squinting. However, positioning her with her back to the sun has resulted in harsh shadows under the eyes and nose. The light also appears flat and there is little detail in her hair.**

*Left:* **To remove the shadows, I used fill-in flash but the amount that was fired in auto mode was too much, resulting in hot spots on the skin.**

To calculate the amount of fill-in flash to use, imagine that the daylight reading is 1/60 second at f/11. However, the subject is in shadow and the skin tones look dull. The camera is set to this exposure but the flash needs to be set to give half (1:2 ratio) of this exposure or even a quarter (1:4 ratio) – f/8 or f/5.6 respectively. In other words, there is less flash output than the daylight. The shot is then taken at f/11. With this combination, the surrounding areas are perfectly exposed and the amount of flash falling on the subject is just enough to brighten up the shot and create a more flattering portrait. If your camera has built-in flash, this might not be possible to do and you will have to rely on the camera's fill-in flash mode, if it has one.

**To remove the hot spots, I set the flash to manual and cut its output by 1/4. This has resulted in a far more flattering portrait, with more detail in the hair and the face lifted out of shadow. You can just see the pinpoints of the flash in the pupils.**
> Canon EOS 1DS MK2, 155mm lens, 1/125 sec, f/11.

See also:
**Flash** pp. 29–30
**Reflectors** pp. 184–5

# Reflectors

In photography, a reflector is anything that can 'bounce' light back onto your subject. Although often very inexpensive, they can make an enormous difference to your shots.

## Custom-made reflectors

There are many custom-made reflectors to choose from, starting at a cost of a few pounds through to several hundreds. They mostly come on an expandable metal or plastic frame, which either springs out into a circular shape with a diameter starting at about 300mm (12in) or into a rectangle that could be as large as 2 × 1.5m (6½ × 5ft). The frame is covered in a reflective material that is either white, silver or gold. Some custom reflectors come with a collapsible frame that slots together, with the reflective material stretched over it or attached with Velcro. Several of this type can be joined together to make a structure resembling an enormous tent.

## Improvised reflectors

Not all reflectors have to be so elaborate, and many can be improvised out of everyday items. At the beach, for example, a white towel could do the job just as adequately as a custom-made reflector. Remember, though, that if you were to use a light-coloured towel, perhaps green,

### Professional tips

- Small reflectors can easily be carried in a camera bag or pocket.

- Remember that the colour of the reflector will create a colour cast.

- Make your own reflector from something as simple as a napkin or newspaper.

- Highly reflective surfaces can be as dazzling as the sun, so use them carefully.

*Far left:* I was photographing this model outdoors on a bright sunny day. With his face to the sun, it was hard for him to keep his eyes open without them watering. Turning him around so that his back was to the sun was more comfortable for his eyes but his face was then slightly in shadow and the lighting looked very flat.

*Left:* I then used a reflector with a white surface. This has brightened the light on his face and clothes, but the effect is rather cool.

For the final shot, I selected a gold reflector. This has brightened the light in the same way as the white reflector but has added some warmth, which I find more attractive.
> Canon EOS 1DS MK2, 70mm lens, 1/125 sec, f/4.5.

this would create a green cast on your subject's skin, which might not be quite the effect you had in mind. Another improvised reflector could be a newspaper, an open book or a white piece of card.

## When to use a reflector

A reflector is ideal when the sun is too bright for it to shine on your subject's face without making them squint and their eyes water. To remedy this, you could turn your subject so that their back is to the sun and then use the reflector to bounce light back onto the face. You can then direct the reflector to the area where you want more light.

For a head shot, it's often possible for the subject to hold the reflector. If you decide to use a highly reflective surface, such as gold or silver, remember that this can be as intense as the sun and could result in your subject screwing up their eyes. The further away you position the reflector, the less intense the effect.

See also:
**Flash** pp. 29–30
**Fill-in flash** pp. 182–3

# Infrared photography

Developed originally for military and medical purposes, infrared photography became popular with mainstream photographers as a way of creating unusual and surreal-looking images. It is a relatively recent phenomenon with digital photographers.

## The effects of infrared

In black-and-white landscape photography, infrared film makes trees and other foliage appear a ghostly white, while the sky is rendered a deep black. At first glance, you might mistake an infrared image for a negative, and it is only on closer inspection that you realize it is a positive image because clouds and shadows record correctly as white and black (in a negative, the reverse would be true).

## Working with infrared

Not all digital cameras are capable of infrared photography because the sensor that records the image has "hot mirror filters" placed between the lens and the sensor. Their purpose is to filter out the wavelengths

**Photographed in infrared, these clouds stand out particularly well, while the strong wind has added another element to the shot, as shown by the movement in the branches of the palm trees. You can see by the length of the shadows that this shot was taken late in the day.**
> Fuji FinePix S2 Pro, 20mm lens, 1 sec, f/3.4, No. 87 filter.

of the electromagnetic spectrum that are sensitive to infrared light. Technically speaking, these wavelengths are measured in nanometres (nm). Visible light, that is what the human eye is capable of seeing, falls between 400 and 700nm. Infrared goes far beyond this range.

Both my Canon cameras, the EOS 1DS and the EOS 1DS MK2, are incapable of reproducing a good infrared image because the hot mirror filters are so efficient that the results end up looking like a heavily fogged picture. I could prevent this by removing the hot mirror filter and replacing it with a piece of clear glass, but this would mean the camera would be useless for any other type of photography and render any warranty void – not something I would particularly want to do with a piece of kit that costs thousands!

I solved this problem by testing some of the earlier digital models on the second-hand market. The one that worked really efficiently was the Fuji FinePix S2 Pro, which I normally use fitted with a Nikon AF-S 17–50mm f/2.8 lens. Although expensive, this lens consistently gives me sharper results than some of the cheaper ones available.

With the camera (and cable release) on a tripod, I set the program to black-and-white, and the metering to manual mode. A tripod is essential for infrared photography, as some of the exposures you might

**I find that bright sunlight provides the best conditions for infrared digital photography, as shown by the strong shadows on this boardwalk. The almost-black sky and the ghostly white foliage epitomize the infrared effect.**
> Fuji FinePix S2 Pro, 17mm lens, 1 sec, f/4, No. 87 filter.

The infrared effect works well on blonde, fair-skinned people, as shown here. Even though the infrared has given a ghostly look to the grass and trees, the model appears unaffected. Although it was quite windy when I took this shot, I liked the effect the wind had on the branches.
> Fuji FinePix S2 Pro, 17mm lens, 1 sec, f/8, No. 87 filter.

require could be as long as 30 seconds, although in bright daylight one or two seconds should suffice. These long exposures are necessary because the filters that you need to place over the lens are virtually black. For all the shots shown on pages 186–9, I used a Lee gel filter No. 87, which transmits light above 730nm. Be aware that gel filters are very susceptible to dirt and grease, and scratch quite easily. Glass filters, such as the Hoya R-72, are also available, and Heliopan manufactures a comprehensive range, but these are extremely costly.

If you use a gel filter, which normally slides into a holder, you will have to make modifications to prevent stray light from creeping in through the sides and nullifying the infrared effect. The best way I've found to avoid this is to fix the filter to the holder with gaffer tape on all four sides so that it is completely light-tight. With the holder ring screwed onto the lens, I compose the picture, focus (making sure I turn off the auto-focus) and place the holder on the ring. I then shoot using a cable release to make the operation as smooth and steady as possible.

I find that tree and plant foliage shot in infrared produces the most stunning effects but, as not all plant species react in the same way, a certain amount of trial and error will be necessary. However, the results will be worth it. Direct bright sun produces the best effects, with trees and plants appearing a ghostly white, while the sky is quite black. If the light isn't bright enough, the foliage will not react in the best way possible. Changing the filter can help: a No. 89B filter, for example, is far more sensitive to wavelengths higher up the electromagnetic spectrum. Of course, the great advantage you have when shooting digitally is that you can review your results instantly and make the necessary adjustments. With film, you would have to wait for it to be processed.

*Above:* As this shot had a long exposure, a tripod and cable release were essential. However, it was a very still day, so the trees have recorded quite sharp. At first glance, the image could be mistaken for a snow scene.
> Fuji FinePix S2 Pro, 17mm lens, 6 secs, f/8, No. 87 filter.

*Left:* Water can add another dimension to your infrared photography. It's best for it to be completely still, otherwise the ghostly reflections will be lost in the ripples. Water always seems to be at its stillest early in the morning.
> Fuji FinePix S2 Pro, 20mm lens, 1 sec, f/3.4, No. 87 filter.

## See also:

**Exposure** pp. 44–5
**The shutter** pp. 68–9
**Black-and-white landscapes** pp. 90–3

# Aerial photography

Once the preserve of a small band of professionals using special aerial cameras, aerial photography can now be pursued by anyone with a DSLR – and a head for heights.

## Getting the best shots

Aerial shots can be taken from a hot air balloon, glider, plane or helicopter – even regular passenger planes can provide excellent opportunities for aerial photography. My first choice is always a helicopter. None of the other options has such manoeuvrability, visual openness and hovering ability. Admittedly, the hot air balloon does have the openness but it can't hover to let you take your shot or go back so that you can approach the scene again.

Generally, when I'm shooting from a helicopter, the passenger door is removed, and since there are no wings or propellers in the way as you would have in a plane, I have a completely unimpeded view. I wear a lap belt – not a seat harness that would stop me from being able to turn towards the door opening and lean forwards – so that I can look straight down on the scene that I am photographing. If you have never done anything like this before, you might start off feeling absolutely terrified, and wonder how much protection a lap belt is going to give you. However, it is amazing that when the helicopter banks and you are

*Far left:* **Helicopters give the best view for aerial photography. For this view over the suburbs of Los Angeles, the door had been removed, which enabled me to use an ultra wide-angle lens without anything obstructing the view.**
> Canon EOS 1DS, 17mm lens, 1/3200 sec, f/2.8.

*Left:* **Aerial shots are great for giving a different perspective from those taken at ground level. Here, the meander of this Argentinian river shows up dramatically as it snakes its way through the landscape.**
> Canon EOS 1DS MK2, 70mm lens, 1/400 sec, f/6.3.

leaning into nothingness you remain held in position. Unless you suffer from severe vertigo, you will quickly get used to it. But remember that complacency is the first step to an accident and, however simple I may make this seem, I always take certain precautions.

## Basic kit

The first thing I do if I'm working without an assistant is to pare my kit down to the bare minimum. My kit is usually made up of two camera bodies and three lenses: 17-35mm, 24-70mm and 70-200mm. I make sure that all the camera batteries are fully charged and I carry two spares. I then check that I have sufficient compact flash cards. My assistant, if I'm working with one, will be seated behind me and we will shoot tethered. This means that the camera is connected directly to the laptop computer, so that once I have taken a shot, it comes up almost instantly on the screen. My assistant can then tell me that the white balance is correct and that the shot is sharp, correctly exposed and has good contrast. Although I can do all these things myself on the camera by checking the preview and the histogram and also get a pretty good idea of sharpness by enlarging the preview, this is not quite so accurate or as efficient as seeing each image on the computer screen.

**A helicopter allows you to circle your subject - here, the Great Barrier Reef - as you search for the best view. Once you've found it, the pilot can then manoeuvre and hover in exactly the spot you ask for. This would not be possible with a plane.**
> Canon EOS 1DS, 24mm lens, 1/1600 sec, f/11.

## Being organized and safe

Having chosen my kit, I then make sure that it is well organized and easily accessible. Helicopters aren't cheap to hire and I don't want to waste precious shooting time searching for the compact flash card, for example. I usually put all the cards in one pocket and then, as I use them, place them in another pocket so that they don't get muddled up. The same goes for the spare batteries, should they be required. I keep the two lenses I'm not using in a small kit bag placed on the floor between my feet and tied to the fixing at the bottom of my seat so that it can't fall out. Last of all, I secure the two camera bodies with a length of cord to another fixing in the cockpit. If I were to drop one of the cameras and it hit the small rear rotor of the helicopter, it would mean only one thing – the helicopter would plunge straight to the ground!

With all that taken care of, I put on headphones and a mouthpiece so that I can communicate with the pilot. Most pilots are used to photographic trips: when I signal to hover or turn the craft around so that I can shoot from another direction, circle the subject to get the best view or bank, for them it's all in a day's work.

**Aerial photographs can give a fascinating overview of a city. The helicopter pilot hovered as steadily as he could so that I could shoot the expressway interchange in the foreground of the picture, while keeping the downtown area of Los Angeles in the background.**
> Canon EOS 1DS, 28mm lens, 1/1250 sec, f/4.5.

*Above:* Getting well-composed shots can be tricky from the air, but in this picture, which is a good example of the golden section, or rule of thirds, the dome fills the foreground and the *Queen Mary* makes a perfect diagonal in the frame.
> Canon EOS 1DS, 35mm lens, 1/3200 sec, f/2.8.

*Left:* For this pilot's view of coming into land, I kept the camera angle low, as it was quite a hazy day. Haze, which is just visible here in the distant mountains, can be a real problem when shooting aerial pictures.
> Canon EOS 1DS, 70mm lens, 1/500 sec, f/8.

See also:
**Accessories** pp. 26–31
**The golden section** pp. 52–3

# Night photography

There are just as many photographic opportunities to be had at night as during the day, particularly in towns and cities when buildings and roads are lit up and headlights create light trails. There's also as much to shoot in winter as there is in summer.

## The twilight hour

My favourite time to shoot cityscapes at night is during the twilight hour, which occurs about half an hour after sunset and, confusingly, lasts for about 20 minutes. If you want to take full advantage of this period, you need to be in position well in advance. I like this time because the sky turns a deep blue, which offsets illuminated buildings to best effect. After this time, the sky records as a deep black, which often looks too heavy and isolates buildings as blobs of light with little detail of their structure.

## Equipment

An essential piece of equipment for night photography is a tripod, so that your shots come out pin sharp. A good-quality tripod is definitely a worthwhile investment, and it will be useful for other applications besides night photography. You should also have a decent cable release.

Buildings can reflect beautifully in water at night, provided you get the timing right. In this shot of the J K Bridge in Brasilia, the sky is just beginning to turn – if I'd taken the shot any later, the sky would have been quite heavy, requiring more exposure. This, in turn, would have burnt out the street lighting.
> Canon EOS 1DS MK2, 85mm lens, 5 secs, f/8.

*Below:* It is tempting to shoot famous buildings as soon as they come into view. I took this shot of St Basil's Cathedral in Moscow in the mid-morning light, even though I knew that it would look so much better at night.
> Canon EOS 1DS MK2, 180mm lens, 1/200 sec, f/8.

*Above:* For this shot, I waited for the sun to sink in the sky until it hit the cathedral almost horizontally. The light was warm, which made the cathedral look much more attractive than it did mid-morning.
> Canon EOS 1DS MK2, 160mm lens, 1/400 sec, f/4.

*Above:* It was only at 10pm that night that I got the shot I really wanted, but it was certainly worth the 12-hour wait. The sky is a lovely twilight blue and the cathedral looks far more majestic than it did earlier in the day.
> Canon EOS 1DS MK2, 75mm lens, 1/4 sec, f/2.8.

## Exposure times

Longer than normal exposure times are required at night. Many cameras have a shutter setting known as 'bulb', or 'B'. Set to this, the shutter will remain open for as long as the shutter release is pressed, but this can drain the battery quite rapidly, so make sure that you have plenty of back-up. However, as many cameras now have shutter speeds of up to 30 seconds, you may never need to use this setting. Long exposures can create 'noise', giving a grainy look to images, which is especially obvious on large prints. Most cameras have a noise reduction, or long exposure, mode which you should set before you start shooting.

Keep an eye on your ISO setting. Increasing this to cut down on exposure time is common, and it can do the trick, but it can also increase the noise. As a rule, I would rather use a lower ISO and increase the exposure. Some cameras are better at reducing noise than others, and it is only by experimenting that you can determine the effectiveness of yours.

Once I've mounted the camera on a tripod and attached the cable release, I choose the 'mirror-up' mode from the menu. This prevents the camera from vibrating at long exposures when the shutter is fired. In most cameras, this usually works on a double action procedure. When you have pushed the cable release halfway, the mirror goes up. Wait a few seconds, push the cable release further and the shutter fires.

## Shooting options

Shoot RAW if you can so that you are able to adjust and improve your images on the computer if you need to. If you shoot JPEGs, important information might be discarded as the camera interpolates the image.

## Photographing fireworks

Fireworks are particularly worth shooting at night, but forward planning is essential. If you are familiar with the location of the display, get in position an hour ahead of the first fireworks going off to be sure that your view won't be blocked.

Set the camera up on a tripod in such a way that people in the crowd won't kick the legs. As you will be at the front of the crowd, try putting two legs through any barrier, and place the third leg between yours. In this way, the tripod should be stable.

I usually work at 100 ISO and set the camera to 'B' with an aperture of about f/8. I focus the camera manually on a point below which the fireworks are going to explode. Once the display starts, I try to judge the frequency of the bursts and then open the shutter accordingly. As soon as there is a burst or two, I close the shutter. Fireworks soon turn the sky misty, so your best shots will be from the start of the display.

**Evocative night pictures can sometimes be taken just after sunset. In this shot of Whitby Pier in North Yorkshire, the street lights were coming on, emphasizing that the day was over. The line of lamps creates a strong compositional element, while the red capstans add a splash of colour.**
> Canon EOS 1DS, 50mm lens, 1/8 sec, f/5.6.

I always try to photograph fireworks early on in the display before the sky becomes heavy with smoke, obscuring the detail. A tripod and cable release are essential for shots of fireworks.
> Canon EOS 1DS MK2, 70mm lens, 1 sec, f/8.

See also:

# Close-ups

Taking close-ups can be incredibly rewarding. Fortunately, the DSLR camera, with its enormous range of attachments, is perfectly suited to this field of photography.

## How to get in close

There are several ways of photographing close-ups with a DSLR camera: with a macro lens; with extension tubes and bellows; or with a close-up lens that fits on the front of your lens like a filter. Although a close-up lens is the cheapest option, optically it is inferior to the lens you would be using with extension tubes or bellows, or a macro.

## Macro lenses

Close-ups are best taken using a macro lens because they are specially made for this type of photography. However, beware that although many lenses are described as macro, they are not really – a true macro lens has the ability to photograph objects at life-size magnification.

As well as letting you get in close to your subject (approximately 30–60cm/1–2ft), a macro lens must allow you to shoot from a reasonable working distance. (If you need to get in any closer, you will have to combine your macro lens with an extension tube or bellows, see page 200.) For example, when photographing a nature subject, such as a spider, you wouldn't want to get in very close physically because you would disturb the creature, causing it to run off and hide. I would, therefore, recommend a 180mm macro lens because it gives you a comfortable working distance as well as the ability to shoot life-size (with a shorter lens, such as a 50mm macro, your working distance for shooting life-size will be considerably reduced).

Keeping a maximum working distance from your subject is important for other reasons. If you're too close, there is always the chance that you could cast your own shadow over the subject. In addition, there might not be enough room for you to use a small reflector, additional lighting or a lens hood to prevent flare.

Some macro lenses come with a tripod mount, which enables you to move the camera quickly from a horizontal to a vertical position, and vice versa. This is important because if you change position with the pan-tilt head, you will alter the height of the camera and then have to adjust the tripod legs or its central column to compensate. In nature photography, this time lapse could be the difference between getting or failing to get the shot!

---

**Professional tips**

- Extension tubes are a more economical option than a macro lens.

- Use a tripod and cable release.

- A 180mm macro lens will give you a greater working distance than, say, a 50mm macro lens.

- Be careful not to cast a shadow over your subject.

*Above:* I shot these bicycle cogs using a macro lens. With my focus on the middle cog, it is easy to see how little depth of field there is when working this close to your subject.
> Canon EOS 1DS MK2, 180mm macro lens, 1/5 sec, f/11.

By using a 180mm macro lens, I could keep a reasonable distance from this spider on its web but still get in close. If the focal length of the lens had been any shorter, I may have disturbed the spider and lost the shot.
> Canon EOS 1DS MK2, 180mm macro lens, 1/30 sec, f/8.

I positioned myself for this close-up of bay leaves so that they were backlit by the sun. **This has emphasized the detail of the veins and their intricate pattern, which would have been lost if the shot had been lit from the front.**
> Canon EOS 1DS MK2, 125mm lens + No. 1 extension tube, 1/30 sec, f/8.

## Extension tubes and bellows

Instead of a macro lens you can use extension tubes or bellows. Both fit between the lens and the camera body and enable you to get closer than normal to your subject. Their drawback is that they don't allow the lens to focus on infinity, so you have to remove them for normal photography.

Extension tubes come in a variety of sizes. The bigger the tube, for example 25mm as opposed to 12mm, the closer you will be able to focus. Two tubes can be joined together for even greater magnification, but this will require an even greater increase in exposure. Extension tubes can be used with many different lenses but they're not compatible with fisheye and other ultra wide-angle lenses.

If you're thinking of doing a lot of close-up photography, you might want to consider buying extension bellows. These work in a similar fashion to extension tubes except that the magnification is variable, whereas with extension tubes it is fixed.

I shot this close-up of pencil shavings with studio flash as well as a No. 1 and a No. 2 extension tube doubled up. **This meant that the front of the lens was only about 25mm (1in) away from the pencil shavings. A macro lens would have given me more working distance.**
> Canon EOS 1DS MK2, 65mm macro lens + No. 1 and No. 2 extension tubes, 1/60 sec, f/8.

## Focusing

Focusing is critical with close up photography, and manual focusing is probably better than relying on auto-focus. This is because depth of field when shooting this close is minimal and the A/F focusing point might have difficulty establishing a definite point on which to focus. A tripod and cable release are also advisable, as would be the use of the mirror-up facility and the self-timer.

When shooting close-ups, I focus, then depress the shutter release halfway, which sends the mirror up. I then press the release all the way. An alternative is to use the self-timer, which allows a reasonable amount of time to pass for the camera to settle and for any vibration that may have been caused by the shutter being fired to cease.

There is a tendency in close-up photography to stop the lens down as far as possible with the intention of increasing the sharpness of the shot. However, this is a fallacy because, although stopping the lens down might increase the depth of field, it won't increase the sharpness of the point on which the lens is focused. This is because light bends when it passes through the lens, and the smaller the aperture, the more the light bends. A rule of thumb as to the optimum aperture for maximum sharpness is to stop down only three stops from the maximum widest aperture. Therefore, a lens with a maximum aperture of f/2.8 will probably be at its sharpest when stopped down to f/8.

**This shot illustrates perfectly the small amount of depth of field that's possible when going in close. I used an aperture of f/16 but you can see that the area of sharp focus is only millimetres.**
> Canon EOS 1DS MK2, 180mm macro lens, 1 sec, f/16.

**You don't realize how quickly snails can travel until you try to photograph one. Fortunately, this snail was quite compliant and didn't mind continually being repositioned.**
> Canon EOS 1DS MK2, 180mm macro lens, 1/50 sec, f/4.5.

See also:
**Lenses** pp. 19–25
**Accessories** pp. 26–31
**Using auto-focus** p. 46

# Post-production

# Setting up a digital darkroom

The digital darkroom brings you out from the gloom into the daylight but it needs some key kit: a fast computer with a good-quality screen, some image manipulation software and, at the very least, a printer.

## The computer

The first thing to get right is the computer, and there are some basics to look for. No matter whether you opt for an Apple Mac or a Windows PC, buy the one with the biggest screen you can afford. Go for the largest amount of hard disk space (the storage) and ditto for the amount of RAM – I would recommend a gigabyte (GB) RAM but definitely no less than 256 megabytes (MB). This is because you'll quickly find the hard drive filling up with the large images that modern DSLRs can make. Image editing software packages are memory-hungry beasts, needing lots of RAM to do their work. Too little RAM and you might find the programs running slowly or crashing on a regular basis.

**A computer (here, an Apple Mac) that's ideal for image editing has plenty of hard disk space, lots of RAM and comes with a good-quality, large screen.**

As well as having USB and FireWire ports, this HP computer has built-in memory card readers (at the top) so that you can plug a memory card directly into the computer to upload your shots.

Ideally, your computer should also have at least two USB ports (preferably the fast USB 2.0 system) and two FireWire (or IEEE 1394) ports to give you optimum communication speeds between devices.

## The printer

Today's desktop inkjet printers can produce stunning photographs. They range in size from small, inexpensive, stand-alone printers producing 15 × 10cm (6 × 4in) prints to expensive A3 and larger printers. Many machines are combined printers, copiers, faxes and scanners but all, bar the most basic (cheap) models, can still produce good prints. The advantage of buying an all-in-one model is that you save on desk space without necessarily compromising on print quality. Some printers can bypass the computer and print directly from the memory card.

The printer manufacturer will recommend which paper and ink to use. These are generally their own brands, and they tend to be more expensive. However, this really isn't just a ploy to make you spend more money – the recommended ink and paper combination really does produce the best resuts.

Most inkjet printers use at least four, but as many as nine, inks together to achieve a good result. The four main colours are CMYK: cyan (C), magenta (M), yellow (Y) and black (K, which stands for 'key' and means the black ink). Additional inks can include light cyan and magenta to help with fine detail rendering, or red and purple to improve the range of colours that can be achieved on the print), while additional blacks and 'light blacks' are used for the same reason or to help improve black-and-white output. Generally speaking, the more inks there are, the better the output, but the more expensive the printer. To help keep costs down, try to buy a printer with separate ink tanks because, unlike printers with combined ink tanks, where more than one colour is built into a unit, you need replace only the tanks that are empty. As a rule of thumb, choose the highest-specified printer you can afford, but keep in mind the costs of the ink and paper.

## The software

Image editing software is the final factor involved in producing great prints. Although with many DSLRs you can print directly from the camera without linking up to a computer, being able to access your

images and manipulate them on the computer screen offers you a whole new world of creativity. The software ranges from inexpensive to very pricey, depending on how creative you want to be.

Your DSLR may come supplied with some form of image editing software – certainly, the camera should come with software to deal with RAW files. Adobe's Photoshop CS is one of the top-end very expensive image editing packages but Adobe also makes the much more affordable Photoshop Elements. Other packages include PaintShop Pro Photo XI, another Photoshop-like editing package. Again, this is much less expensive but it still has a full range of features and is very powerful.

The best course of action is to shop around and balance the level of skill you have (or don't have) with your budget, and if the software that was provided with your DSLR seems sophisticated enough, then you need not spend any more money anyway.

Another useful gadget that can help enormously with image manipulation is a graphics pad. Essentially, you 'draw' your edits on, and make changes to, your images with a pen-like stylus, instead of a computer mouse. Although this piece of equipment is quite costly, it does offer a more natural way of working than with a computer mouse, and you may consider that it is worth the investment.

**A helpful accessory for image editing is a graphics pad. This allows you to draw edits onto your images, instead of using a mouse, which feels more natural and also gives you greater precision.**

**DSLRs are often supplied with image editing software but, if not, there are many packages available on the market, such as Adobe Photoshop.**

# Basic colour management

You have a memory card full-to-bursting with images and now you want to print them. But, before you start, there are a few things you can do to make sure that your prints will be of the highest possible quality.

## Consistent colour

Colour management is simply a method of ensuring consistent colour on all your imaging tools and devices. This means that colour is handled on every piece of equipment, from computer monitor to desktop printer, in exactly the same way. To achieve this, you must calibrate your monitor to ensure it is properly set for colour balance and brightness. From this calibration process, a Colour Profile is created that can be used by image editing packages, such as Photoshop. Calibration should be carried out as often as once a week to ensure it remains consistent.

## The calibration process

The exact screen calibration process varies depending on your computer, but they're all broadly similar. I use an Apple Mac, and calibrate its screen through Apple's ColorSync Utility. Once you have found your computer's screen controls in System Preferences or the Settings folder on your hard drive, you can start using the Screen Calibration Wizard that walks you though the necessary steps.

First, select a 'Target Gamma', which is a basic contrast adjustment: Mac Gamma is 1.8; for a PC, 2.2 is the norm. Next, determine the screen's 'Native Response', or its luminance properties. A series of sliders and striped images appears, which have to be adjusted until you're happy.

**Correct screen colour calibration is a critical first step to obtaining consistent colour across all your equipment and perfect prints.**

Now, select the 'White Point', which is, basically, the colour temperature of the display. The 'Native' setting will be very blue-white but for imaging you'll need to use a setting of around 5000K, a similar colour to white paper viewed under normal daylight. This will look quite warm at first but your eyes will quickly adjust. Finally, save the settings.

You can also calibrate using a Monitor Spyder. These devices are attached to the monitor and measure its colour output, helping to create extremely accurate colour profiles. Primarily used by professionals, Spyders are expensive but may be worth investigating.

## Calibrating your monitor

The start screen for calibrating the monitor on an Apple Mac looks like this. By following the prompts, you can calibrate your monitor correctly. What you see on screen should match any printed output. Carry out the calibration process at the time of day you'll be using the screen, as the calibration will vary according to the light levels in your room.

*Right:* This display gives you an idea of the sliders you'll encounter in the screen calibration Wizard. These allow you to fine-tune the screen's response to colour and brightness. It is a good idea to sit further back from the screen and squint during this part of the process, as it helps you achieve the correct brightness and neutrality.

# Downloading, storage and back-up

Once you've taken your shots, you will need to transfer them onto a computer and, for additional security, save them to a separate back-up in case your computer crashes at a later date, losing all your images.

## Connecting the camera

Your DSLR will have been supplied with a variety of cables, some of which enable you to connect the camera directly to your computer. The cable, whether a USB or FireWire (you may have a camera with both), allows you to offload your images to your computer for safe storage and also for image manipulation. You can also transfer data from a memory card with a memory card reader (see below); they're fast, easy to use and save on battery power.

Depending on whether your camera has a USB or FireWire connection or both, you'll be able to plug the camera into a spare USB or FireWire port on your computer (in reality, it doesn't matter which type you use). However, computers with USB 2.0 or FireWire connections will be faster than the older USB 1.0 types. To connect, plug one end of the lead you're going to use into the relevant port on your camera, then plug the other end into a spare (and relevant) port on your computer.

Turn your camera on and it will automatically 'see' the computer and 'talk' to it; on some cameras, you may need to activate the playback mode (press the review button) to get them talking. The camera should mount as a small hard drive icon on the desktop from which you can drag and drop your images to a folder of your choosing. Depending on how your computer is set up, it may offload the images to a designated 'Pictures' folder automatically or you may have to create a folder first.

You can connect your camera directly to the computer via a USB or FireWire connection and download your images. This will save you having to use a separate memory card reader.

This is a typical card reader, designed to accept multiple memory cards of varying types. It can be a convenient way of transferring images from your camera's memory cards onto your computer.

## Memory card readers

These small devices are designed to accept a variety of memory cards that can be left plugged into a spare port on your computer; there's no need for extra software to use them. As the memory card reader is plugged into the computer, not the camera, you save camera battery power, and a reader is often faster in terms of shifting image data. To use one is simplicity itself: plug the memory card into the slot on the card reader that corresponds to it. The card is then mounted on the desktop.

## Wireless connection

Transferring images by wireless connectivity, which allows any WiFi device or camera to connect seamlessly with another WiFi-enabled device, is becoming increasingly common. An obvious advantage of WiFi is that it cuts down on cable clutter that quickly builds up on your desk and it allows you to beam images to your computer from anywhere within range of the WiFi system you're using. Bluetooth is another wireless connection type; it has a shorter connection range than WiFi devices but works in broadly the same way, although it is slower.

## Storage and organization

Your saved images will quickly fill up the hard drive, and you will need to start thinking about organizing and storing them. There are external hard drives available for this, ranging from a few gigabytes up to many hundreds, even thousands. They are simple to use and set up, plugging straight into your computer via a spare USB or FireWire port.

Some image editing packages come with organizing abilities. These can provide a way to browse your entire library as thumbnails, sorting the images by date, for example, as well as putting them on the web.

## Backing-up

If you keep all your images on just one computer and there is then a problem with it, you risk losing all of them. That's where backing-up comes in. It is simply a case of moving or copying your important data to a different location, whether another computer, an external hard drive or even CDs or DVDs. Helpfully, many external hard drives provide software as part of the package when you buy them for just this purpose.

Some computer operating systems have back-up systems built into them, making life even easier. Windows XP Home Edition is one such system, although the back-up is not installed by default and must be installed from the supplied disks.

The most common back-up method, though, is a scheduled back-up to an external hard drive. Back-ups should always be made on a regular basis, determined by how much data you can comfortably lose should something go wrong. Typically, you can schedule automatic back-ups on a daily, weekly or monthly basis. The more data is changed or added, the more frequently back-ups should be carried out.

But you don't need software to carry out back-ups – you could just copy or move data from its location on your computer to an external hard drive, but you must remember to do it, and do it regularly. You can even back up to a CD or DVD if you have a disk writer. However, with CDs holding only 700MB of data each, DVDs are more practical options: single density disks hold 4.7GB, while double density disks hold up to 8GB. Even so, you may need more than one disk and you'll need to swap disks as they become full. If it's at all likely that you'll forget to do a regular manual back-up, you'd be best off using software that does it for you automatically.

Whatever method you choose, make sure that back-ups occur regularly and try to keep your data as organized as you can on your computer. It saves time when looking for the data to back up, which is particularly important if you're doing the job manually.

**An external hard drive connects to your computer quickly and easily, providing extra storage space – ideal for backing-up important data, such as images.**

# Processing RAW files

Shooting images with the RAW capture setting on your DSLR provides an indispensable extra level of image control, allowing you to revamp a photograph completely, if you so wish, on your computer at a later date.

## Advantages of shooting RAW

You've shot your images, downloaded the RAW files, and now you're ready to sort through them to choose those you want to process. As RAW images don't undergo any processing in camera, unlike JPEGs, which have compression and other parameters applied, depending on how the camera is set, RAW images can be thought of as digital versions of film negatives: they contain the raw image data before you've gone to the darkroom (or, in this case, the computer) to get the final print.

The key advantage of RAW images is that you can process them later on a computer, adjusting almost every aspect, if necessary, including colour saturation, exposure, sharpness and brightness, even making allowances for vignetting characteristics of your lens.

## Manipulating RAW files in Photoshop

Although the following information and accompanying computer images relate to Photoshop, bear in mind that most other image manipulation software, whether it's provided by the camera manufacturers or by third-party developers, operates along similar lines.

### Editing a RAW image

**Step 1**
Open your folder of images in your software, such as Photoshop. This will load all the images in the folder for you to peruse and select those you want to process.

**Step 2**
Double-click on the image you wish to edit – it will open in a new window. Depending on the image, the software may apply corrections automatically, which can sometimes be enough to rectify the image. But if you feel additional elements need tweaking, you can then make corrections yourself.

**Step 3**
Use the sliders to make changes where necessary: adjusting White Balance, increasing Exposure to produce a high-key image, changing Saturation to boost colours. Remember that the changes you make cannot damage your RAW file, so you can be far more extreme than if you were working on a JPEG. Use the eyedropper tool to fine-tune the white, grey and black points of your image.

**Step 4**
Change other settings, such as sharpness, lens vignetting adjustments, individual colour saturation and hue, using the additional tabs in the stacked control panel. Just click the relevant tab and make the changes. Click on the preview button to ensure any changes are displayed on screen; if you don't like a certain effect, you can easily change it.

**Step 5**
When you're happy with your changes (you can see some of the adjustments made to this image on the control panel sliders), click OK for the software to apply your changes and process the file for further editing, if needed, or you can simply save it ready for printing.

**Step 6**
This side-by-side comparison shows how the adjustments have improved the RAW image. On the left of the black line you can see the unadjusted RAW file; on the right is the finished, processed image ready to print. The colour overall is much brighter and more vibrant, and the contrast is greatly improved.

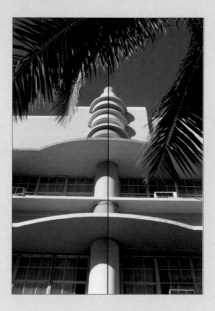

## Batch processing

If you have many similar images that were all shot at the same time in identical conditions, then you can apply the same processing parameters to multiple images using the Previous Conversion command in the drop-down menu of the right-hand Settings panel. This saves you having to repeat the same steps for every single image. Some software may enable you to batch-process whole folders of images without having to feed them in one at a time.

# Fine-tuning your images

Once you've processed your RAW images and saved them to your computer's hard drive, you are ready to start playing with those images that could be improved with just a little bit more work.

## The quick fix

Although your processed images might be almost exactly as you'd like them, there can often be small tweaks to colour, contrast and sharpness you can make, or you may spot an element in a shot that you want to remove. With software such as Photoshop CS (used here) and similar packages (dialogues and menus may vary but the processes are basically the same), you can adjust all these elements on your computer before printing and putting your images into a folio.

Most image editing software has a Quick Fix mode that, at the press of a button, allows the software to make a 'best guess' attempt at fixing any 'problems' in a shot. Illustrated below is the Quick Fix window for Adobe Photoshop Elements III with a before and after example of the changes made by the software. Using the Quick Fix mode can be worthwhile because it may save you time but its effect on an image can often be too much, and that's where the next tools come into play.

Compare the original image on the left of the screen grab with the one on the right, which has been altered in the Quick Fix mode. Quick Fix has automatically adjusted the contrast and colour, making the image more vibrant and punchy, boosting colour and brightness, which is particularly evident in the blue sky.

## Levels

The Levels adjustment helps control colour and brightness within an image and it allows you to change all the colours or individual ones easily and quickly. The histogram in Levels shows at a glance the quality of the image. This is a graph of all the coloured pixels (and their relative brightness) within the image. A well-exposed image will appear with gentle peaks across the entire histogram. If the histogram shows that the pixels don't reach both ends of the graph (darker pixels are represented on the left, brighter pixels to the right), you can make adjustments.

### Adjusting Levels

**Step 1**

Open the image in your software, such as Photoshop, and navigate to Image > Adjustments > Levels. Assess the histogram in the Levels dialogue box for any adjustments that might be beneficial. You can see that the pixels in this histogram don't reach both ends of the graph and that the Levels could be adjusted to improve the image. Click on the Preview box, so you can see the effect of your adjustments.

**Step 2**

Click the Channel drop-down menu and select Red. Move the small pointers beneath the histogram and monitor the effect your changes have on the image as you go. Repeat the process with Green and Blue or until you get the desired result.

# Curves

The Curves command is similar to Levels but provides finer control over tones and brightness within an image. The careful control of curves makes it possible to fine-tune colour balance without affecting any other part of the image. It's ideal for images containing fine detail, such as clouds or a bride's white wedding dress.

## Adjusting Curves

**Step 1**
Open the image to be edited in your software. Navigate to Image > Adjustment > Curves. The diagonal line in the Curves dialogue box shows the tones within the images and runs from bottom left (the blackest parts of the image) to top right (the whitest parts) through the central area (the grey areas).

**Step 2**
Go to the drop-down menu Channels, which allows you to alter each of the three red, green and blue colours independently of each other for fine control. Alternatively, you can adjust them together in the combined, or global, RGB channel. Clicking and dragging on the diagonal line makes the adjustments.

Step 3
Select three anchor points: one in the middle of the dialogue box, one midway between the centre and the top, and one midway between the centre and the bottom. An 'S' curve usually works best but it does depend on the image. Drag the top and bottom points in each colour in turn (or globally) until you have the desired degree of adjustment. Then save your image. As with Levels, you can save any settings for use on similar images.

## Contact sheets

A contact sheet is a term left over from the days of film, whereby you create a single sheet of thumbnail-size images of your negatives for an at-a-glance spread of the shots for editing prior to printing. Fortunately, in the digital darkroom and with software such as Photoshop, which uses an automatic system called Contact Sheet II, you can quickly create a contact sheet of your images.

### Creating a contact sheet

Step 1
Navigate to the folder of images from where you want to create a contact sheet using File > Automate > Contact sheet. A dialogue box will appear in which you establish how you want your contact sheet to look. Your instructions are then carried out automatically.

**Step 2**
Select from the drop-down menu whether you want to make a contact sheet from a folder of images or from the images in the browser window, as shown here. Set the document size, then, using the various fields in the dialogue box, set the size of each thumbnail, output resolution, colour mode, etc. You can either use the image file names as captions or set your own. Use the preview to see how the contact sheet might look.

**Step 3**
Click OK when satisfied that you've set everything properly. The software will then start to churn through the data, building your contact sheet automatically as it goes. Once you have a finished contact sheet, as shown here, save it to your hard drive, ready for printing.

## Useful tips

To help stop the contact sheet growing into a gigantic file size, check the Flatten All Layers box. As the name suggests, this flattens the layers created by the software while it makes the contact sheet, helping to keep the file size at a manageable level. Check the Rotate for Best Fit box to help get more images on a sheet. Upright images will be rotated (or vice versa) to ensure the maximum number of thumbnails on a page.

# Panoramas

Even though you may have an extensive range of wide-angle lenses, it's unlikely that one of them has the angle of view required for really good panoramic shots. The only lens that might be suitable is a fisheye with a 180° angle of view, but the curvature it creates at the sides of the frame will probably be unwelcome.

## Stitching shots together

It is possible, though, to create a panoramic scene with your DSLR and computer by taking several shots and 'stitching' them together using the appropriate software for your camera and then manipulating the images in Photoshop. For the individual shots that make up the panorama, it is essential that you use a tripod so that the 'pan' is kept level throughout.

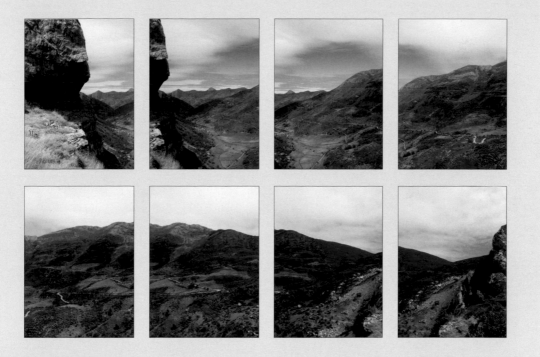

**These are the individual shots taken for the panorama.**

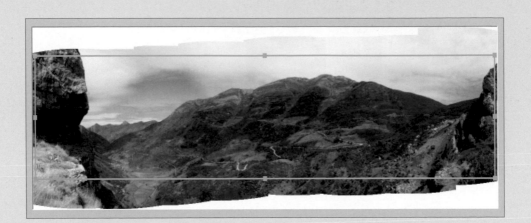

This is what the shots look like in the basic stitch mode. You can see that there is still some fine-tuning to do on the computer.

## Smoothing rough edges

**Step 1**
Use the Clone tool to smooth any visible overlapping edges created when stitching by extending the sky over them.

**Step 2**
Gently erase the badly stitched area of hillside with the Clone tool. Remember that perfect results take practice.

## Blending areas

**Step 1**
Notice the mismatching area of sky caused by stitching two shots together. To blend such mismatching areas, use the Patch tool.

**Step 2**
Select an area of sky with a similar tonal range to use as the patch. Move the selection over the visible join in the sky. I find it better to blend small areas at a time rather than trying to patch the entire area in one go.

**Step 3**
The finished result with a sky that is even in colour.

## Patching areas

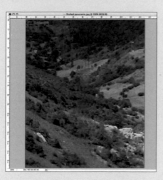

**Step 1**
Locate an area where the joins are obvious and need patching. Select another area that you want to use as the patch with the Patch tool.

**Step 2**
Soften (feather) the edges of the area to be used as the patch by navigating to Select > Feather. The scale of pixels ranges from 250 to 1. The higher the number of pixels, the softer the feathering.

| Edit | Image | Layer | Select | Filt |
|------|-------|-------|--------|------|
| Undo State Change | | | | ⌘Z |
| Step Forward | | | | ⇧⌘Z |
| Step Backward | | | | ⌥⌘Z |
| Fade... | | | | ⇧⌘F |
| Cut | | | | ⌘X |
| **Copy** | | | | ⌘C |
| Copy Merged | | | | ⇧⌘C |
| Paste | | | | ⌘V |
| Paste Into | | | | ⇧⌘V |
| Clear | | | | |
| Check Spelling... | | | | |
| Find and Replace Text... | | | | |
| Fill... | | | | ⇧F5 |
| Stroke... | | | | |
| Free Transform | | | | ⌘T |
| Transform | | | | ▶ |
| Define Brush Preset... | | | | |
| Define Pattern... | | | | |
| Define Custom Shape... | | | | |
| Purge | | | | ▶ |
| Keyboard Shortcuts... | | | | ⌥⇧⌘K |
| Preset Manager... | | | | |

**Step 3**
Copy the patch and then paste it to create a new layer that 'floats' on top of the original background layer. To make it easier to see the floating selection on the page, I have dropped the opacity of the background in this example. Repeat this process using different parts of the image to disguise any joins.

**Step 4**
Once you have selected all the patches, isolate them from the main image by navigating to Window > Layers. Move the patches over the joins.

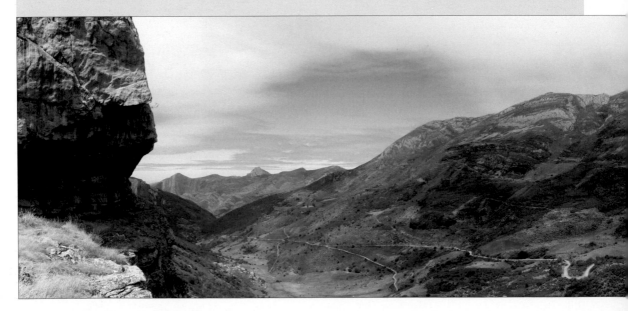

*Left:* This very enlarged section of the finished panorama shows the repair running down the centre. However, when the image is viewed at normal size, the repair, which is towards the left-hand edge of the whole panorama shown below, is not apparent at all. Copying and pasting works well for this type of work. Using the feathered edge gives you a little more control than the Clone tool, and it doesn't smear like the Patch tool or Healing brush.

*Below:* The finished panorama of the Four Valleys of Léon in northern Spain .

# Retouching

Even though you have taken time setting up and taking your pictures, there may still be some small undesirable aspects of your subject that have crept unnoticed into your shots. Many of these, if not all, can be remedied on the computer in Photoshop or a similar image manipulation software. As with any manipulation carried out on the computer, practice definitely makes perfect. Always make a copy of the original image before you start any manipulation because it will be lost forever if you save the changes that you make. The before and after images of a very attractive model are shown below and right; the different stages in the retouching of the photograph are illustrated on pages 228-9.

*Left:* A lot of care had gone into the hair and make-up of this model, and a good deal of attention had been paid to the lighting, but there were still areas that could be improved. An injection scar on her upper arm is still visible in the shot, the lights have caused highlights on her skin and there is a stray area of hair on her forehead that would look better removed.

*Right:* To achieve this final version, I manipulated the image in Photoshop. For the frown line, I used the Healing brush; for the skin highlights, the Clone tool; and for the hair and scar, the Patch tool.

## Removing skin highlights

**Step 1**
Locate any unwanted highlights
on the skin.

**Step 2**
Use the Clone tool with the blending Mode set to Darken. This
changes only those parts of the image that are lighter than
the sampled area. Use the Clone tool in the normal way to fill
in the bright highlight only.

**Step 3**
To lighten any dark areas, use the
Clone tool with the blending
Mode set to Lighten.

**Step 4**
The highlights caused by the
lighting have disappeared and
the shadows to the side of the
nose have been reduced.

*Right:* The Healing brush and Patch tool do similar things, and it is only by trial and error that you can decide which tool will work best in a particular situation. The Healing brush acts like the Clone tool but it automatically blends the surrounding areas.

## Smoothing over a frown line

**Step 1**
From the tool bar, select the Healing brush. Select a blemish-free area of skin similar in size and close to the area to be healed. Move the brush over the area to be healed and click.

**Step 2**
You may need to repeat this process for a really smooth finish.

## Removing a scar

**Step 1**
With the Patch tool, draw an area of a similar size to the scar from an area with a similar tonal range.

**Step 2**
Click on the patch and drag it over the area that needs retouching.

## Tidying the hair

I used the Patch tool in the same way to remove the unwanted hair on the model's forehead, but the Healing brush could also do the job.

# Printing

Printing your images is one of the last tasks to perform once you've completed your edits and RAW file processing. There are some key considerations to bear in mind, as well as different ways to have your images printed.

## Printing options

Your photographs can be printed in a variety of ways: at home on a desktop printer, online or at a high street developers. However, as the quality of your prints is probably of prime importance, you will need to determine the kind of paper and ink that is used by each processor.

## Printing at home

There are two main types of inkjet printer: thermal inkjet and piezo ejection. Thermal inkjets use heat to fire tiny droplets of ink out of nozzles, controlled by the printer and/or your computer. Piezo ejection is slightly different in that it uses minuscule mechanical pumps (one for each nozzle) to eject droplets of ink (again controlled by the printer and/or your computer) onto the paper. Both types of inkjet, which are becoming increasingly inexpensive to buy, can produce amazing quality prints from their respective photo-output modes.

This image shows a Canon inkjet printer, typical of the thermal inkjet type of printer.

*Left:* Inkjet printer and paper manufacturers design their papers to work as a team with their printers and ink for optimum results.

*Right:* Epson inkjet printers, like the printer illustrated here, use piezo ejection technology.

Printer inks are designed to work with specifically designed paper or media. Always try to use media designed to go with your printer and ink type, so that you have the correct colour performance and you'll be guaranteed the best results for the longest amount of time.

Speciality papers, such as fibre-based media and canvas media, are available for more professional or traditional photographic effects, and are particularly useful if you plan to exhibit your pictures. Typically, these papers are made by third-party manufacturers and available in light- or heavyweight versions with a variety of finishes. While the finishes on these types of paper are very good, products are available, such as Print Guard, that can seal the image from the environment and fingermarks and give the print a lift into the bargain.

## Printing online

Online printing necessitates a connection to the internet. Ideally, that connection should be fast because image files can be very large and take a long time to upload. It's possible to upload your images to a number of online organizations (see page 247), who then store the images in folders or online albums, print them for you to your requirements and then post them back. You can even get CDs of the images as well.

## High-street printing

Just like taking a roll of film in to be processed, you can now go into a print shop on the high street, hand over your memory card or a CD of images you've prepared at home and have prints made. Some of these shops also have do-it-yourself print kiosks that allow you to print images via a touch screen.

# Black-and-white from colour

Not all DSLR cameras allow you to shoot in black-and-white mode, which means that you will have to adjust your images on the computer at a later date in order to create black-and-white prints. Even if your camera does have the black-and-white option, I still think it's best to shoot in colour because you then have the option of creating black-and-white images on the computer. Rember that if you shoot in black-and-white, you will not be able to convert to colour later on.

## Desaturation and greyscale

The easiest way to convert a colour image into black-and-white is to desaturate it by navigating to Image > Adjustments > Desaturate, as shown below. This is, however, a particularly crude method and the image will end up looking flat, especially in the highlights and shadows. I would use this method only to give me a quick idea of what a colour image might look like in black-and-white. An alternative method is to convert the colour image to greyscale. To do this, go to Image > Mode > Grayscale. This method has its limitations, too, and it is 'destructive' in the sense that it changes the image file permanently.

### Using desaturation

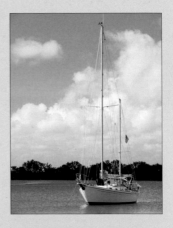

**Step 1**
Open the colour image in Photoshop or chosen software.

**Step 2**
Navigate to Image > Adjustments > Desaturate.

**Step 3**
Although at first glance the converted image looks acceptable, there are better ways of doing the job, which give you far more control over the way in which the different tones are displayed.

# Hue/Saturation method

Converting a colour image to black-and-white using the Hue/Saturation method and adjusting the Hue, Saturation and Lightness can produce a wide range of different effects. There are no hard-and-fast rules regarding the 'perfect' version. Of the three images below, it is the last that works best for me, and it is certainly a great improvement over the simple desaturate version shown opposite.

## Using Hue/Saturation

**Step 1**
Navigate to Layer > New Adjustment Layer > Hue/Saturation and create two new layers. For the top layer, move the Saturation slider to -100 to turn off the colour.

**Step 2**
Change the second new layer from Normal to Color in the Layers palette in the drop-down window. In the Hue/Saturation box, click Colorize. Move the sliders (Hue, Saturation and Lightness) to different positions to create the desired tonal effect. Three different variations are shown below.

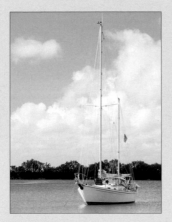

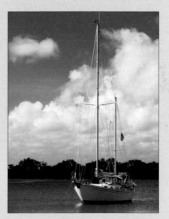

## Channel mixer

My preferred method of changing a colour image to black-and-white is to use the Channel mixer. Increasing or decreasing the values of the red, green and blue channels can produce very similar effects to using colour filters with black-and-white film.

## Using Channel mixer

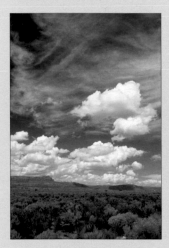

**Step 1**
**Open the colour image in Photoshop or equivalent software.**

**Step 2**
**Click on the middle icon at the bottom of the Layers palette, as highlighted here. Select Channel Mixer.**

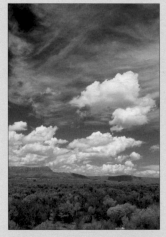

**Step 3**
**Tick the Monochrome box in the Channel Mixer box (right) to remove the colour from the image (far right).**

**Step 4**
Move the sliders to achieve the desired effect – here, it is to emulate a red filter, darkening the sky and enhancing the clouds. The trick to keeping a full range of tones is to make the sum of the values close to 100, as shown here (+200 Red / -82 Green / -18 Blue = 100). Tick the Preview box so you can monitor your changes.

**Red filter mode**

**Step 5**
Emulating a green filter by increasing the value in the Green channel has flattened and lightened the foliage. Remember that using a filter the same colour as the subject lightens it, whereas a complementary one will darken it.

**Green filter mode**

**Step 6**
Emulating a yellow filter results in less drastic changes. The sky has darkened but not as much as with the red filter. However, there is much more detail in the cloud. In my opinion, this is the best version because it displays a full range of tones and will make a first-rate black-and-white print.

**Yellow filter mode**

# Duotones and tritones

Once I've taken my shots, I often experiment with different printing techniques. Some of these, such as lith printing (see pages 240–1), emulate methods used in the wet darkroom. The duotone is particularly suited to digital imagery. This is a combination of two colours or, strictly speaking, inks, but the process can be taken further to produce images made up of three colours (tritones) or four colours (quadtones).

## Creating a duotone

**Step 1**
Open your colour image in Photoshop or equivalent software. Navigate to Image > Mode to convert it to Grayscale.

 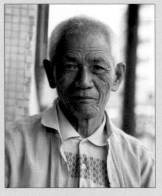

**Step 2**
Using a combination of Curves and Levels (see pages 217–19), add contrast and mood to the image by selecting those areas that you feel need to be lightened or darkened to improve the overall tone. Once you've made the adjustments, the image will probably be good enough to print.

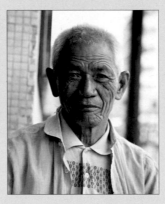

**Step 3**
If you wish, you can take the process a step further to produce an image with a richer tonal range. Navigate to Image > Mode > Duotone (above). In the Duotone Options box that then opens, click on Duotone to display two ink colours (black and white). Click on Ink 2 to open the Custom Colors box.

## Step 4
Click on Picker to open the Color Picker window (left). Choose the most appropriate additional colour. This is often a case of trial and error but it is an absorbing process – you may get lost in the sheer choice of tones available.

## Step 5
If you wish to fine-tune the image, click on the first left-hand Ink box in the Duotone Options box (above left) to bring up the Duotone Curve box (above right). Make adjustments using the six points on the graph until you achieve the desired result. Repeat the process for the second Ink box.

## Step 6
I now have a monochromatic image with a full range of tones, which I think is a distinct improvement on the original colour photograph. When converting your colour images in this way, always look for a shot that is full of detail, such as this man's face.

## Creating a tritone

**Step 1**
To take the process a stage further, I introduced a third colour. Select this in the same way as for the duotone (see pages 236–7). You can use any combination of colours – sometimes the difficulty is knowing when to stop. Two examples of tritones using very different colour combinations are shown above.

**Step 2**
By experimenting with a variety of different colour combinations, I arrived at my final image (right). The rich but subtle array of tones gives the image much greater depth than the original. Cropping into the picture and adding a small amount of grain from the plug-in filter Grain Surgery™ (see page 240) increases the impact.

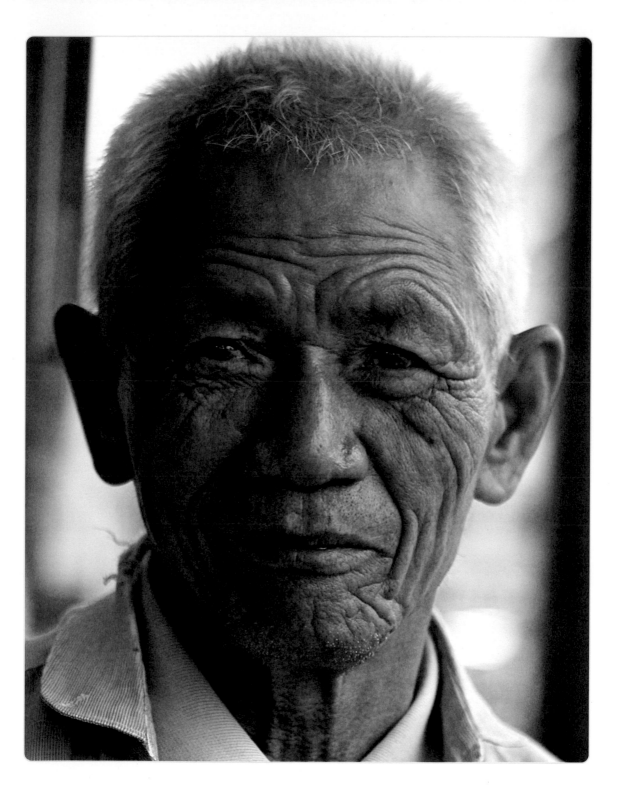

# Lith prints

Lith prints are traditionally associated with the wet darkroom, where a special paper and a lith developer are used. In the darkroom, creating lith prints is time-consuming and it's virtually impossible to repeat the image exactly. By contrast, you can create a beautifully toned lith image digitally, as well as being able to print it just the same again and again.

## Creating a lith print

**Step 1**
Start with a black-and-white image, such as used in Duotones on page 236.

**Step 2**
Navigate to Image > Mode > RGB Color, then to Image > Adjustments > Curves. In the Curves box, click on the Red Channel to reintroduce colour. Make a gentle 'S' shape until you achieve the desired effect.

**Step 3**
Click on the Blue Channel. Move the highlight point of the curve down from the top right. This adds a yellow tone into the highlight because the opposite of yellow is blue.

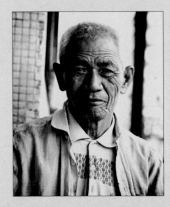

**Step 4**
For additional fine-tuning (left), navigate to Image > Adjustments > Hue/Saturation (above). Control the colour with the Hue slider and the intensity of the colour with the Saturation slider.

**Step 5**
For my final print (right), I added some grain, characteristic of a lith print, from the plug-in filter Grain Surgery™.

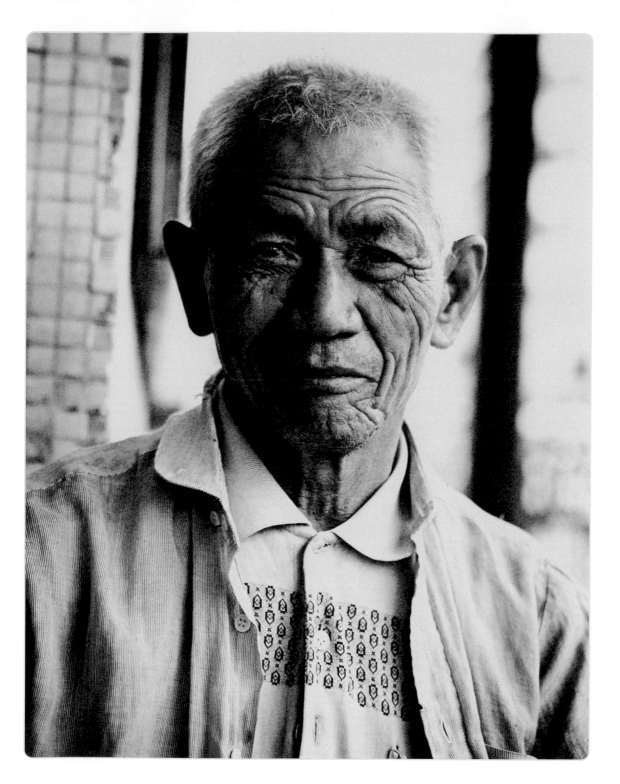

# Toning

As well as converting a colour image to black-and-white, you can tone a monochrome image to enhance it further. This can alter a photograph considerably, just as chemical toning does in the wet darkroom.

## Toning an image

**Step 1**
Open a black-and-white image in Photoshop or equivalent image manipulation software.

**Step 2**
Navigate to Image > Adjustment > Curves. For this photography of different woods, I boosted the red (opposite of cyan), while removing blue (opposite of yellow), to add warmth to the original image.

**Step 3**
For a split-tone effect, boost red and yellow in the highlights, while increasing blue and cyan in the shadows.

# Presenting your images

Once you've successfully edited and perhaps even printed your images, you'll probably want to share them with others. Fortunately, there have never been so many great ways to present your images to the world as there are today.

## Choosing your presentation

There are many different ways of presenting your work, and you may find that you'll need a combination of them all, from a printed portfolio to your own website. Bear in mind that how you present your images needs careful thought: it all depends on how your images will end up being used. Also, be strict and edit your images rigorously, then edit them again so you include only the very best pictures. And don't forget to update your folio on a regular basis, particularly if you're aiming to sell your images – a folio of images for one prospective client might not be at all suitable for another.

## Traditional folios

In a printed portfolio, it's important to have the highest-quality images. Desktop printers are ideal for this, as you can quickly update the folio whenever you need to, as well as achieving high-quality prints from

**A good-quality folio containing your best images is an effective presentation tool, particularly if you're touting for business or intending to sell your images.**

material and originals that you can control. The folios themselves can be expensive but they make a very good first impression. Make sure that the folio you buy is of archival quality, made from materials that that won't leach chemicals into your prints, skew colours or make the prints fade. Ensure that it's robust enough to be carried around without becoming tatty, and that it protects your work and presents it to the best advantage.

## Web presentation

Building a modest website to present your images is always a good idea, allowing you to get your images online quickly and efficiently for prospective clients who are familiar with the internet. Many image-editing programs come with simple-to-use web-building elements to help you create a basic website. A bespoke web build can be expensive,

**A website can be expensive to build, but most image-editing software has quick, easy-to-use tools to help you build a basic online folio of images.**

**A digital projector is an ideal way to present your images if they've been burnt onto a DVD.**

so consider some of the free online sharing communities (see right). On some sites you can also sell your photographs. Although most of these are free to sign up to, they do require registration.

## Folios on disk

Another route to take is to burn a slide show of your images onto a DVD or CD. There are numerous film-making software packages that come bundled with your computer's operating system, such as iMovie, that allow you to create professional-looking slide shows of images. You can present these on your computer or project them with a digital projector. If you have a lot of large images, choose a DVD, not a CD, because it has a capacity of 4.7GB as opposed to 700MB. Projectors can be plugged into a computer, which can be used to control the show, or into a DVD player with a disk with a pre-burnt slide show presentation on board. For more basic presentations, you can even use Microsoft's Powerpoint.

## Email

Last but not least comes the humble email, which is an invaluable tool for the quick and basic distribution of proof-quality, low-res images. If you have a PC and a connection to the Internet, then you'll almost certainly be using email already. Attaching individual images or a small slide show that you've compressed in software specifically for an email is easy to do. You can then email the attachment to a multitude of people quickly and at little cost. If anyone shows serious interest in your work as a result of the email, you can send them the images on a disk.

# Resources

### Manufacturers
This is a selection of leading manufacturers of digital cameras, lenses and accessories.
www.canon.co.uk
www.fujifilm.co.uk
www.nikon.co.uk
www.olympus.co.uk
www.pentax.co.uk
www.sony.co.uk

### Flash
Metz is the market leader for on-camera flashguns, while Johnsons-photopia (Broncolor) and Elinchrom are popular makes of professional studio flash kit.
www.elinchrom.com
www.johnsons-photopia.co.uk
www.metzflash.co.uk

### Reflectors
You can use a range of materials to improvise a reflector, such as white card or a sheet. For a huge range of proprietary ones, try Lastolite.
www.lastolite.com

### Equipment retailers
Some professional retailers also rent out equipment. This means that that you can try before you buy, possibly saving you money in the long run.
www.calumetphoto.co.uk
www.jessops-uk.co.uk
www.jigsaw24.com
www.robertwhite.co.uk
www.teamworkphoto.com

### Distributors and importers
These distributors cover a wide range of popular and lesser-known items of digital kit.
www.intro2020.co.uk
www.johnsons-photopia.co.uk

### Printers
Canon is the market leader for inkjet printers but the others are catching up fast.
www.canon.co.uk
www.epson.co.uk
www.hp.co.uk

### Fine art inkjet papers
Every month new printing papers are marketed. As well as the usual finishes, such as glossy or matt, many have textured surfaces.
www.chaudigital.com (Da Vinci )
www.epson.co.uk
www.fotospeed.com
www.hahnemuehle.com
www.inveresk.co.uk (Somerset)
www.permajet.com

### Online printing
You can upload your image files to various organizations who will then store and print your images.
www.bonusprint.co.uk (one of many traditional photo printing companies that now work online)
www.foto.com
www.metroimaging.co.uk
www.photobox.co.uk
www.snapfish.co.uk

### Professional digital printers
These printing companies produce work to the highest standard.
www.metroimaging.co.uk
www.tapestry.co.uk

### Sensor cleaning and repair
Although there are many kits on the market, I would recommend that you have your sensor cleaned professionally by a company such as Fixation.
www.fixationuk.com

### Web presentation
The following sites are free online sharing communities, where you can upload your images to be accessed by interested parties.
www.flickr.com
Google Images
www.myspace.com

### Galleries and organizations
These organizations are a fantastic resource centre for both students and assistants.
www.michaelhoppengallery.com
www.photofusion.org
www.photonet.org.uk (The Photographers' Gallery)
www.tate.org.uk/modern (Tate Modern)
www.the-aop.org (The Association of Photographers)
www.vam.ac.uk/collections/photography (Victoria & Albert Museum)

# Glossary

**Alpha channel**
Extra 8-bit greyscale channel in an image that is used for creating masks to isolate part of the image.

**Angle finder**
Device attached to a viewfinder that allows an image to be viewed at right angles to the camera.

**Aperture**
Variable opening in the lens that determines how much light is allowed to pass through the lens.

**Aperture priority**
Camera metering mode that allows you to select the aperture, while the camera automatically selects the shutter speed.

**APO (Apochromatic) lens**
Lens that reduces flare and gives greater accuracy in colour rendition.

**ASA (American Standards Association)**
Series of numbers that denotes the speed of camera film, now superseded by the ISO number (see below), which is identical.

**Auto-focus**
Lens that focuses automatically on the chosen subject.

**AWB (Automatic White Balance)**
Automatic assessment by the camera of white balance.

**B (bulb setting)**
Setting on the shutter speed dial on the camera that keeps the shutter open for as long as the shutter release is pressed.

**Backlight**
Light behind your subject, falling onto the front of the camera.

**Barn doors**
Movable pieces of metal attached to the front of a studio light to flag unwanted light.

**Beauty dish**
White dish within a reflective baffle that reflects light onto the subject with a very even spread of light, similar to a satellite dish.

**Between the lens shutter**
Shutter built into the lens that allows flash synchronization at all shutter speeds.

**Bit**
Unit of computer information.

**Boom**
Attachment for a studio light that allows the light to be suspended at a variable distance from the studio stand.

**Bracketing**
Method of exposing one or more frames either side of the predicted exposure and at slightly different exposures.

**Byte**
Computer file size measurement: 1024 bits = 1 byte, 1024 bytes = 1 kilobyte, 1024 kilobytes = 1 megabyte, 1024 megabytes = 1 gigbyte.

**Cable release**
Attachment that allows for the smooth operation of the shutter.

**Calibration**
Means of adjusting screen, scanner, etc. for accurate colour output.

**CCD (Charge Coupled Device)**
Light sensor.

**CD R**
Recordable CD.

**CD RW**
Recordable CD that can be overwritten.

**CdS**
Cadmium sulphide cell used in electronic exposure meters.

**Centre-weighted metering**
TTL metering system that is biased towards the centre of the frame.

**CMYK**
Cyan, magenta, yellow colour printing method used in inkjet printers.

**Colour bit depth**
Number of bits that are used to represent each pixel that makes up an image.

**Colour temperature**
Scale for measuring the colour temperature of light in Kelvins (K). 5000K is the colour temperature of daylight.

**Compact flash card**
Removable storage media used in digital cameras. Also known as a memory card.

**Compression**
Various methods used to reduce the size of a file. Often achieved by removing colour data (see JPEG).

**Continuous auto-focus**
Method whereby a camera focuses automatically, even when the subject is moving.

**Continuous lighting**
Flicker-free source of light balanced to daylight. Also known as HMI.

**Contrast**
Range of tones in an image.

**Cyan**
Blue-green light whose complementary colour is red.

**Data**
Information used in computing.

**Dedicated flash**
Method by which the camera assesses the amount of light that is required and adjusts the flash output accordingly.

**Default**
Standard setting for a command or software tool if the settings have not been changed by the operator.

**Depth of field**
Distance in front of the point of focus and the distance beyond that is acceptably sharp.

**Dialogue box**
Window in a computer application like Photoshop where the user can change the settings.

**Diaphragm**
Adjustable blades in the lens that determine the size of the aperture.

**Diffuser**
Material such as tracing paper that is placed over a light source to soften the light.

**Digital zoom**
Digital camera feature that enlarges central part of the image at the expense of quality.

**Download**
Transfer of information from one piece of computer equipment to another.

**DPI (Dots Per inch)**
Measure of resolution of a printed image (see PPI).

**Duotone**
Black-and-white image that has another colour added later on the computer.

**EVF (Electronic viewfinder)**
Type of viewfinder found in high-end digital cameras.

**Exposure meter**
Instrument that measures the amount of light on the subject.

**Extender**
Device fitting between the camera body and lens that increases the focal length of the lens.

**Extension bellows**
Attachment that enables the lens to focus at a closer distance than normal.

**Extension tube**
Attachment that fits between the camera and the lens to allow close-up photography.

**F/number**
Aperture setting of the lens. Also known as f/stop.

**File format**
Method of storing information in a file, such as JPEG and TIFF.

**Filter**
Device fitted over or behind the camera lens to correct or enhance the final photograph.

**Filter factor**
Amount of exposure increase required to compensate for a particular filter.

**Firewire™**
High-speed data transfer device up to 800 mbps (megabits per second). Also known as IEEE 1394.

**Fisheye lens**
Lens with an angle of view of 180°.

**Fixed focus**
Lens whose focusing cannot be adjusted.

**Flag**
Piece of material to stop light spill.

**Flare**
Effect of unwanted light entering the lens and ruining the shot.

**Flash memory**
Fast memory chip that retains all its data even when the power is switched off.

**Focal plane shutter**
Shutter system that uses blinds close to the focal plane.

**Focusing screen**
Area that the eye focuses on when looking through the viewfinder.

**Fringe**
Unwanted border of extra pixels around a selection caused by the lack of a hard edge.

**Gel**
Coloured material that can be placed over lights either for an effect or to colour correct or balance.

**Ghosting**
Hexagonal shapes caused by surface reflections in front of the aperture.

**GIF (Graphic Interchange Format)**
Compressed file format used over the internet.

**Gigabyte**
One billion bytes.

**Gobo**
Device used in a spotlight to create different patterns of light.

**Golden section**
Theory used by artists to give a pleasing composition. Also known as rule of thirds.

**Greyscale**
Image that comprises 256 shades of grey.

**Hard drive**
Internal permanent storage system of a computer.

**High key**
Photographs where most of the tones are taken from the light end of the scale.

**Histogram**
Graphical representation of variables over a range of values.

**HMI**
See Continuous lighting.

**Honeycomb**
Device fitted to the front of a light source that creates a directional light.

**Honeycomb metering**
See Matrix metering.

**Hotshoe**
Device that is usually mounted on the top of the camera, for attaching accessories, such as flash.

**Image stabilization**
Method for reducing camera shake especially when using a telephoto lens.

**Incident light reading**
Method of reading the exposure required by measuring the light falling on the subject.

**Internal storage**
Built-in memory found in some digital cameras.

**Interpolation**
Increasing the number of pixels in an image.

**Invercone**
Attachment placed over the exposure meter for taking incident light readings.

**ISO (International Standards Organization)**
Rating used for film speed that has been replicated in digital photography denoting sensitivity.

**JPEG (Joint Photographic Expert Group)**
File format for storing digital photographs where the original image is compressed to a fraction of its original size.

**Kelvin (κ)**
Unit of measurement of colour temperature.

**LCD (Liquid Crystal Display)**
Flat-screen display of information.

**Lens hood**
Device fitted to the front of the lens for shielding it from extraneous light.

**Lens shield**
Performs the same function as a lens hood but is generally attached to the camera lens with a flexible arm.

**Lossless**
File compression that does not lose any data or quality.

**Lossy**
File compression that does lose some data.

**Low key**
Photographs where most of the tones are taken from the dark end of the scale.

**Macro lens**
Lens that enables you to take close-up photographs.

**Magenta**
Complementary colour to green, formed by a mixture of red and blue light.

**Matrix metering**
Method of customizing the camera's colour space. Also known as multi-zone or honeycomb metering.

**Megabyte**
One million bytes.

**Megapixel**
1,000,000 pixels.

**Memory card**
See Compact flash card.

**Mirror lock**
Device on some DSLR cameras that allows you to lock the mirror up before taking your shot in order to minimize vibration.

**Moiré**
Interference pattern similar to the clouded appearance of watered silk.

**Monobloc**
Flash unit with the power pack built into the head.

**Montage**
Image formed from a number of different photographs.

**Multi-zone metering**
See Matrix metering

**Network**
Group of computers linked by cables or a wireless system so they can share files. The web is a huge network.

**Neutral density filter**
Filter that can be placed over the lens or light source to reduce the required exposure.

**Noise**
Grainy effect in images occurring in low light.

**Pan tilt head**
Accessory placed on the top of a tripod that allows smooth camera movements in a variety of directions.

**Panning**
Method of moving the camera in line with a fast-moving subject to create the feeling of speed.

**PC lens**
Perspective control, or shift, lens.

**Photoshop**
Image manipulation software package (the industry standard).

**Pixel**
The element from which a digitized image is made up.

**Polarizing filter**
Filter that darkens blue skies and cuts out unwanted reflections.

**PPI (Pixels Per Inch)**
Measure of resolution of an image (see DPI).

**Predictive focus**
Mode of focusing whereby the lens memorizes a selected point of focus while focusing on another subject.

**Prime lens**
Lens with a fixed focal length, unlike a zoom lens.

**RAM (Random Access Memory)**
Component of a computer in which information can be stored temporarily and accessed quickly.

**RAW**
Digital equivalent of a film negative.

**Resolution**
Amount of pixels in an image.

**RGB (Red, Green and Blue)**
Colour model used to represent the colour spectrum.

**Ring flash**
Flash unit where the tube fits around the lens, giving almost shadowless lighting.

**Satellite dish**
Similar to a beauty dish.

**Shift and tilt lens**
Lens that allows you to shift its axis to control perspective and tilt to control the plane of sharp focus.

**Shutter**
Means of controlling the amount of time that light is allowed to pass through the lens.

**Shutter lag**
Delay between pressing the shutter release and the picture being taken.

**Shutter priority**
Metering system in the camera that allows the photographer to set the shutter speed while the camera sets the aperture automatically.

**Single area auto-focus**
Mode of focusing that finds the main subject in a scene.

**Slave unit**
Device for synchronizing one flash unit to another.

**Snoot**
Lighting attachment that enables a beam of light to be concentrated in a small circle.

**Soft box**
Attachment placed on the front of a light, giving diffused illumination.

**Spill**
Lighting attachment for controlling the spread of light.

**Spot metering**
Method of exposure meter reading over a very small area.

**Stop**
Aperture setting on a lens.

**Studio flash**
Powerful form of flash light.

**Terabyte**
One trillion bytes.

**Tele converter**
Device that fits between the camera and lens to extend the focal length of the lens.

**TIFF (Tagged Inventory File Format)**
Format for storing digital images.

**TTL (Through The Lens)**
Exposure metering system.

**Umbrella**
Umbrella-shaped attachment that reflects light from a studio flash head.

**USB (Universal Serial Bus)**
Industry standard connector for attaching peripheral devices, such as a digital camera, to a computer, with data transfer rates of up to 450mbps (megabits per second).

**Vignetting**
Darkening of the corners of the frame if a device, such as a filter, is used that is too small for the angle of view of the lens.

**White balance**
Method used for accurately recording the correct colours in different light sources.

**Zip**
External storage device that accepts cartridges between 100 and 750 megabytes.

**Zoom lens**
Lens with a variable focal length.

# Index

Figures in *italics* indicate captions.

# Acknowledgements

I would like to thank the following organizations for their help in the preparation of this book: Adobe Photoshop; Apple Computers; Calumet UK; Canon Cameras UK; Epson Printers; Fast Track UK; Intro 2020; Fujifilm UK; Kodak; MotorSport Vision Ltd; Nikon Cameras UK; Olympus Cameras UK; Sigma Imaging UK; Sony UK; The Hop Shop, Shoreham, Kent; Phlox Flowers, London.

This book would not have been possible without my team of assistants: Alex Dow, my digital guru, who has been there for eight previous books and is indispensable; David Horwich, Jamie Laing, Simon Lipman, James Meakin, Ade Saul Osoba and Joas Souza, all of whom are destined to become great photographers!

A book like this is a team effort and many people have contributed to its making. In particular, I would like to thank my editor, Helen Ridge, who has shown enormous patience, a keen eye for detail and a real grasp of the subject, and also Doug Harman for his technical expertise. In addition, I would like to extend my gratitude to: Denise Bates, Nick and Booje Beak, Kofia Browne, Caroline Churton, Michelle Cooper, Daz Crawford, Lee Cam Ephson, John Fawdry, Alison Fenton, Debbie Frankham, Allegra Freeman, Katie Freeman, Teresa Freeman, Cathy Gosling, Oksana Gribko, Monica Harris, Ruby Hedley-Dent, Emma Jern, Katie Lawrie, Jaimini Limbachia, Alex Macar, Dario Marainelli, Nicola McLean, Sohal Meenakshi, Jonathan Monks, Helen Moody, Lisa Moore, Holly Newberry, Camise Oldfield, Chris Pailthorpe, Thomas Popesco, Pieter and Victoria Richter, Amelia Saint George, Pavel Straka, Atlanta, Katarina and Jonty Tolleson, Abigail Toyne, Alistair Turner, Tina Wriede. To anyone I may have forgotten, please forgive me.

John Freeman